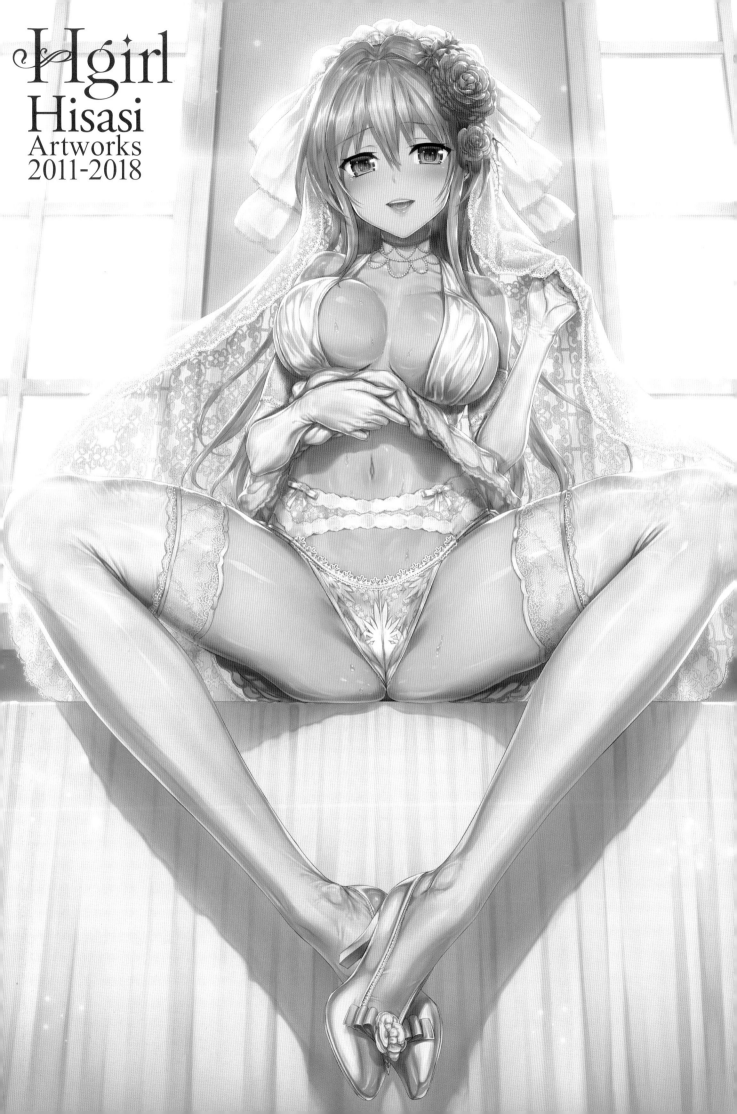

Hgirl
Hisasi
Artworks
2011-2018

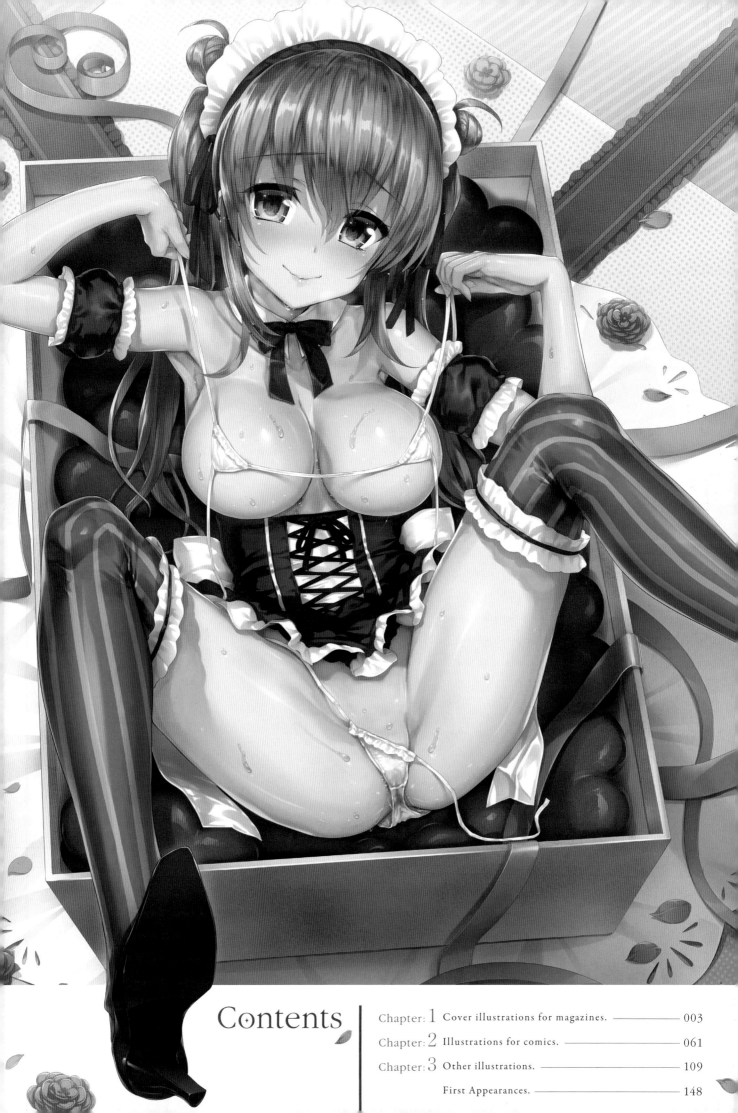

Contents

Chapter:1
Cover illustrations for magazines.

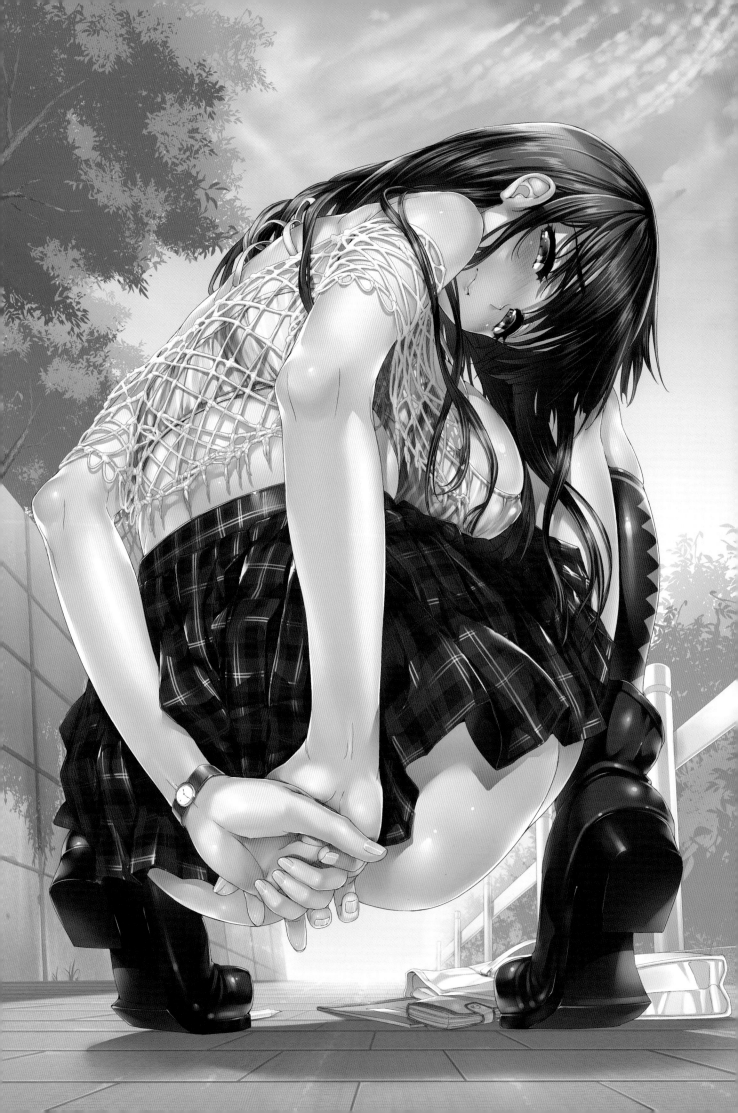

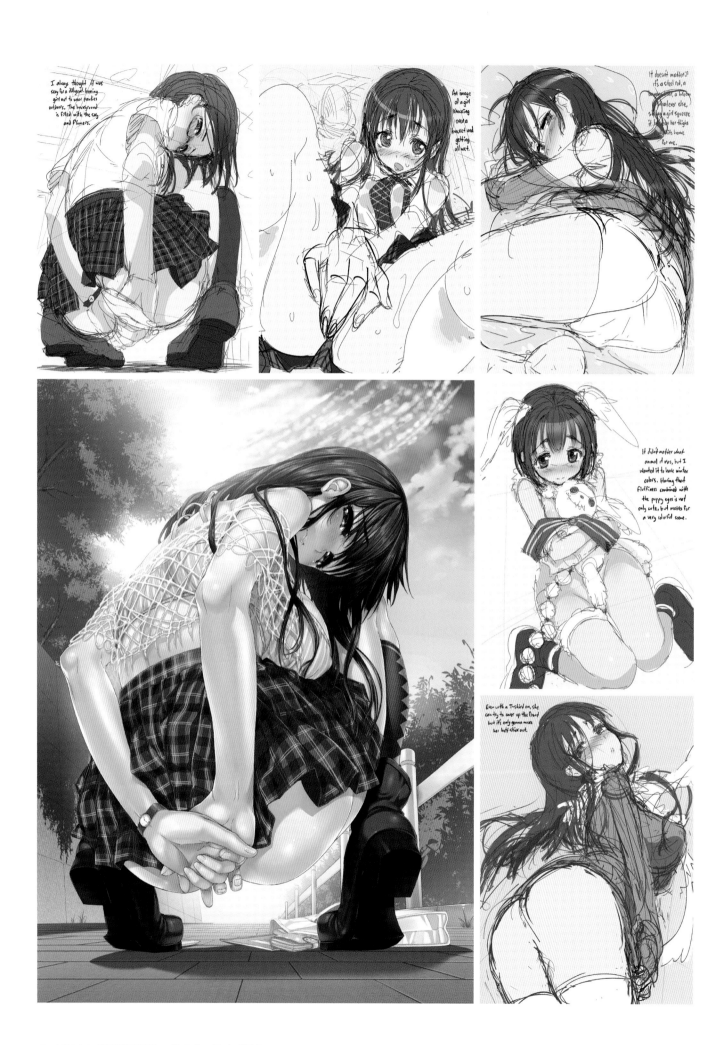

I always thought it was sexy for a diligent-looking girl not to wear panties outdoors. The background is filled with the sky and flowers.

An image of a girl knocking over a bucket and getting all wet.

It doesn't matter if it's a steel rod, a broomstick, a broom, whatever else, seeing a girl squeeze it between her thighs hits close to home for me.

It didn't matter what animal it was, but I wanted to have winter colors. Having that fluffiness combined with the puppy eyes is not only cute, but makes for a very colorful scene.

Even with a T-shirt on, she can try to cover up the front but it's only gonna make her butt stick out.

I always thought it was sexy for a diligent-looking girl not to wear panties outdoors. The background is filled with the sky and flowers.

Comic Kairakuten BEAST 12-2011 Cover Illustration Kurahashi Yuri
2011

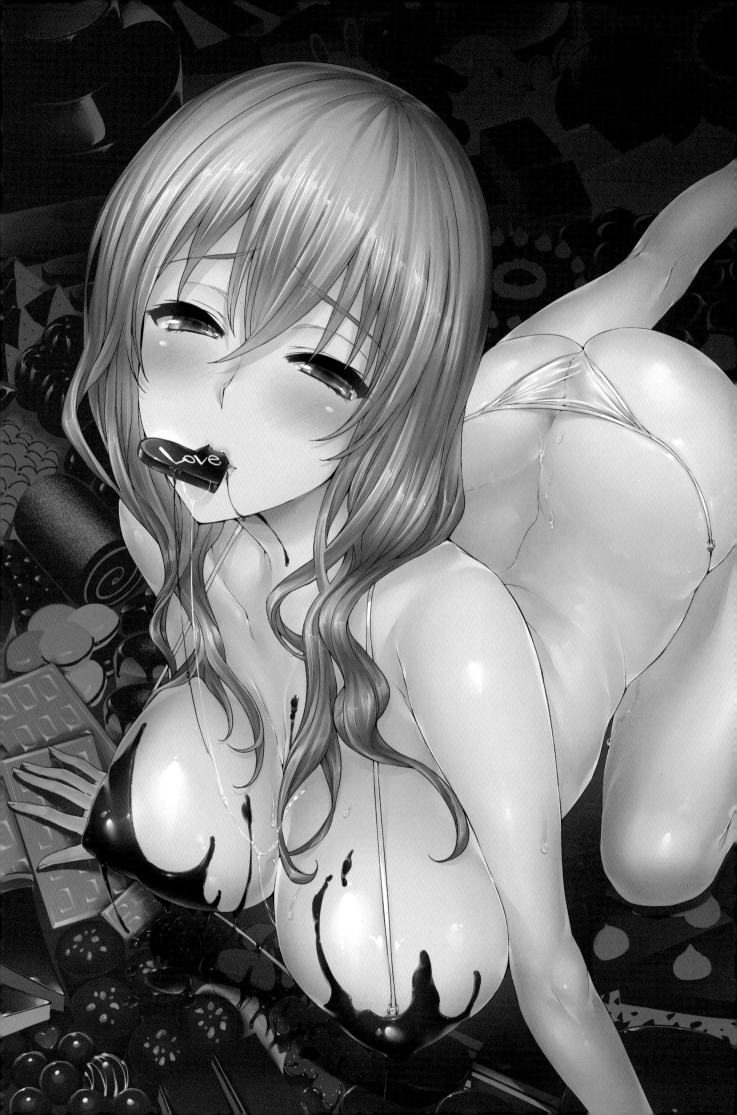

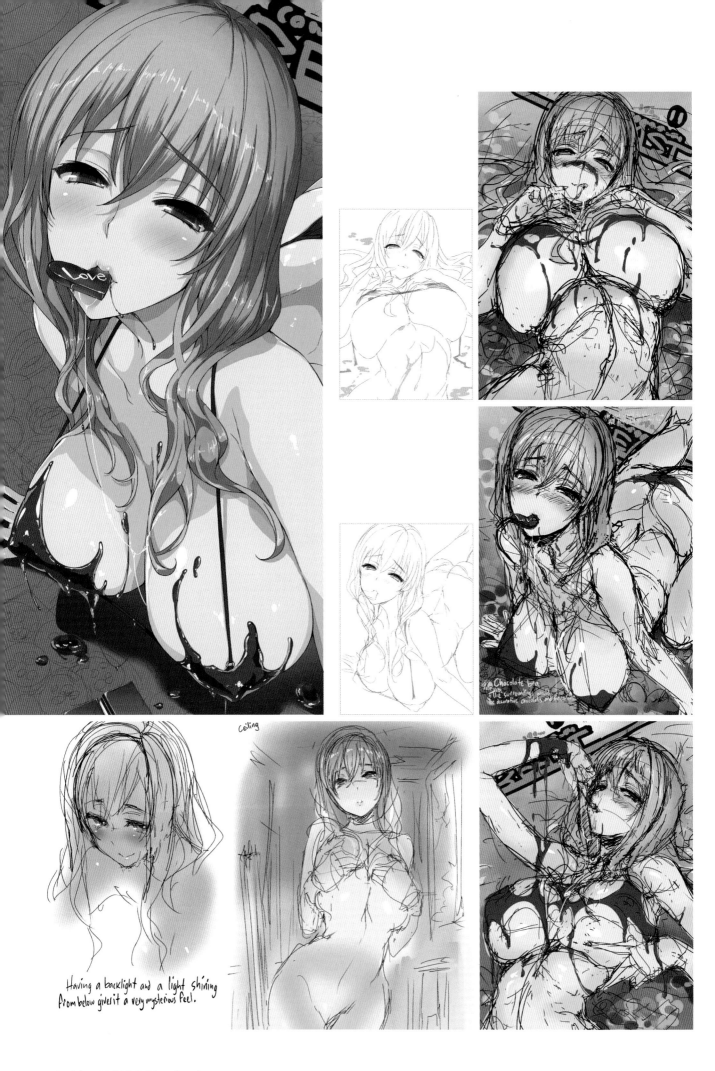

Having a backlight and a light shining from below gives it a very mysterious feel.

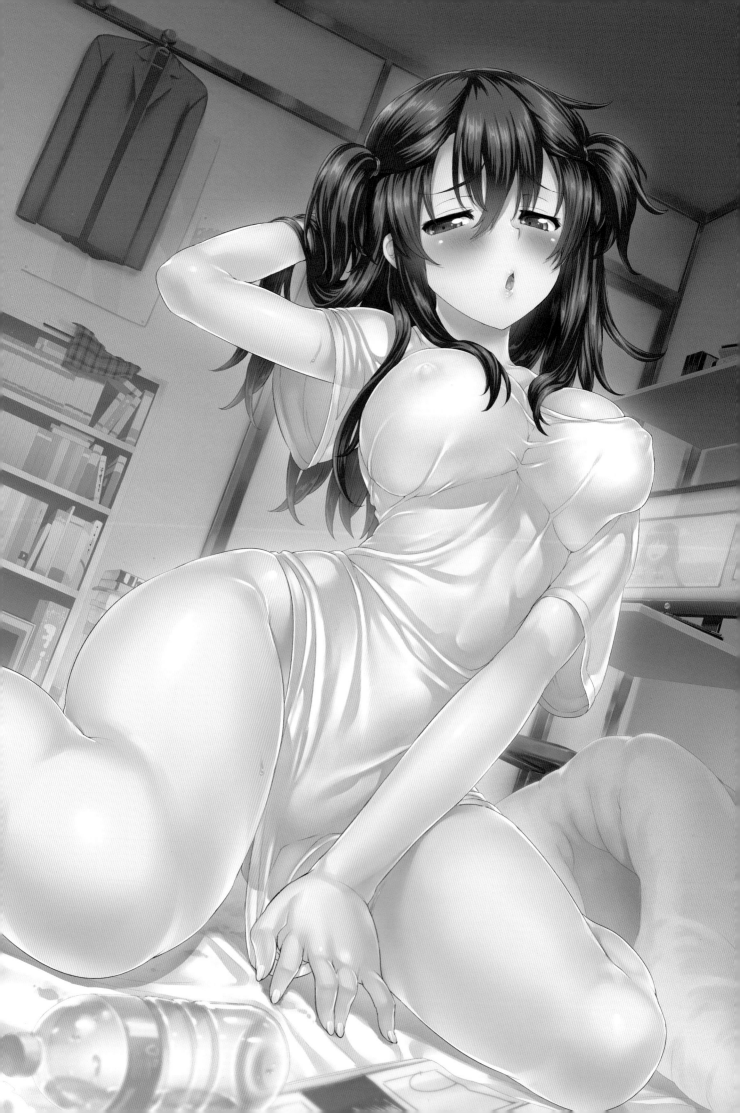

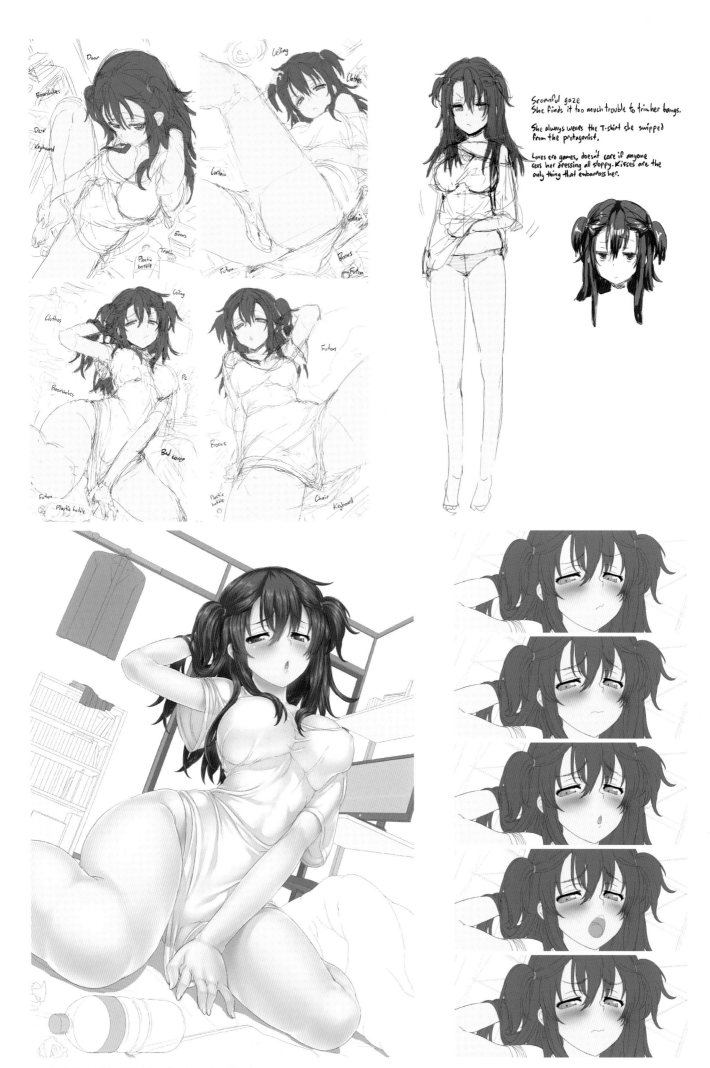

Scornful gaze
She finds it too much trouble to trim her bangs.

She always wears the T-shirt she snipped from the protagonist.

Loves ero games, doesn't care if anyone sees her dressing all sloppy. Kisses are the only thing that embarrass her.

Comic Kairakuten BEAST 06-2012 Cover Illustration Kawashima Kayane
2012

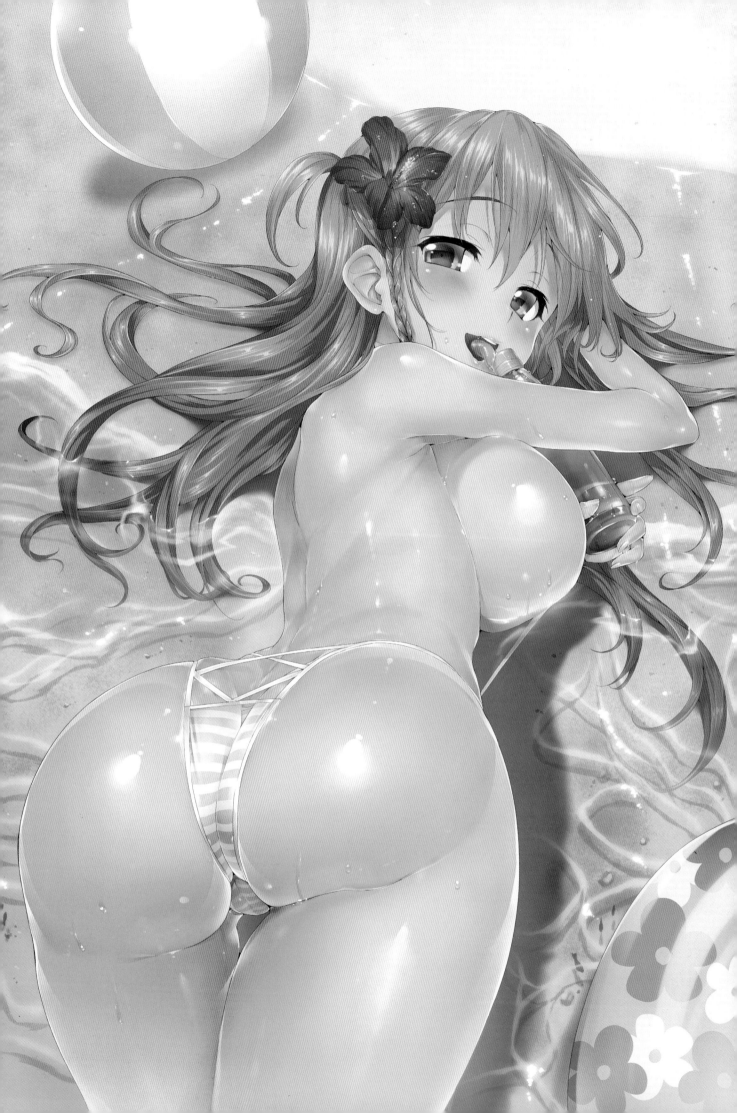

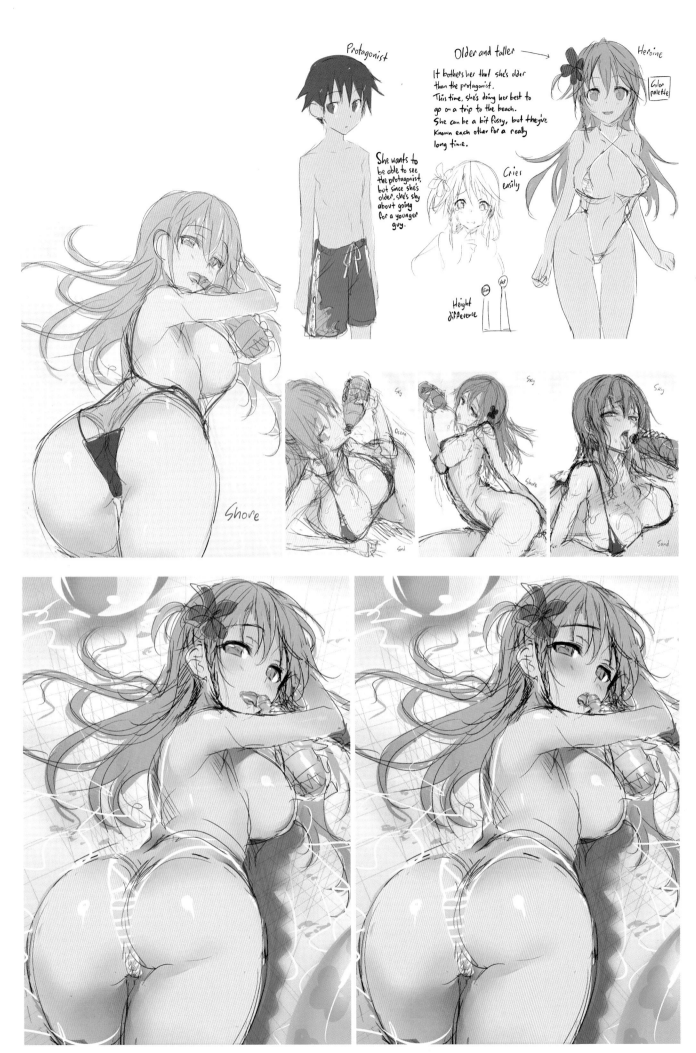

Comic Kairakuten BEAST 09-2012 Cover Illustration Nanami
2012

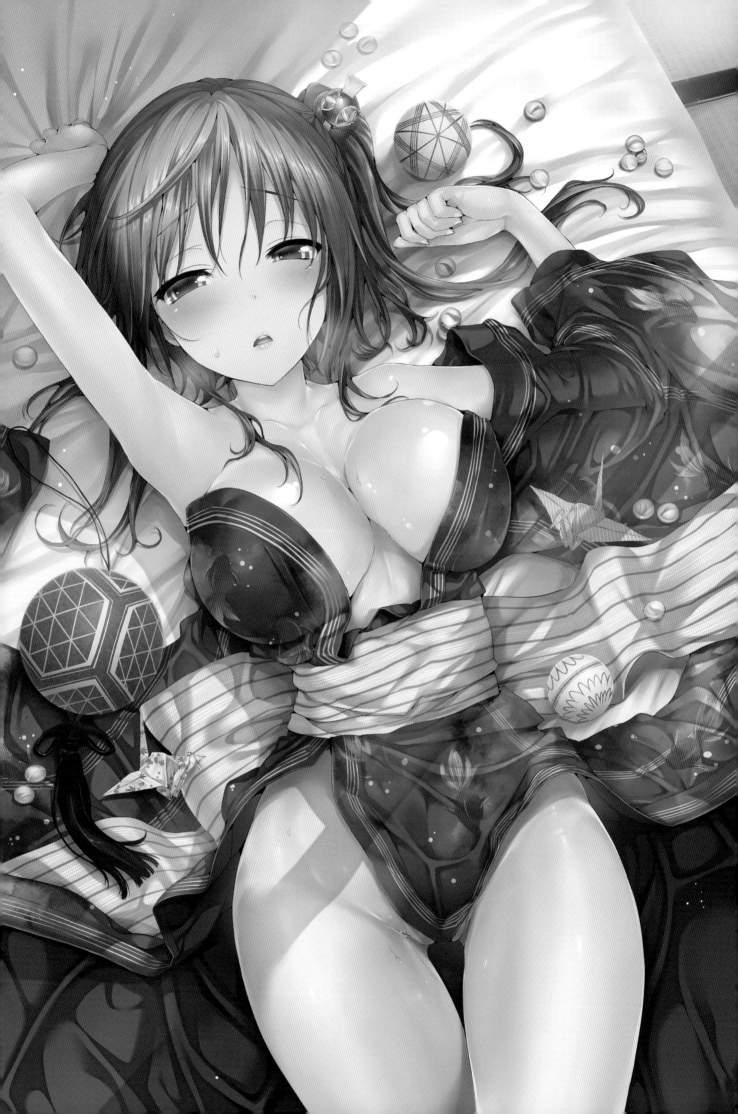

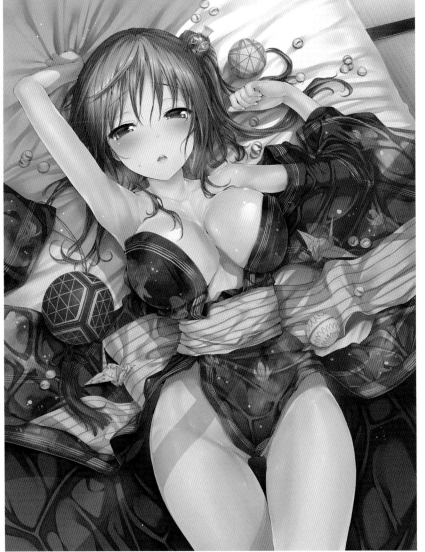

Comic Kairakuten BEAST 10-2012 Cover Illustration
2012

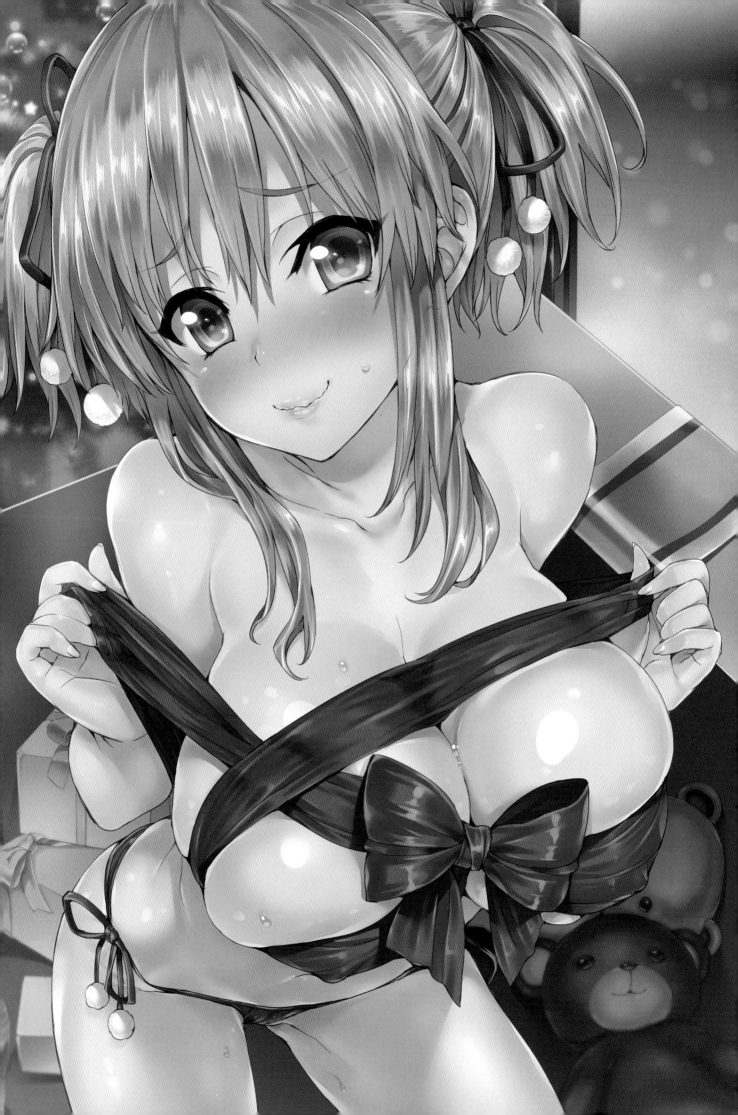

Apparently, cat faces are all the rage now, so I went for something cat-like. The background's a little jumbled, so if it's too much, I can make it a bed instead.

Window showing outside
Large box lid

A girl inside a large present box.

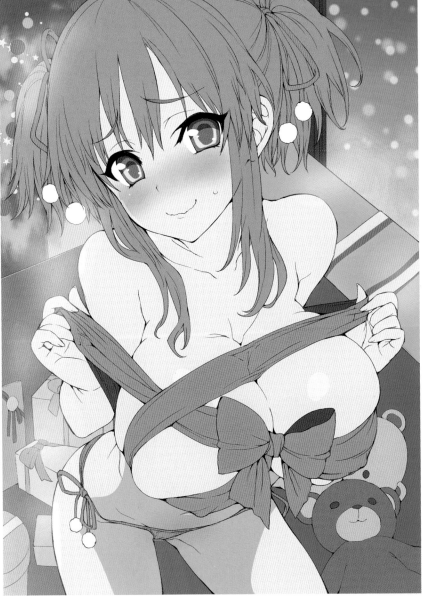

Comic Kairakuten BEAST 01-2013 Cover Illustration Kano
2012

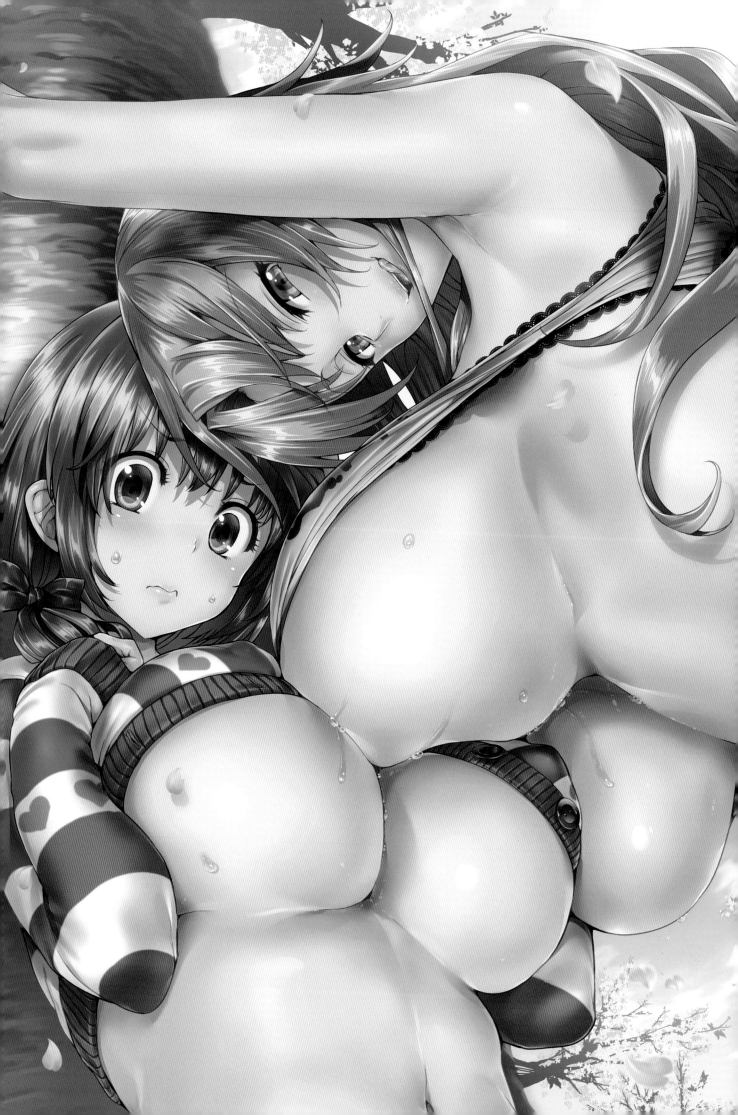

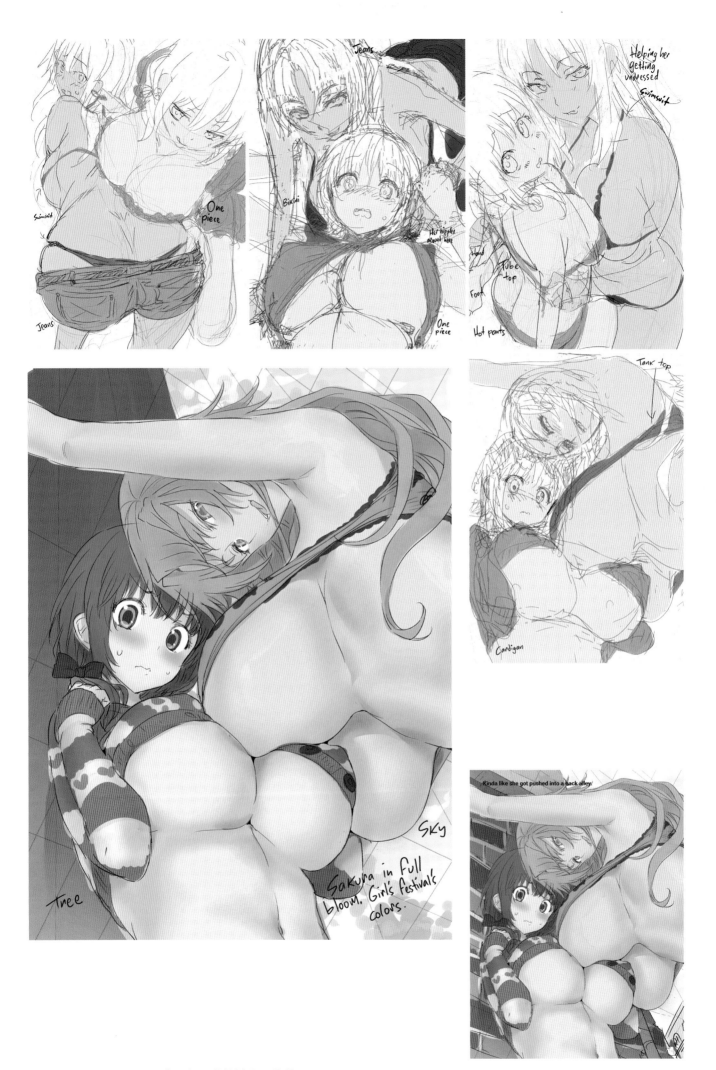

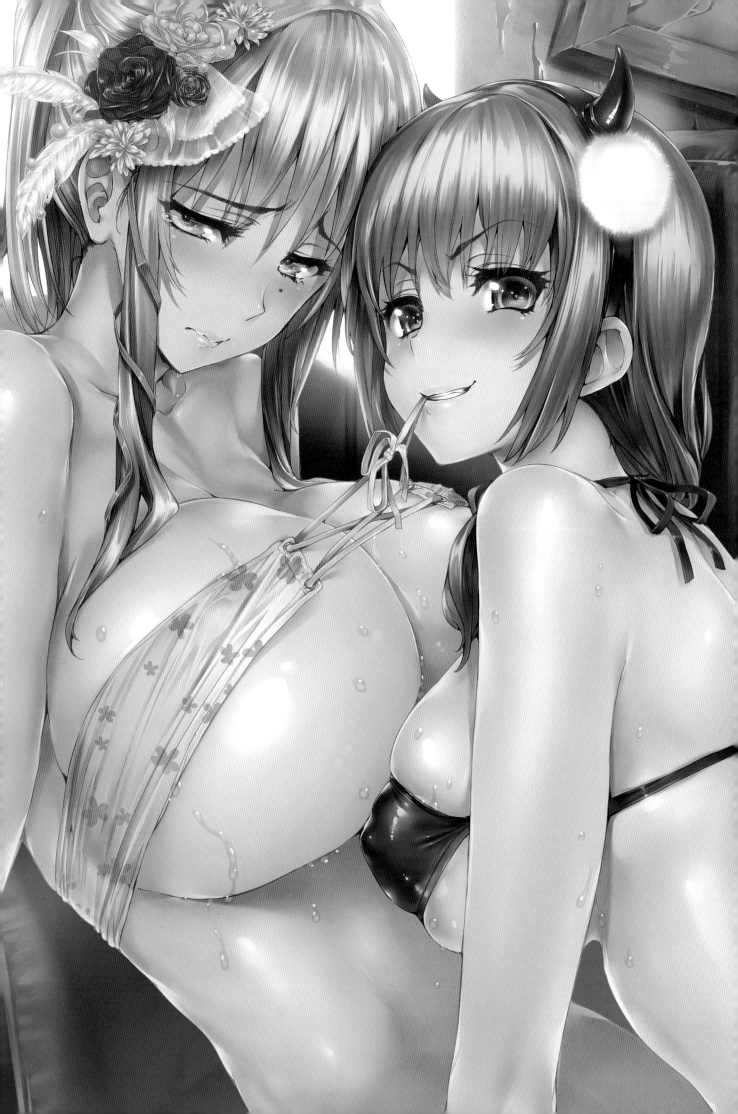

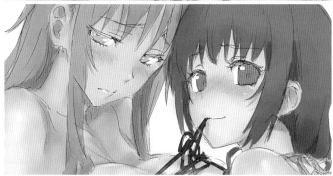

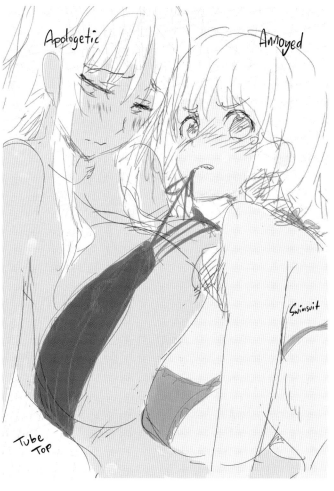

Apologetic

Annoyed

Swimsuit

Tube Top

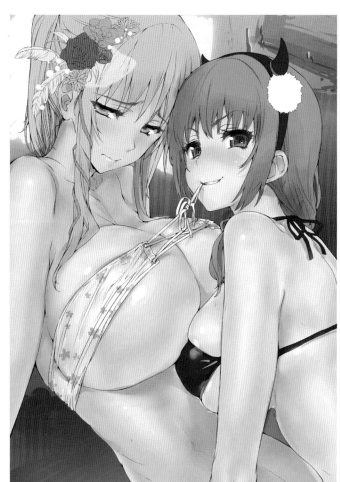

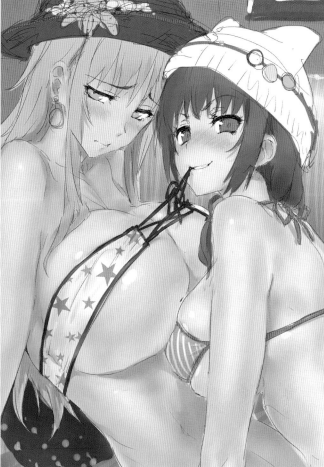

Comic Kairakuten BEAST 05-2013 Cover Illustration Maki (Left) - Sanami (Right)
2013

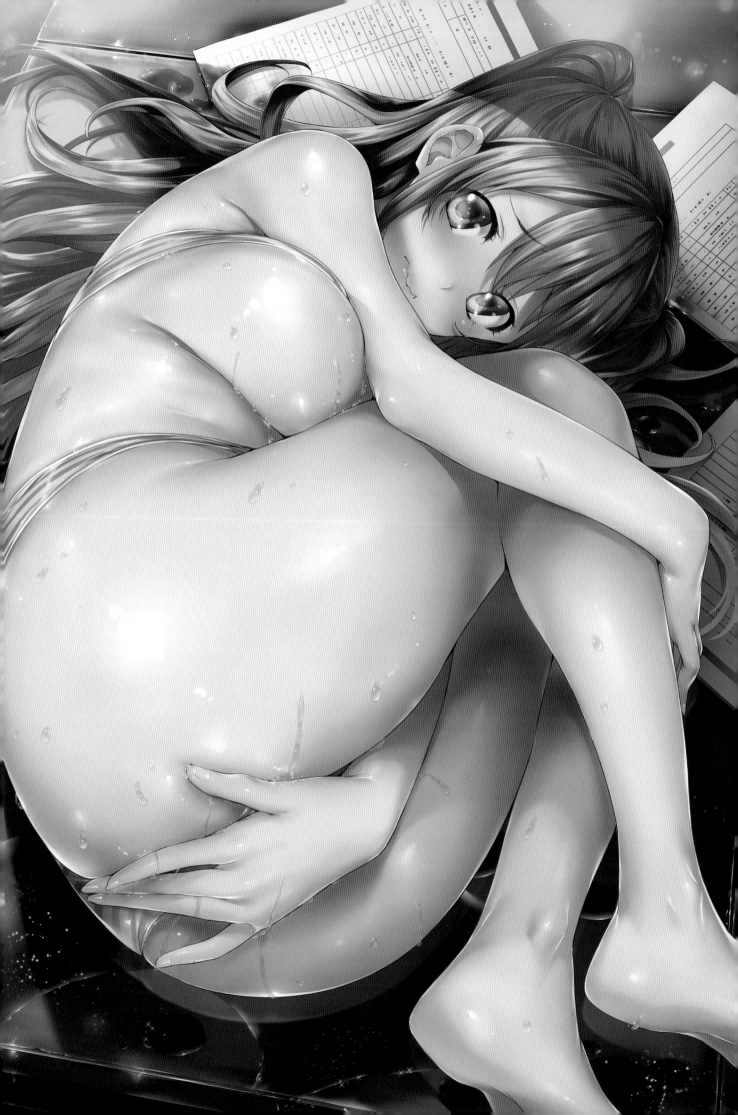

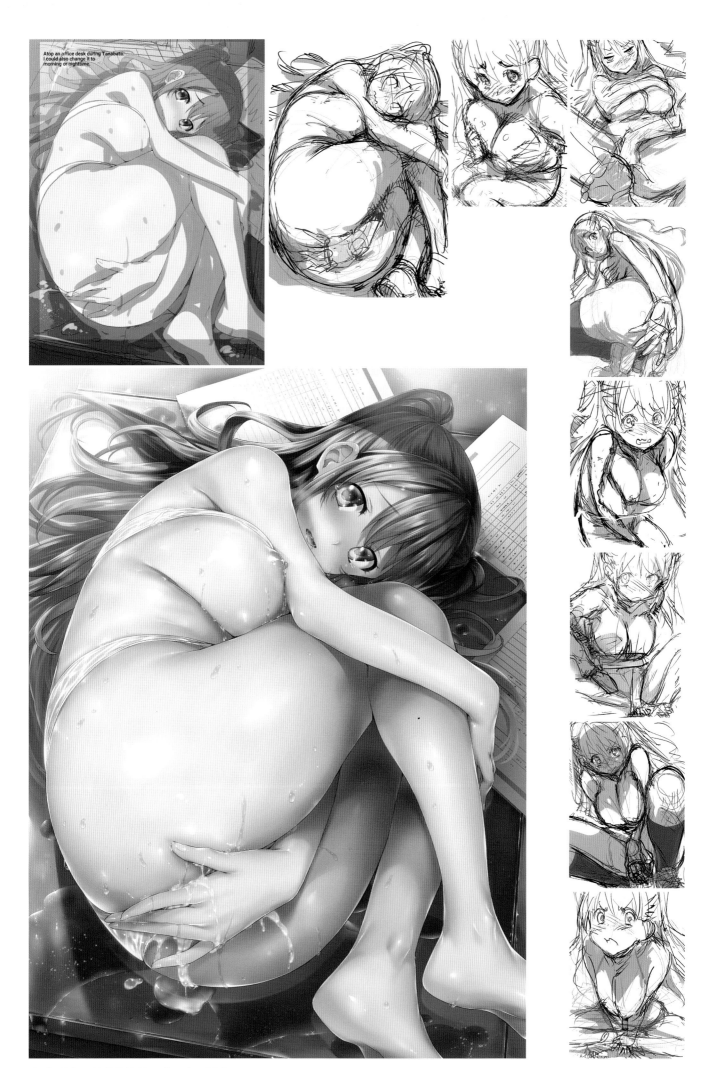

Comic Kairakuten BEAST 08-2013 Cover Illustration　Nakajima
2013

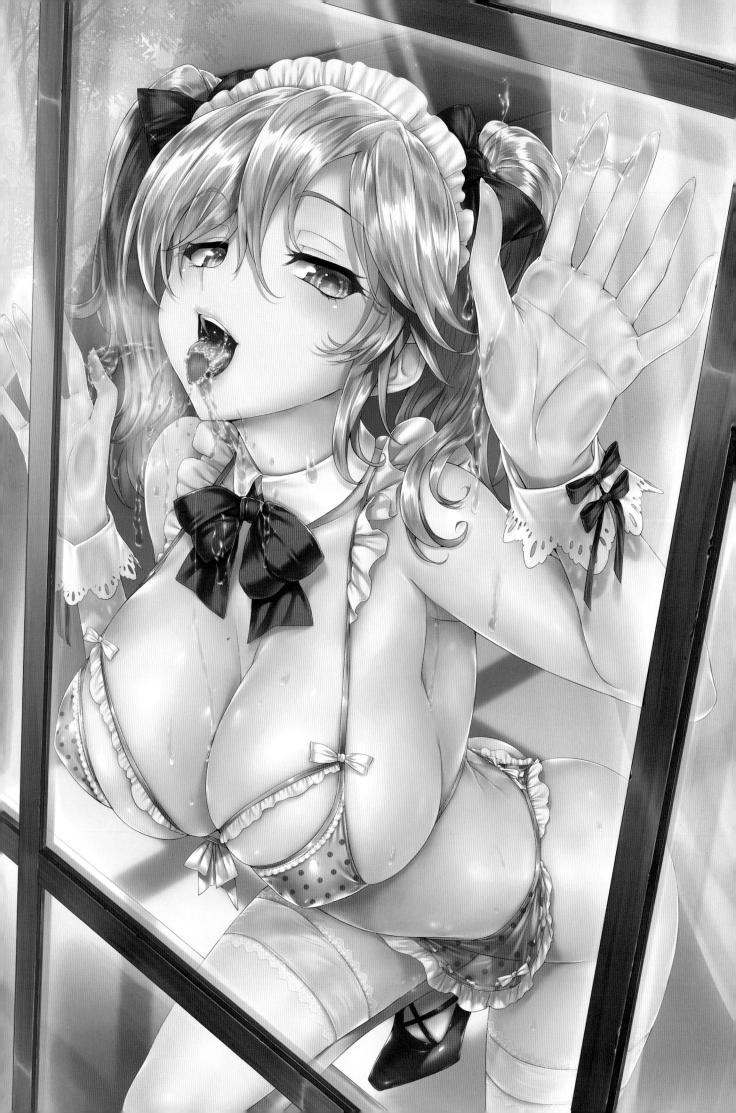

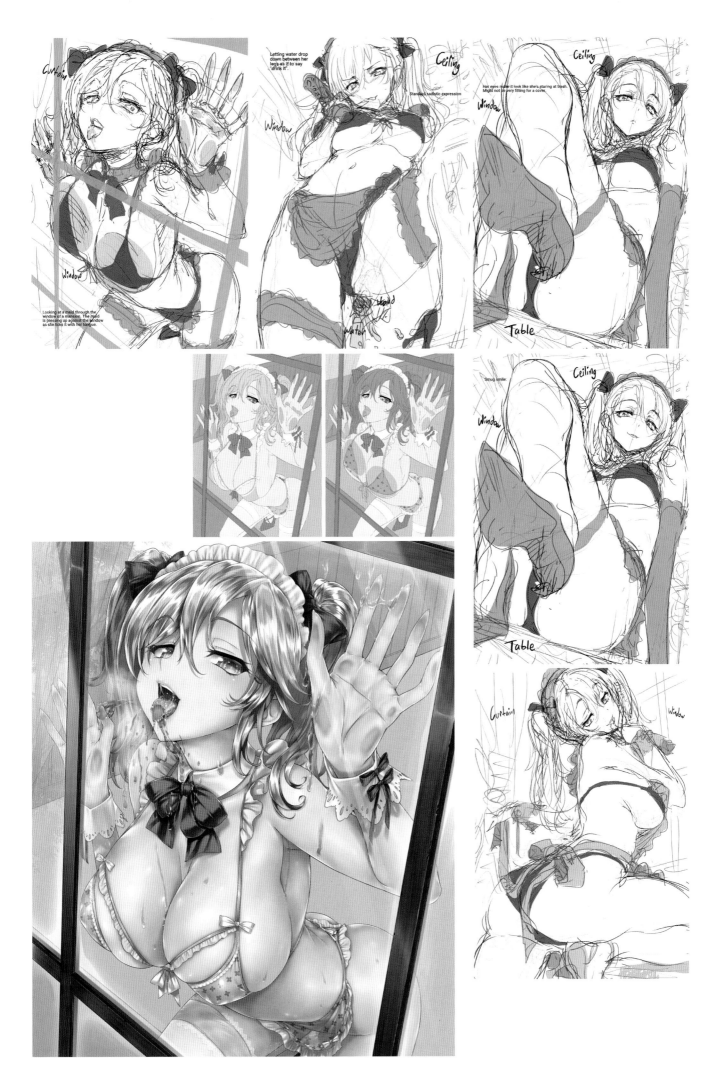

Comic Kairakuten BEAST 12-2013 Cover Illustration
2013

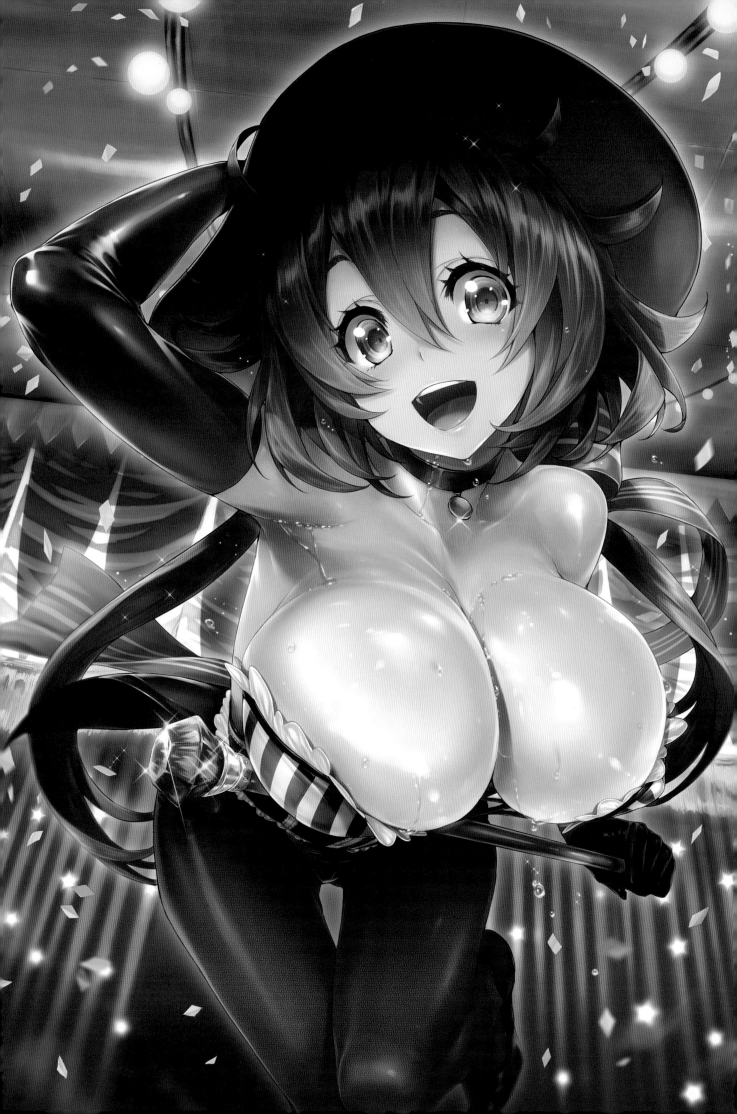

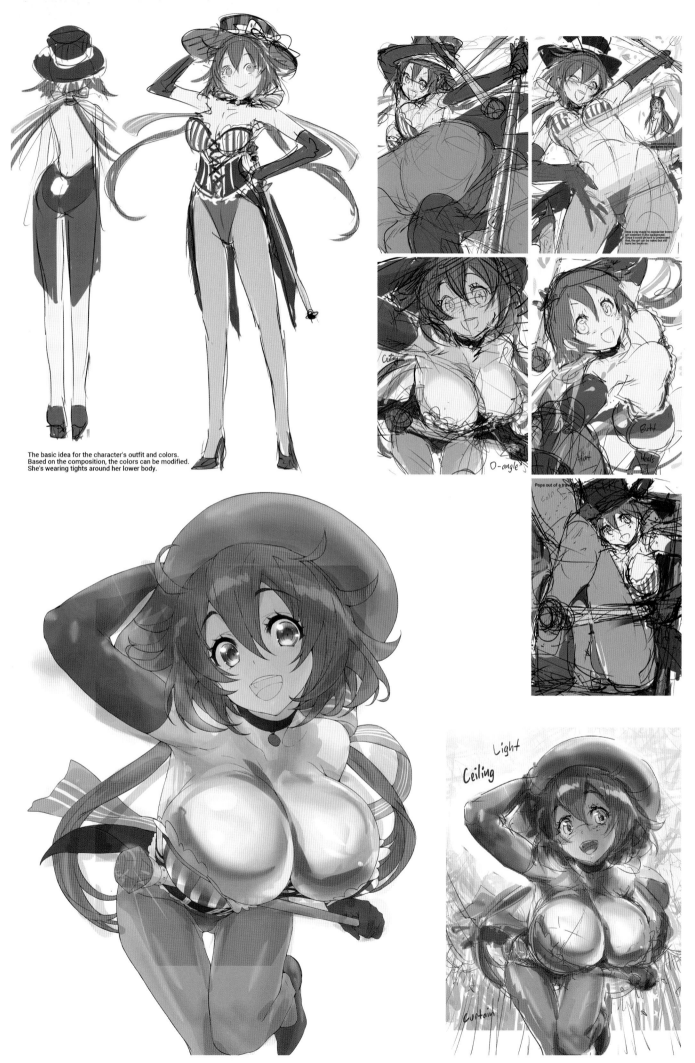

The basic idea for the character's outfit and colors.
Based on the composition, the colors can be modified.
She's wearing tights around her lower body.

Comic Kairakuten BEAST 04-2014 Cover Illustration
2014

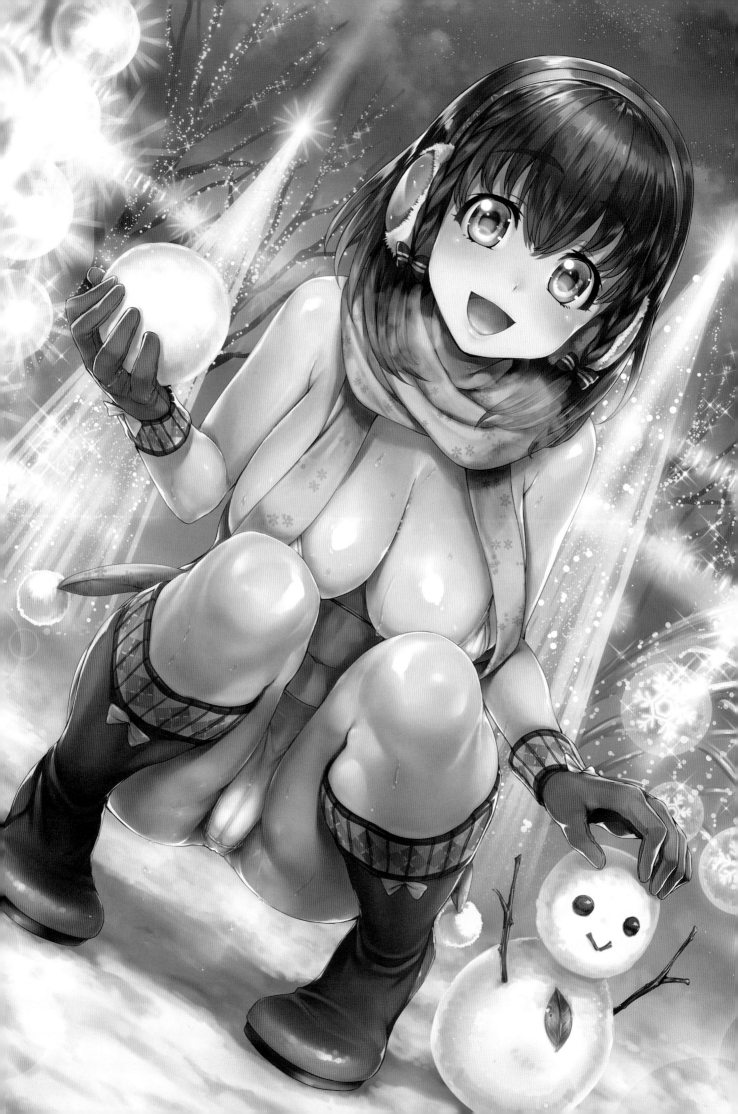

Color palette

Scarf
Swimsuit

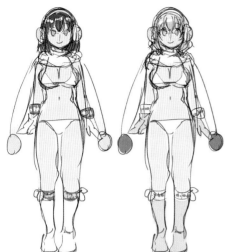

Clothed image.
I decide on
this after I'm
done cementing
the details of the
composition.

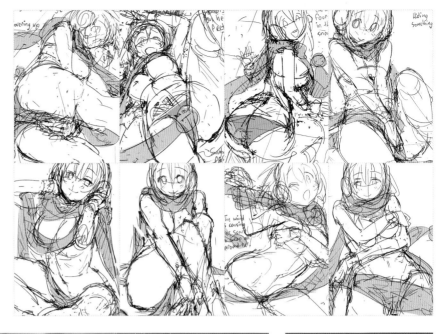

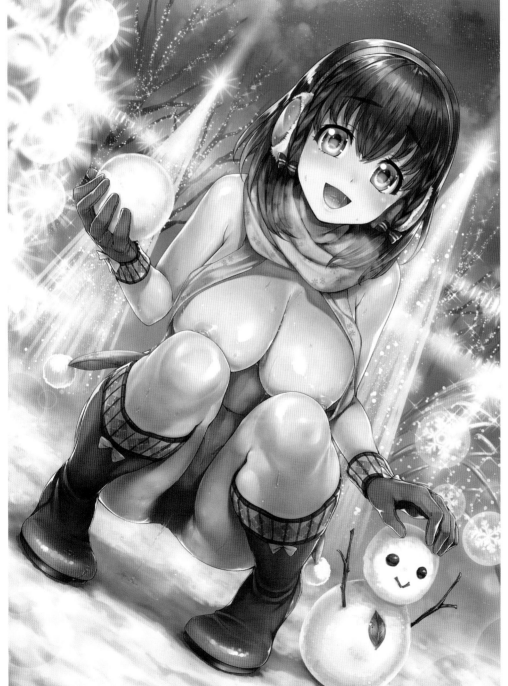

Comic Kairakuten BEAST 01-2015 Cover Illustration
2014

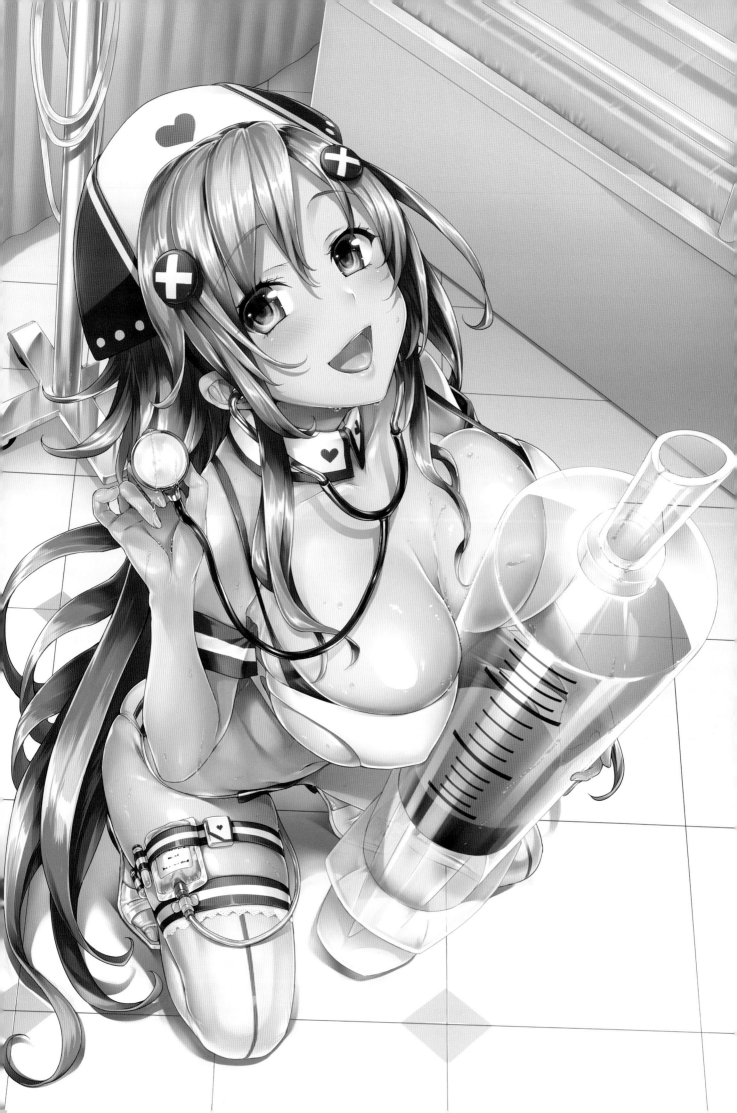

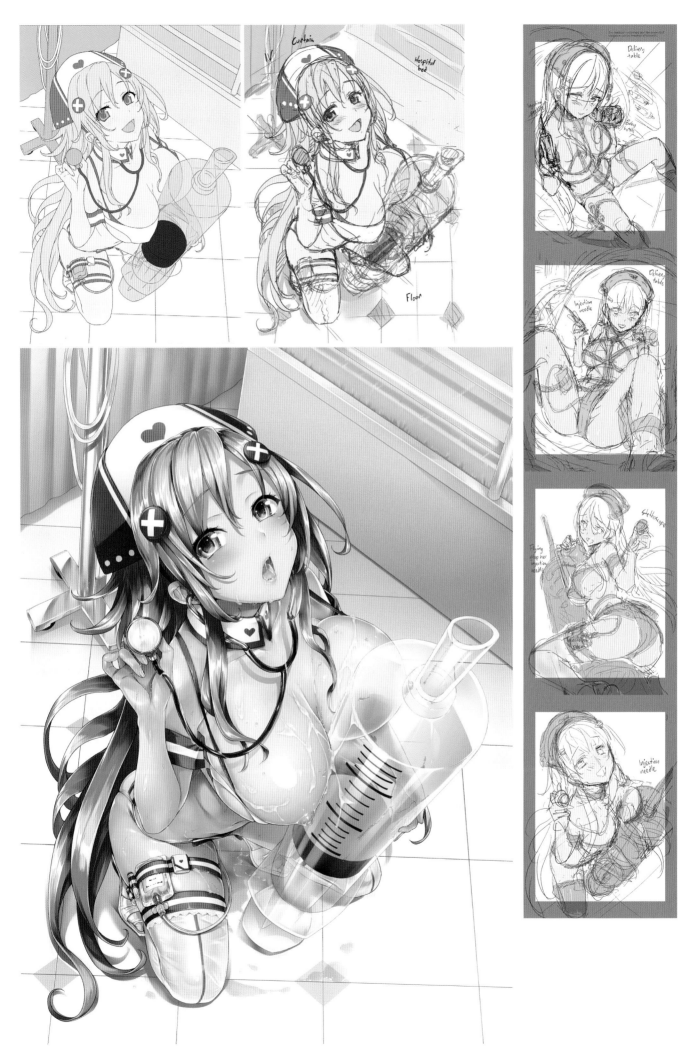

Comic Kairakuten BEAST 05-2015 Cover Illustration
2015

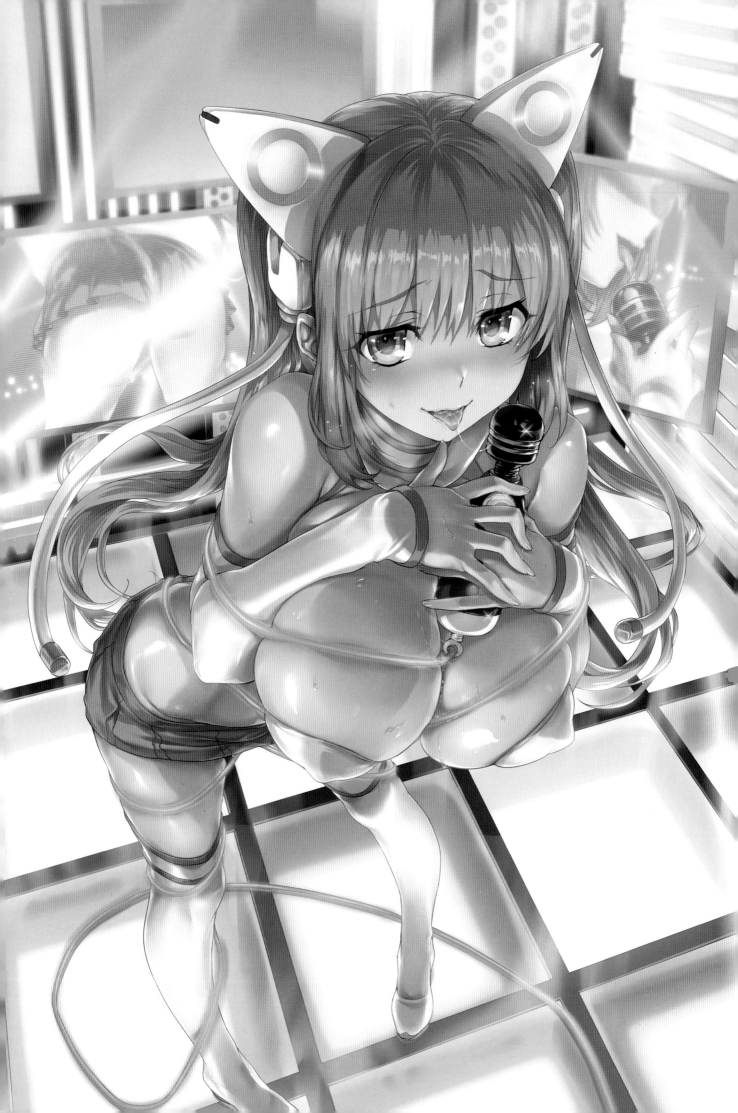

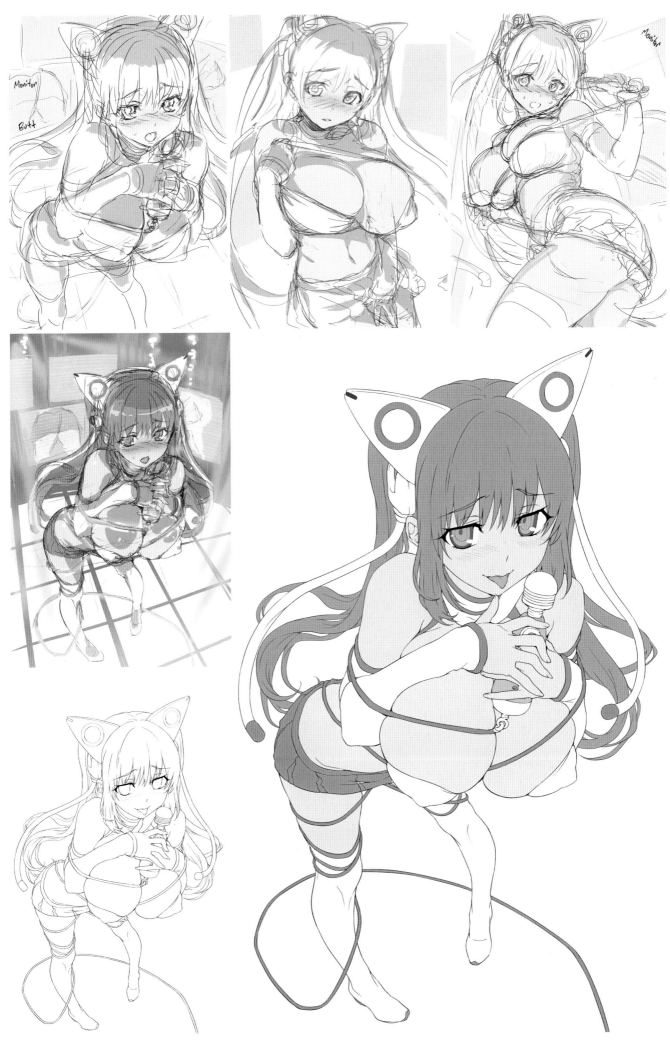

Comic Kairakuten BEAST 01-2016 Cover Illustration
2015

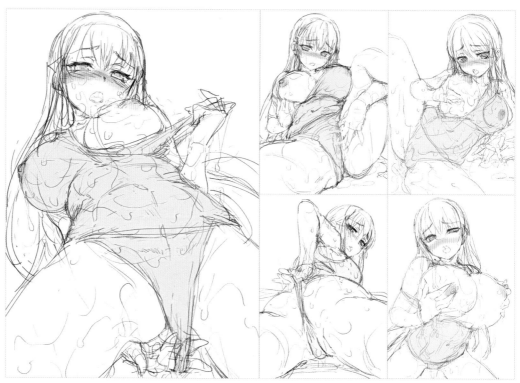

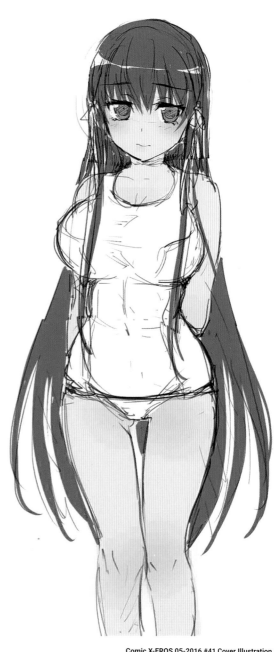

Comic X-EROS 05-2016 #41 Cover Illustration
2016

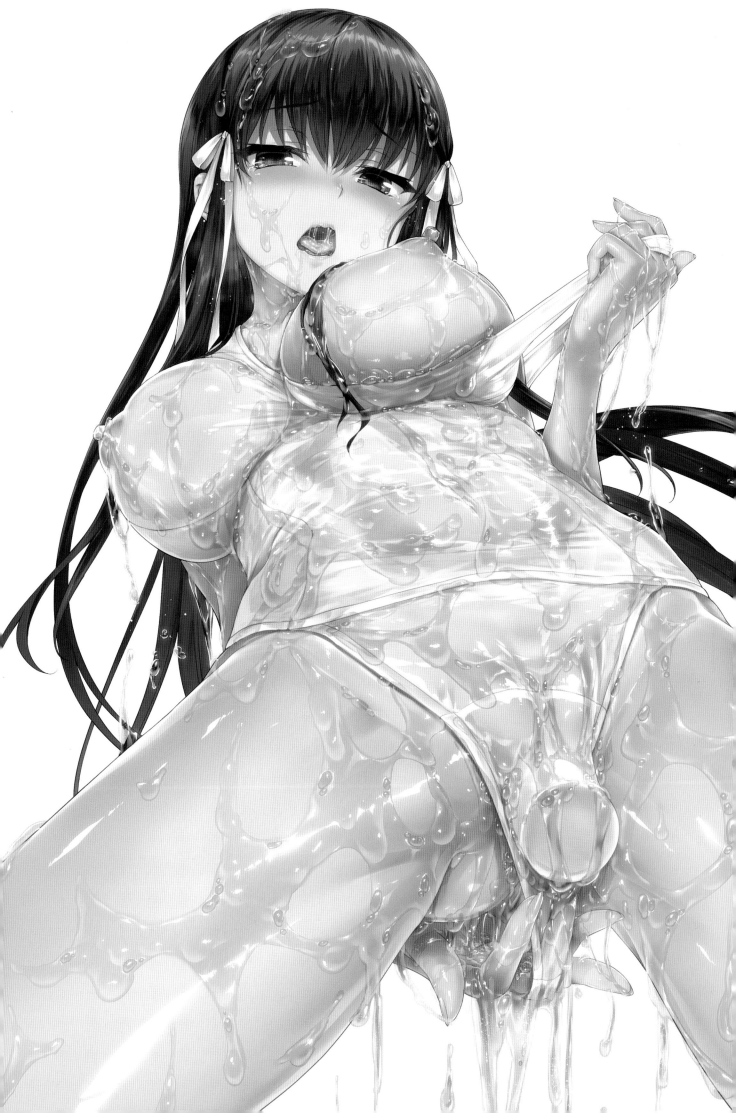

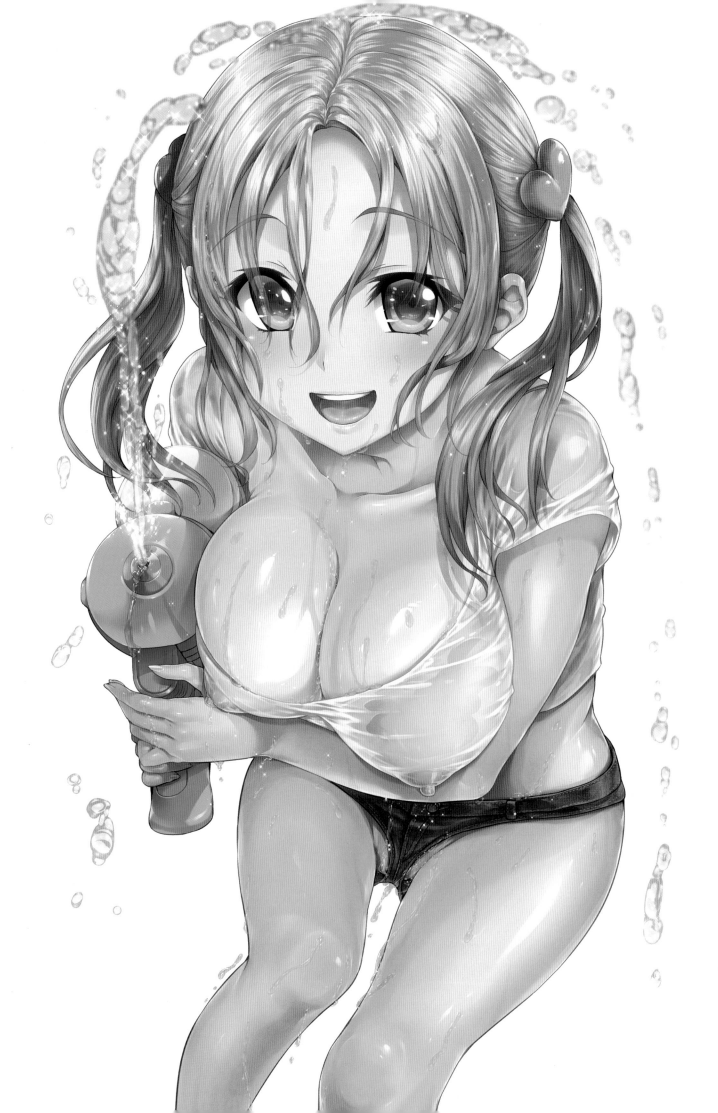

T-shirt
and short
shorts

T-shint
and short
shorts

Fundoshi

T-shint
and short
shorts

T-shint
and short
shorts

T-shint
and short
shorts

Comic X-EROS 10-2016 #46 Cover Illustration
2016

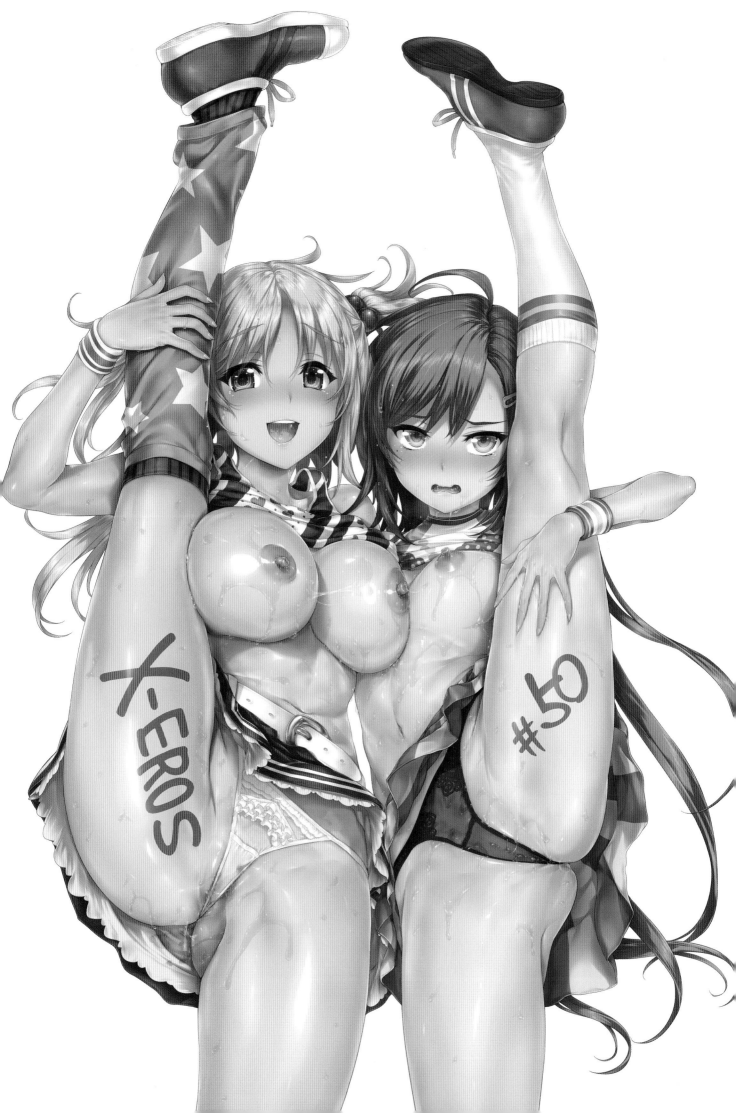

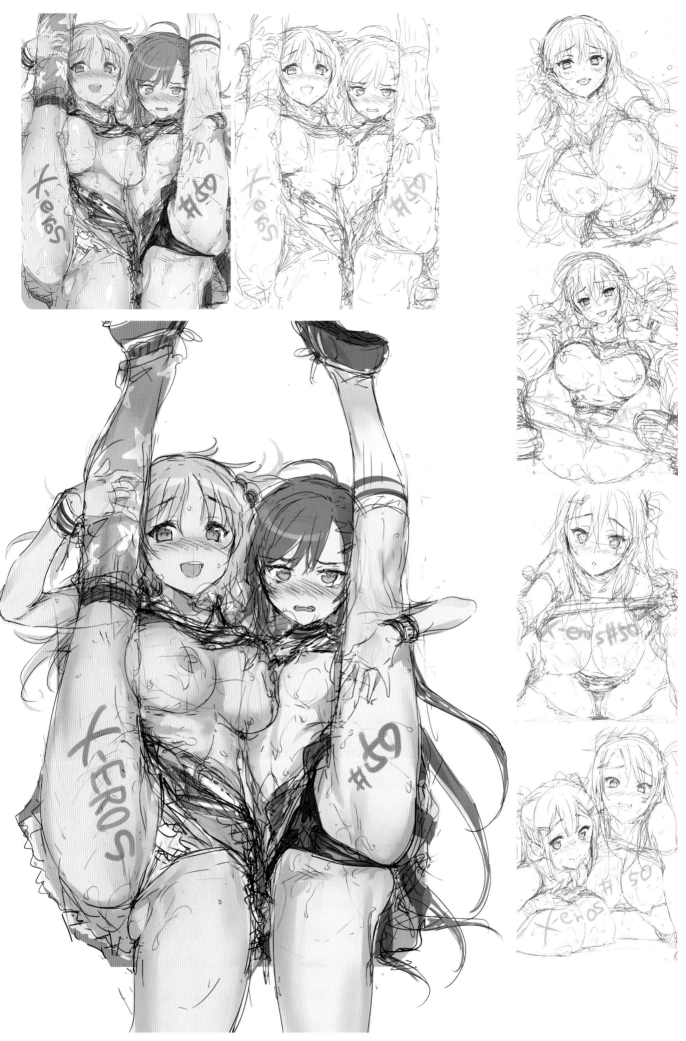

Comic X-EROS 02-2017 #50 Cover Illustration
2016

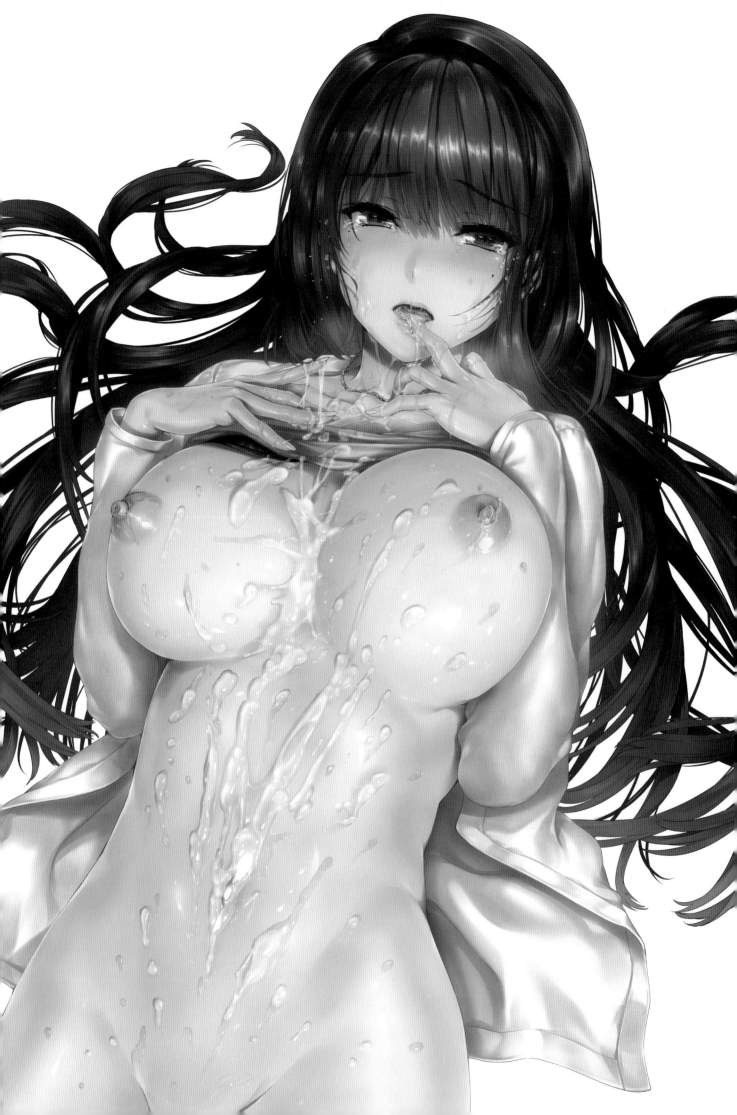

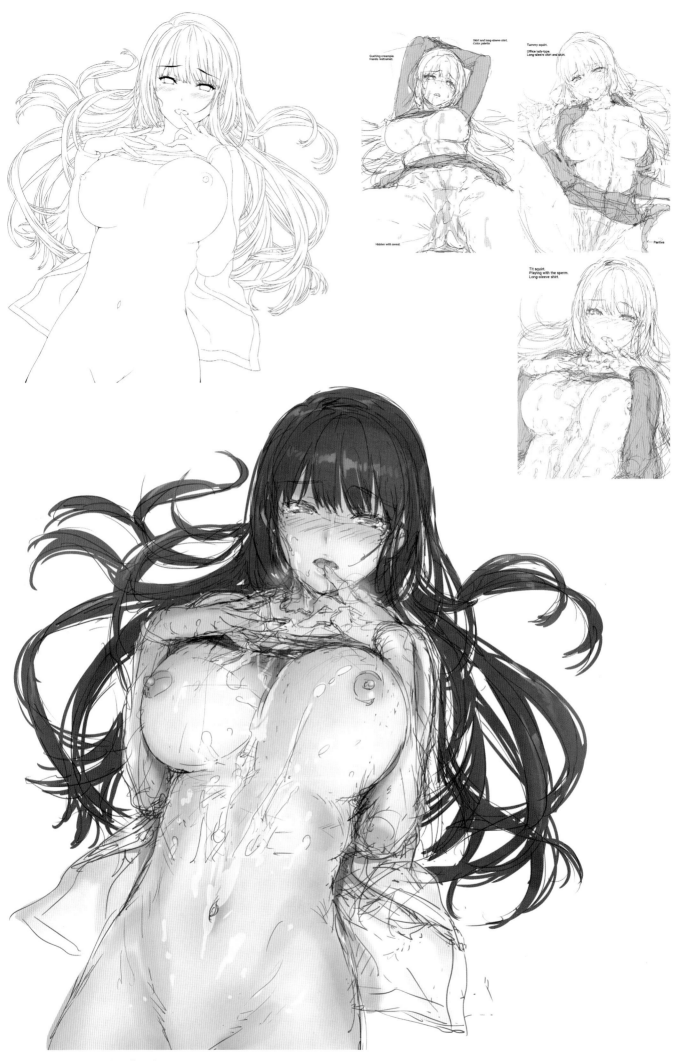

Skirt and long-sleeve shirt.
Color palette.

Gushing creampie.
Hands restraint.

Tummy squirt.
Office lady-type.
Long-sleeve shirt and skirt.

Hidden with sweat.

Panties

Tit squirt.
Playing with the sperm.
Long-sleeve shirt.

Comic X-EROS 07-2017 #55 Cover Illustration
2017

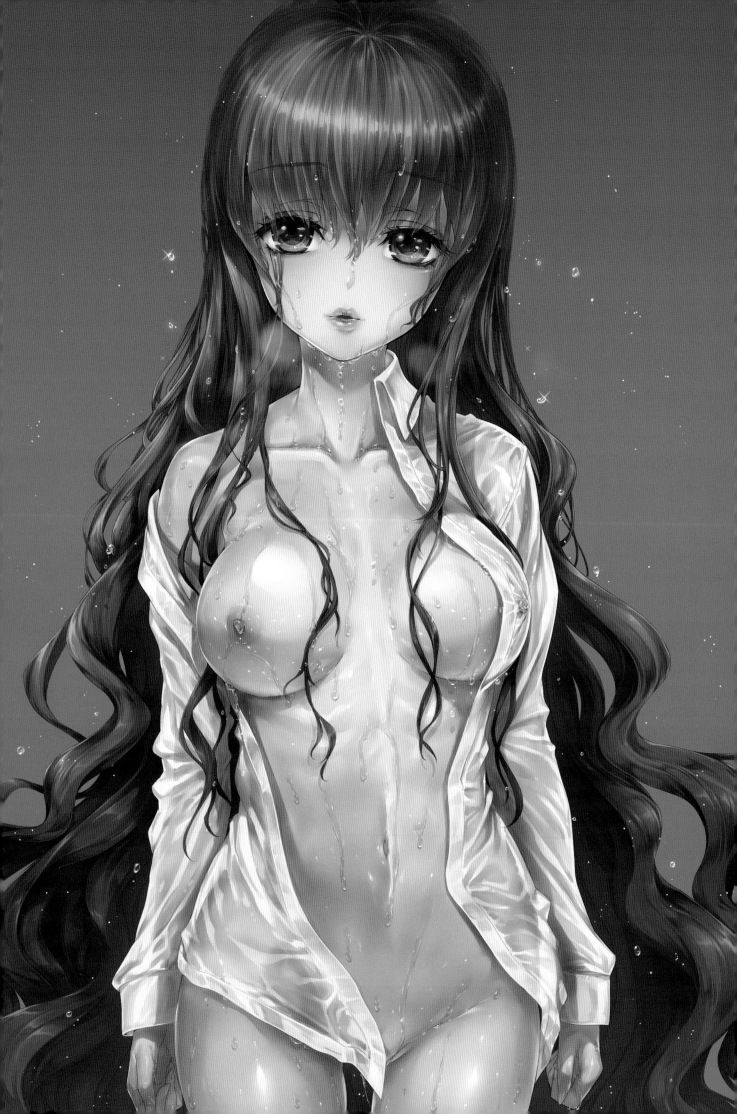

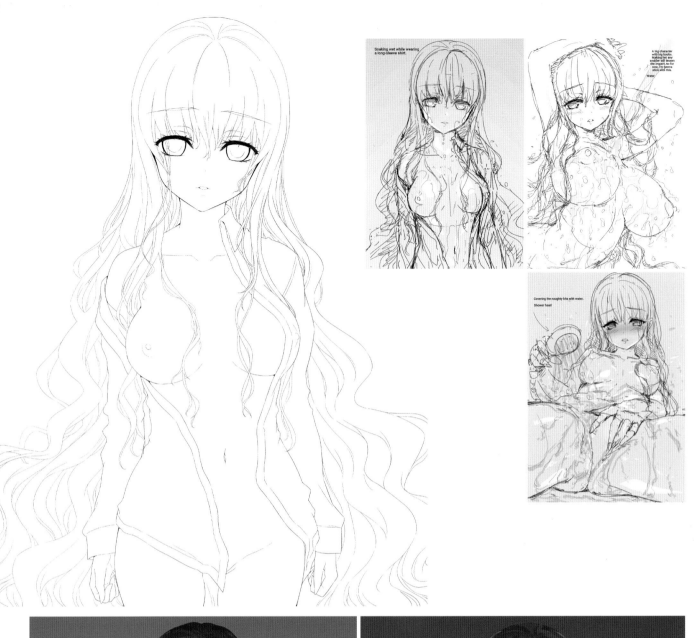

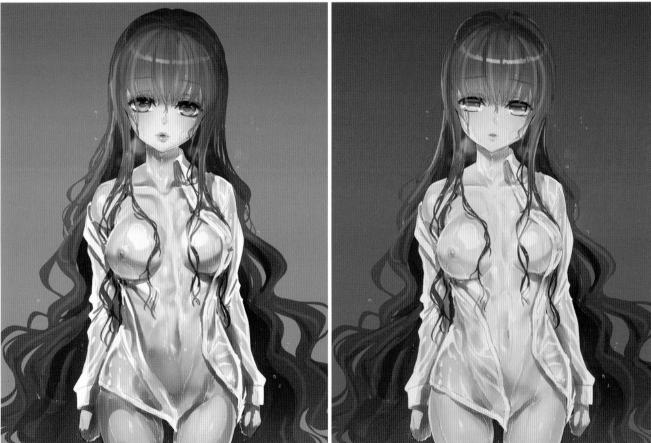

Comic X-EROS 01-2018 #61 Cover Illustration
2017

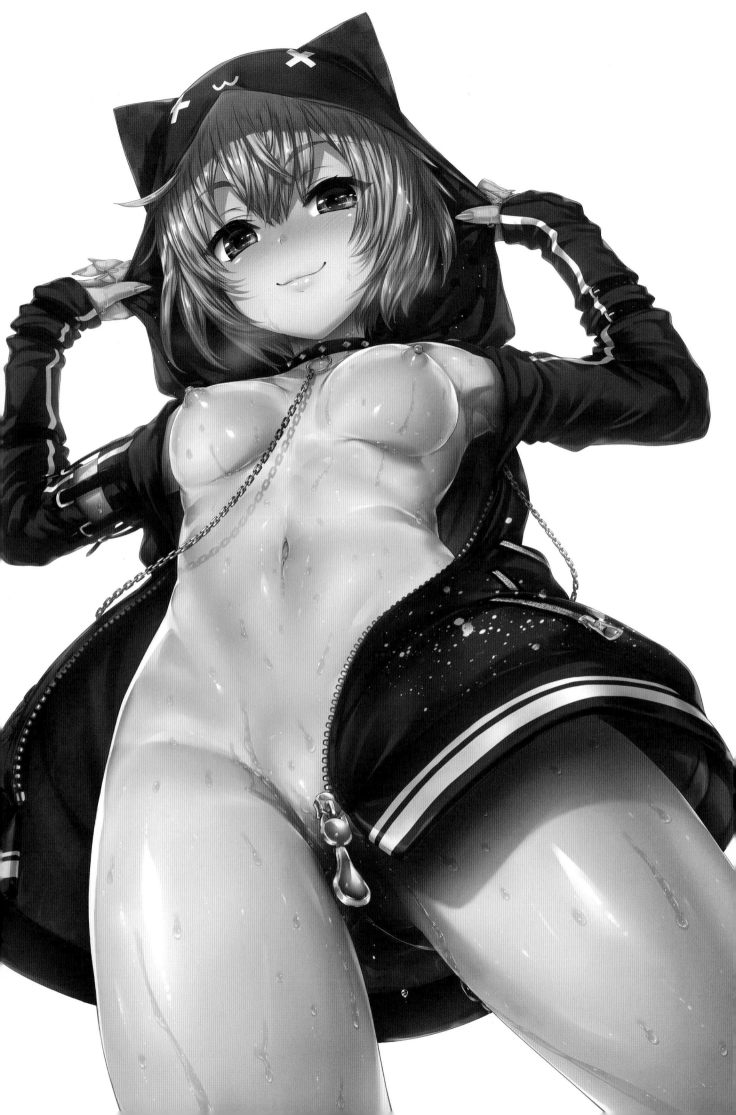

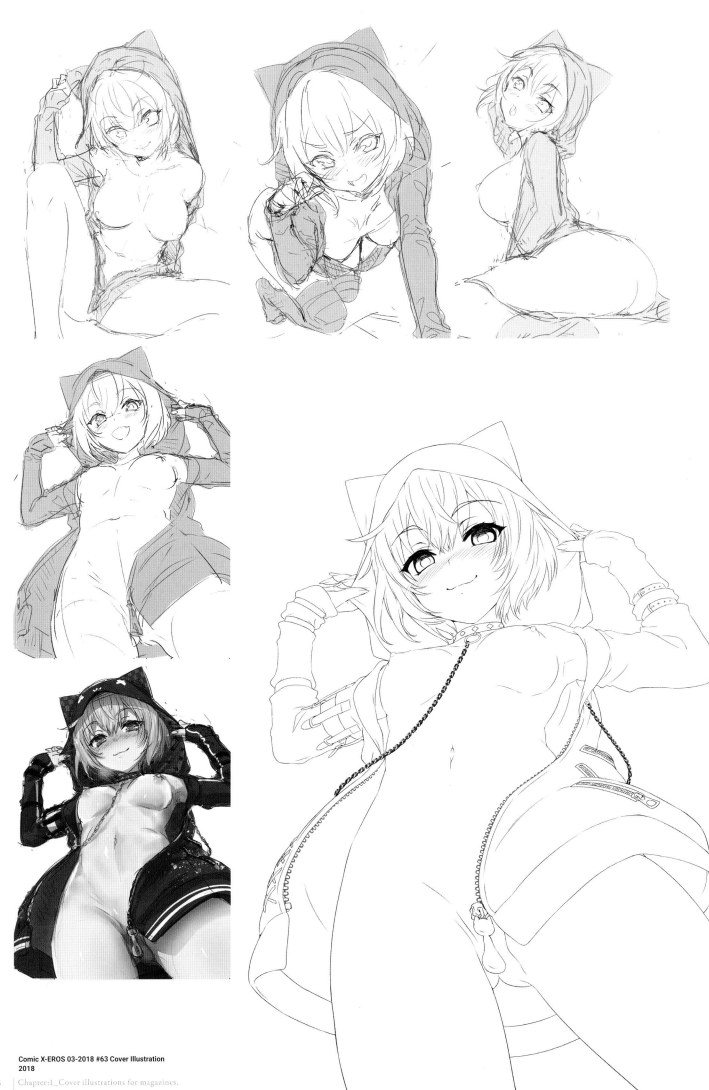

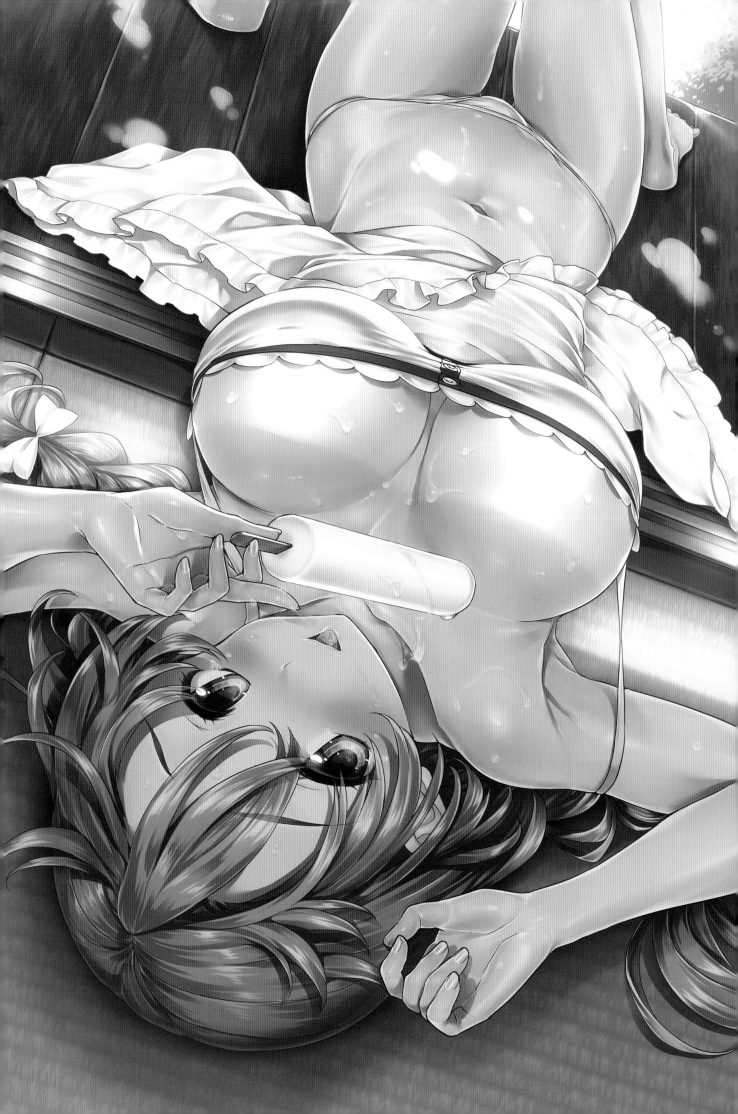

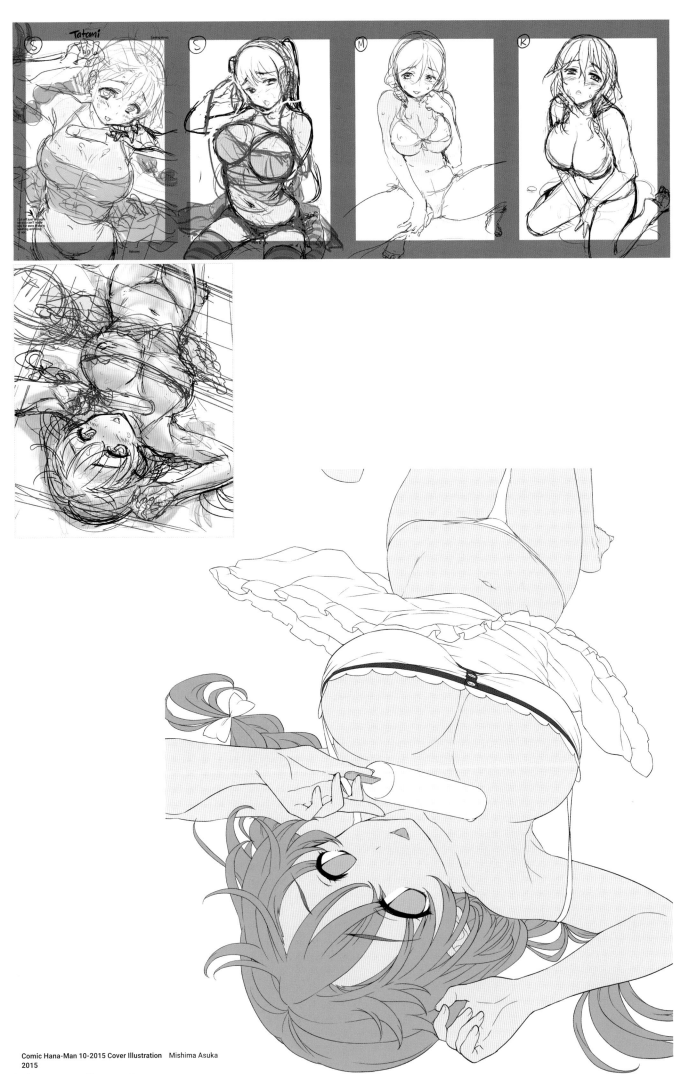

Comic Hana-Man 10-2015 Cover Illustration Mishima Asuka
2015

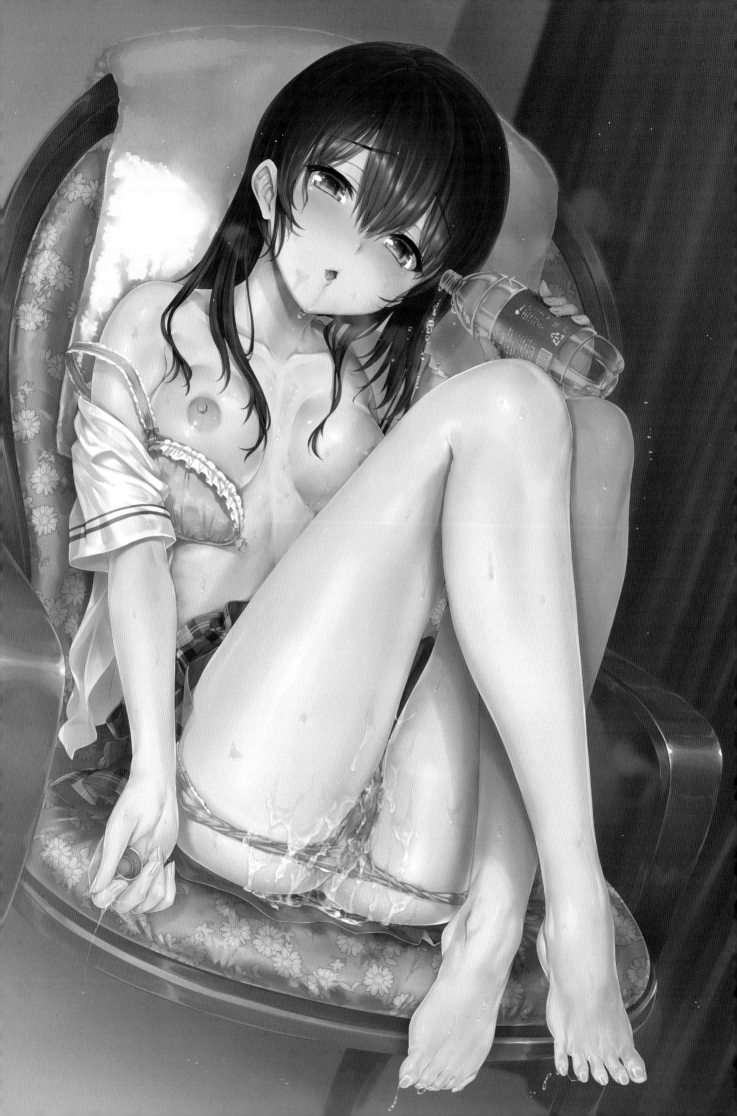

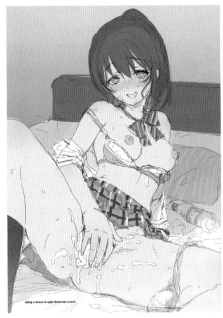

Using a tissue to wipe down her crotch.

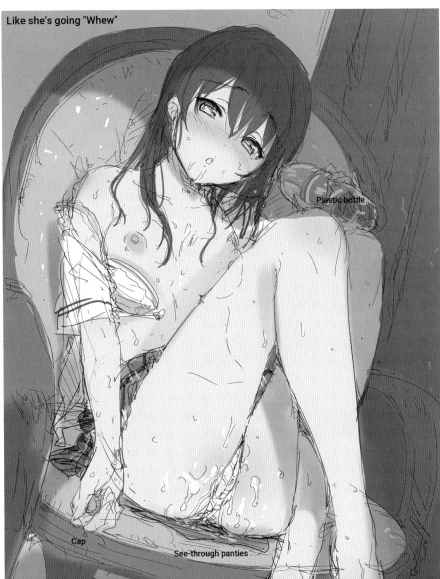

Like she's going "Whew"

Plastic bottle

Cap

See-through panties

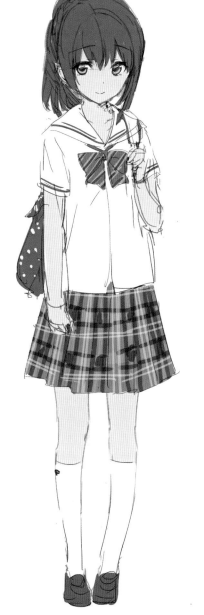

Comic X-EROS #55.56.57 Three consecutive issues worth of limited-edition posters
2017

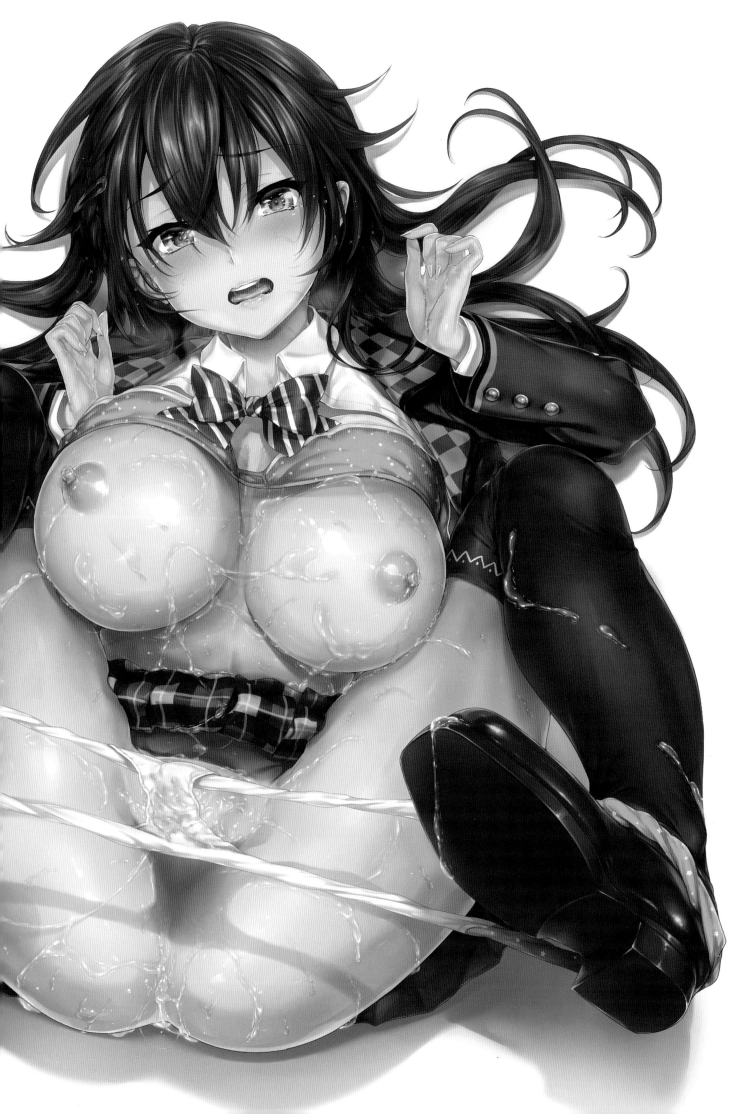

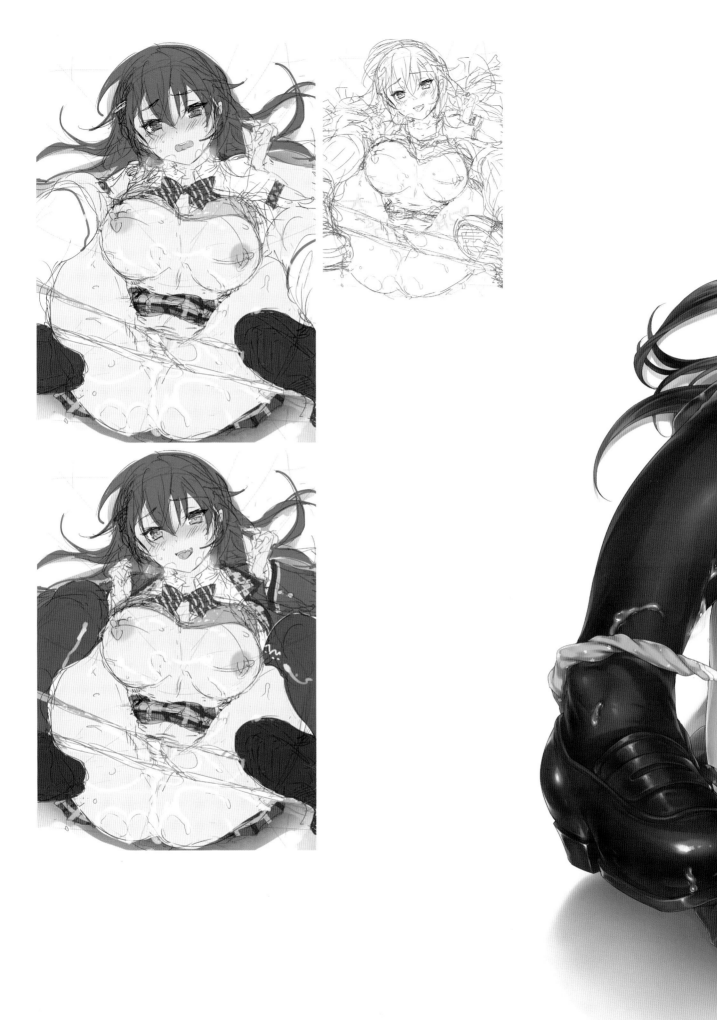

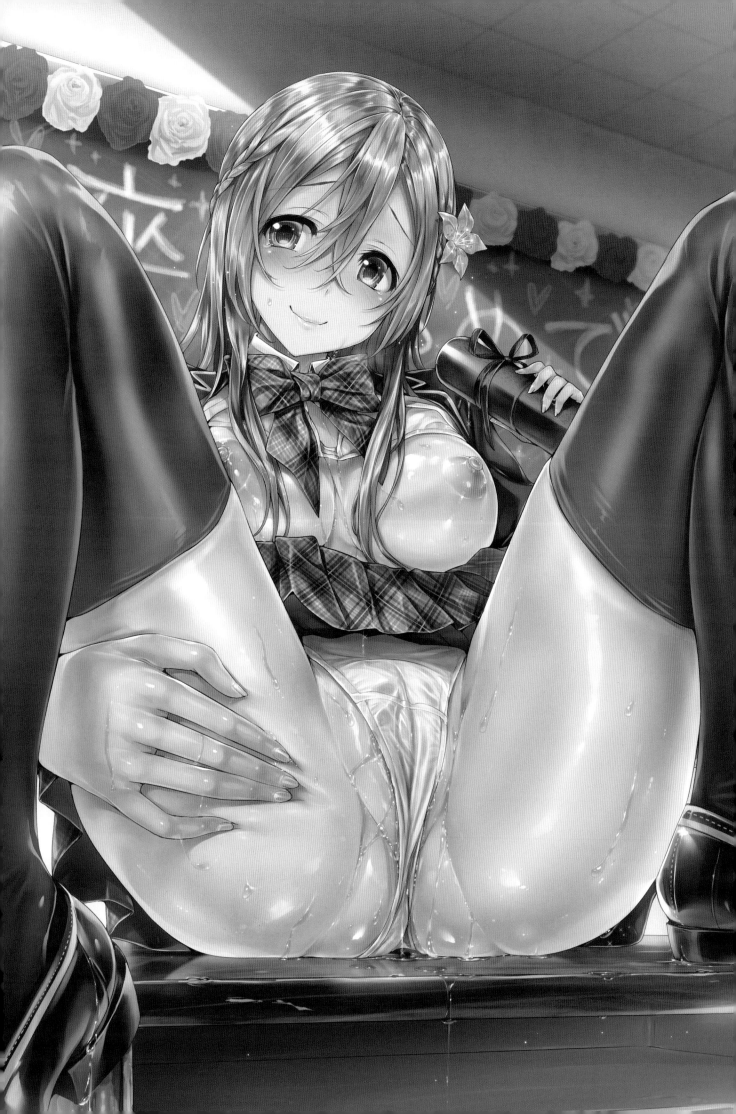

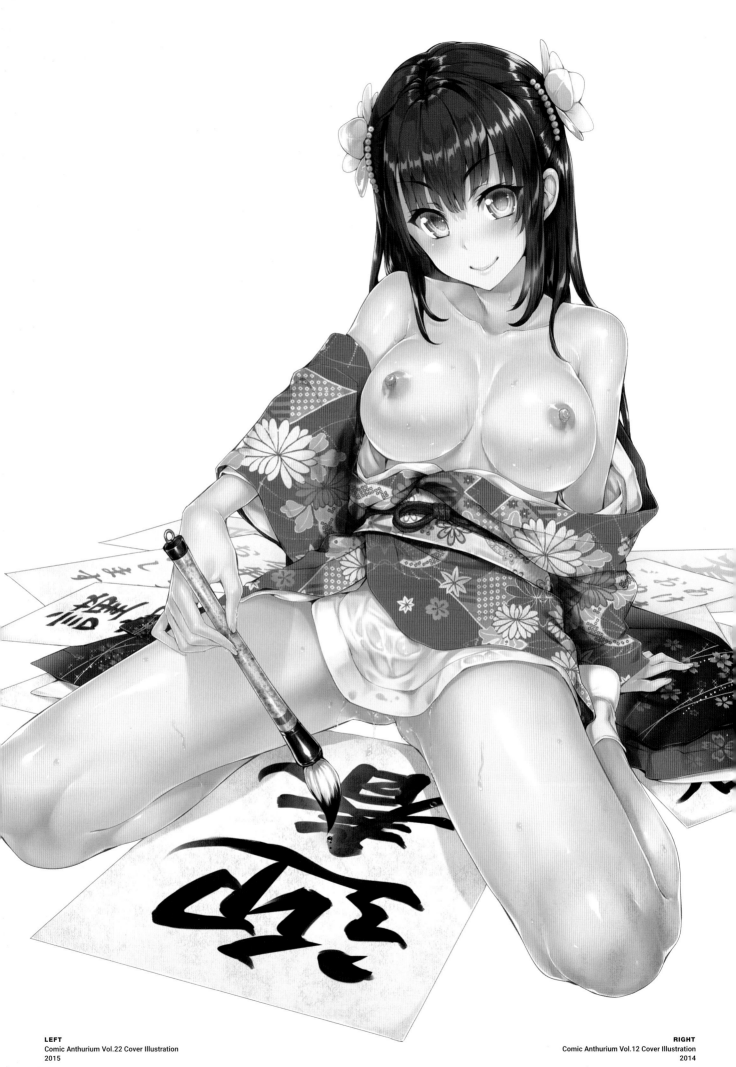

LEFT
Comic Anthurium Vol.22 Cover Illustration
2015

RIGHT
Comic Anthurium Vol.12 Cover Illustration
2014

51 | Chapter:1_Cover illustrations for magazines.

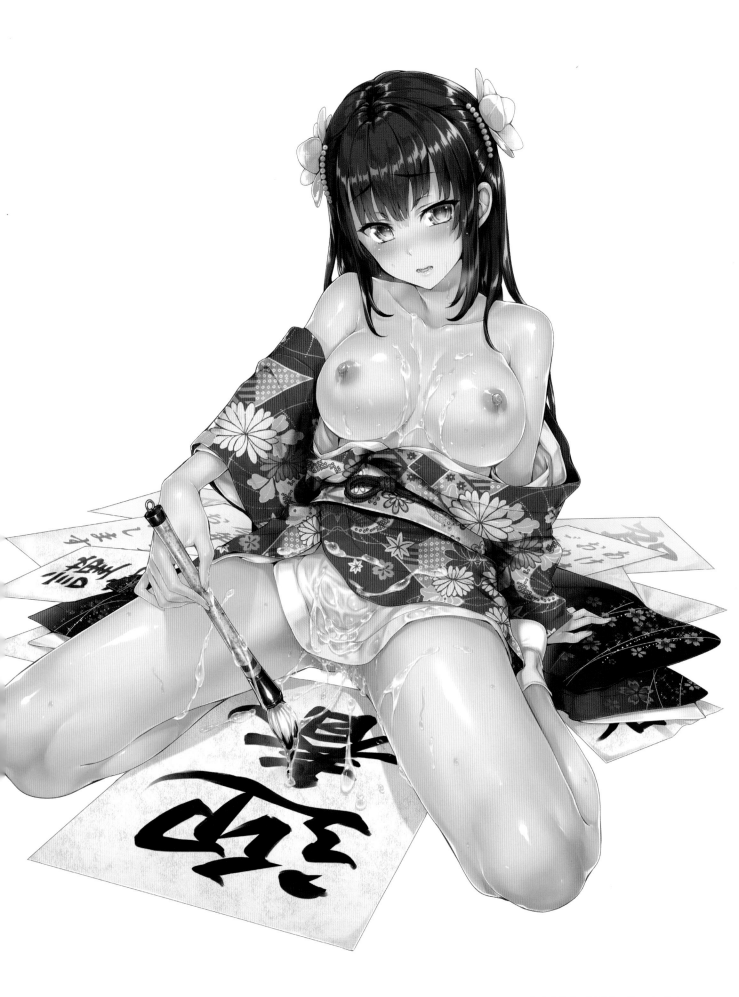

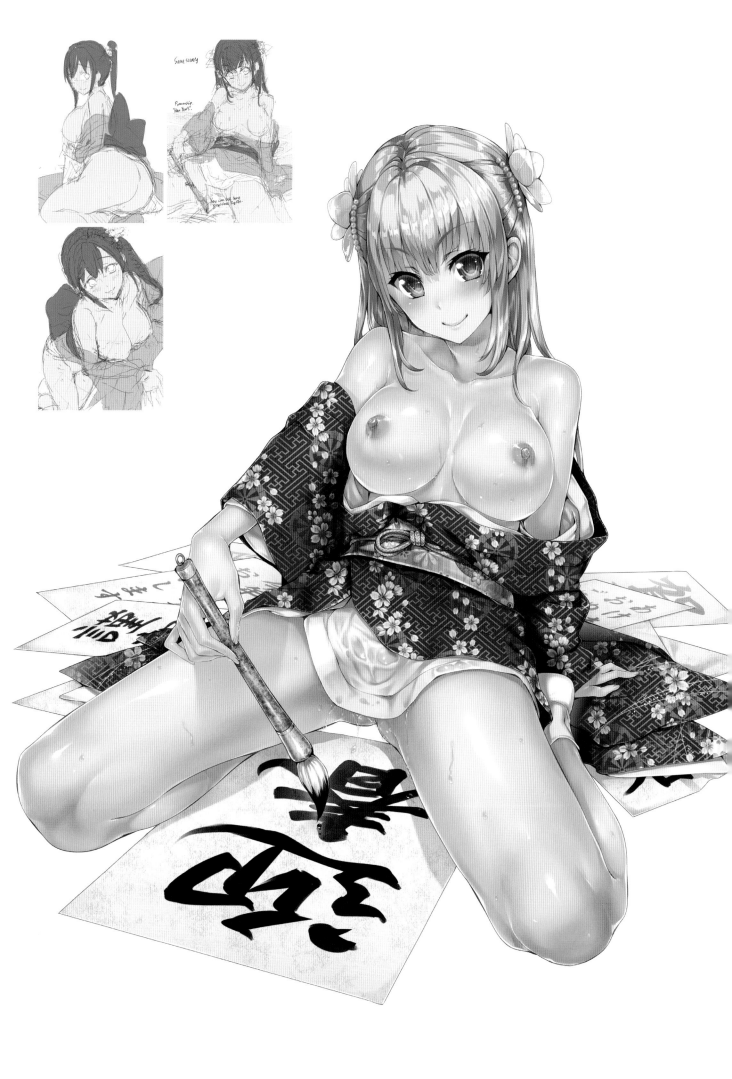

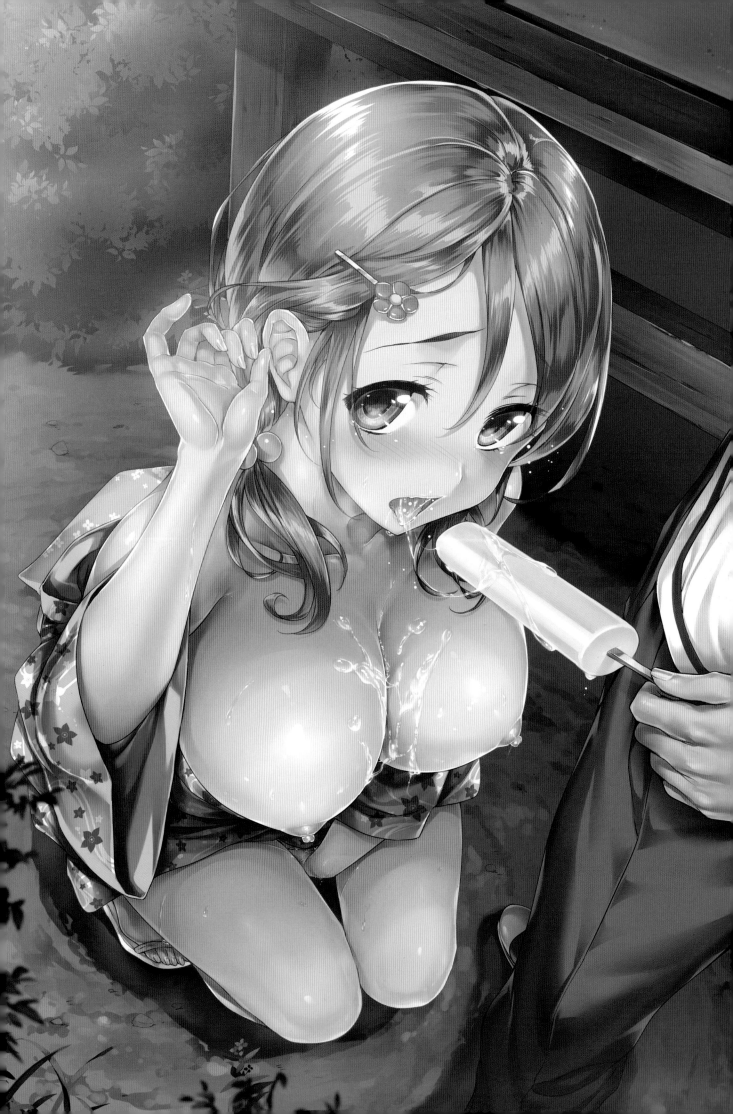

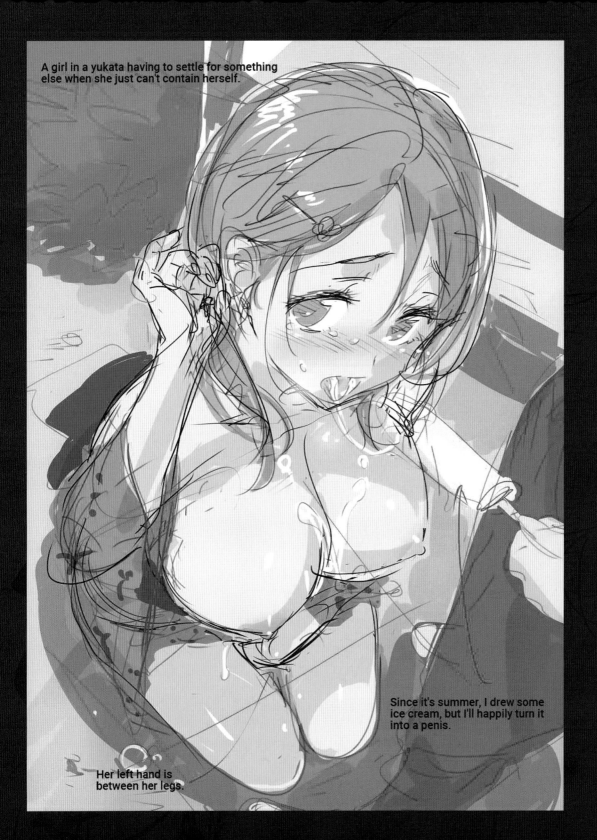

A girl in a yukata having to settle for something else when she just can't contain herself.

Since it's summer, I drew some ice cream, but I'll happily turn it into a penis.

Her left hand is between her legs.

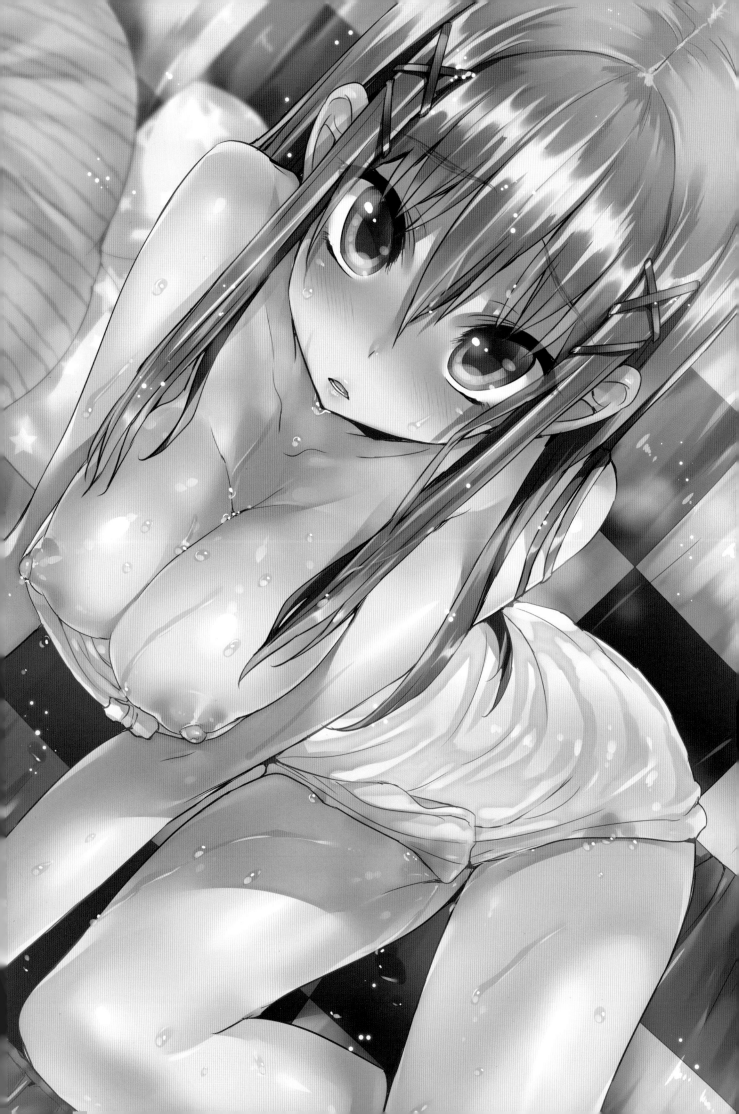

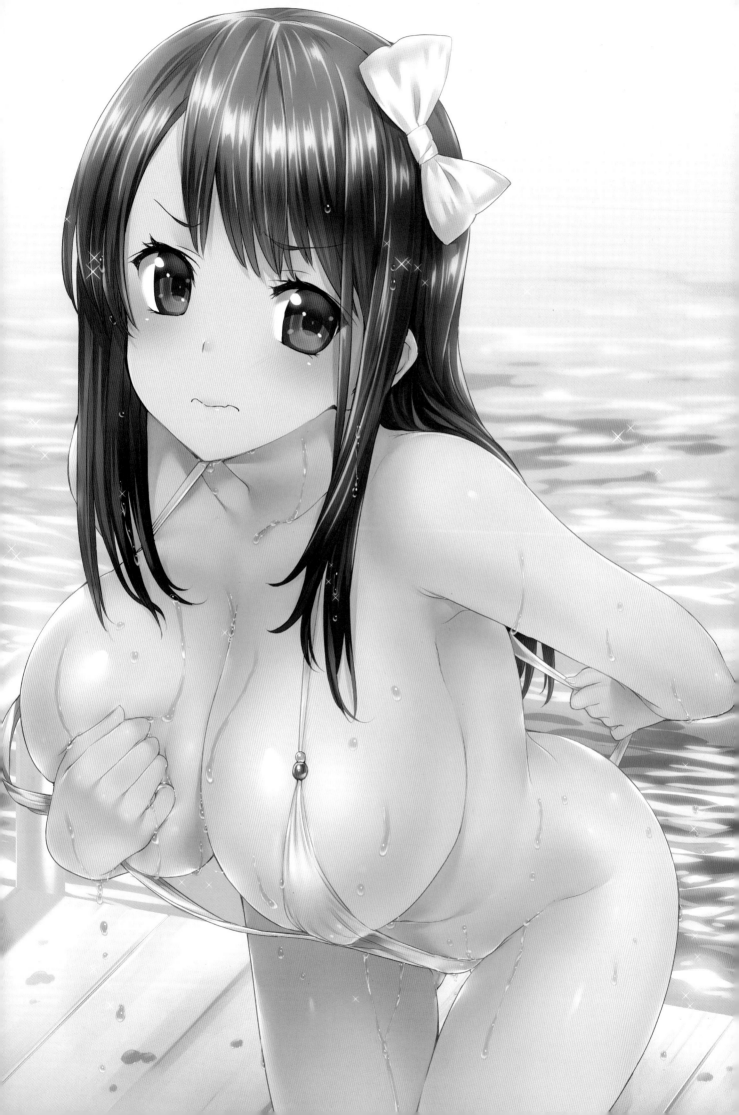

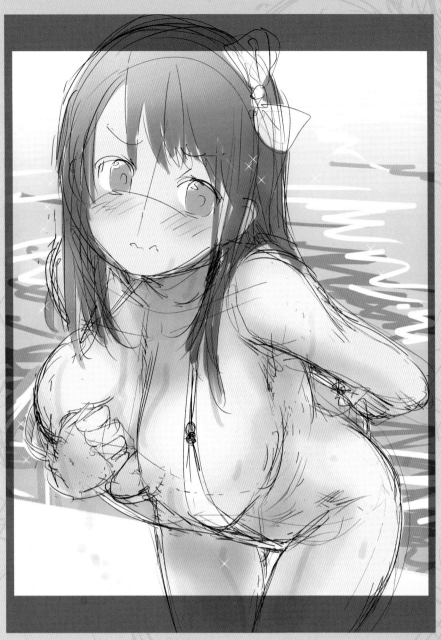

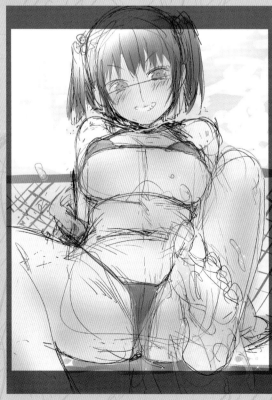

Young Animal 08-06-2013 "Daily Young Animal" no. 23 Index Reversible Poster
2013

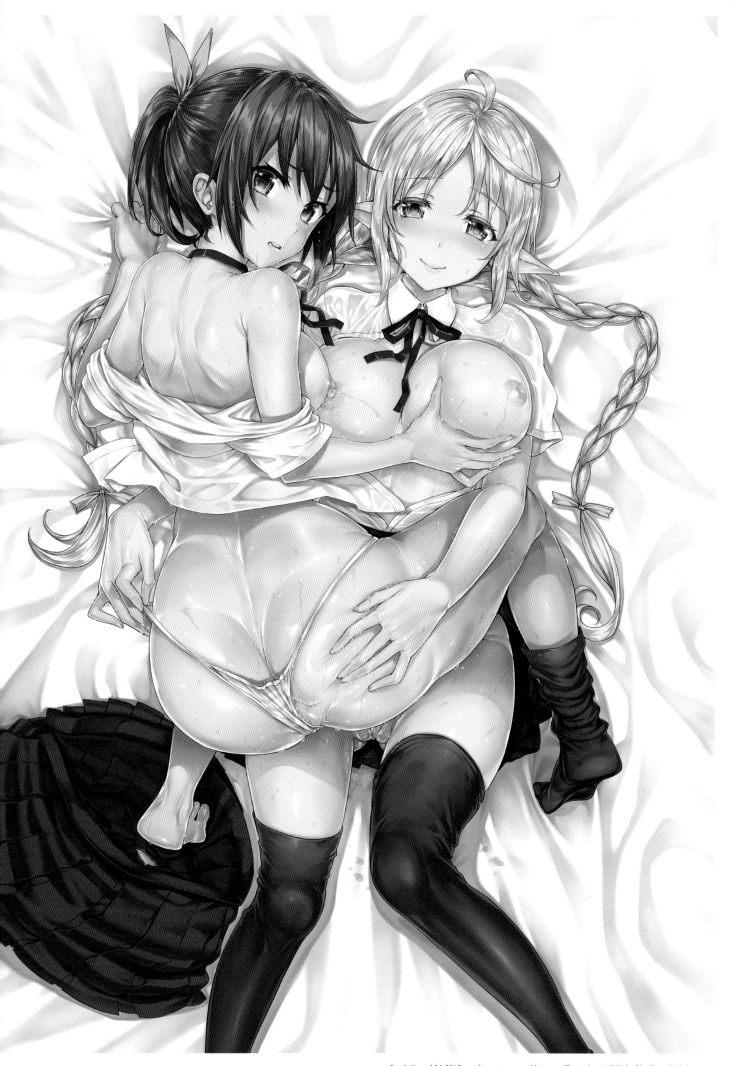

Comic Unreal 06-2015 supplementary pamphlet cover illustration　Hibiki (Left) - Elena (Right)
2015
Chapter:1_Cover illustrations for magazines. | 60

Chapter:2
Illustrations for comics.

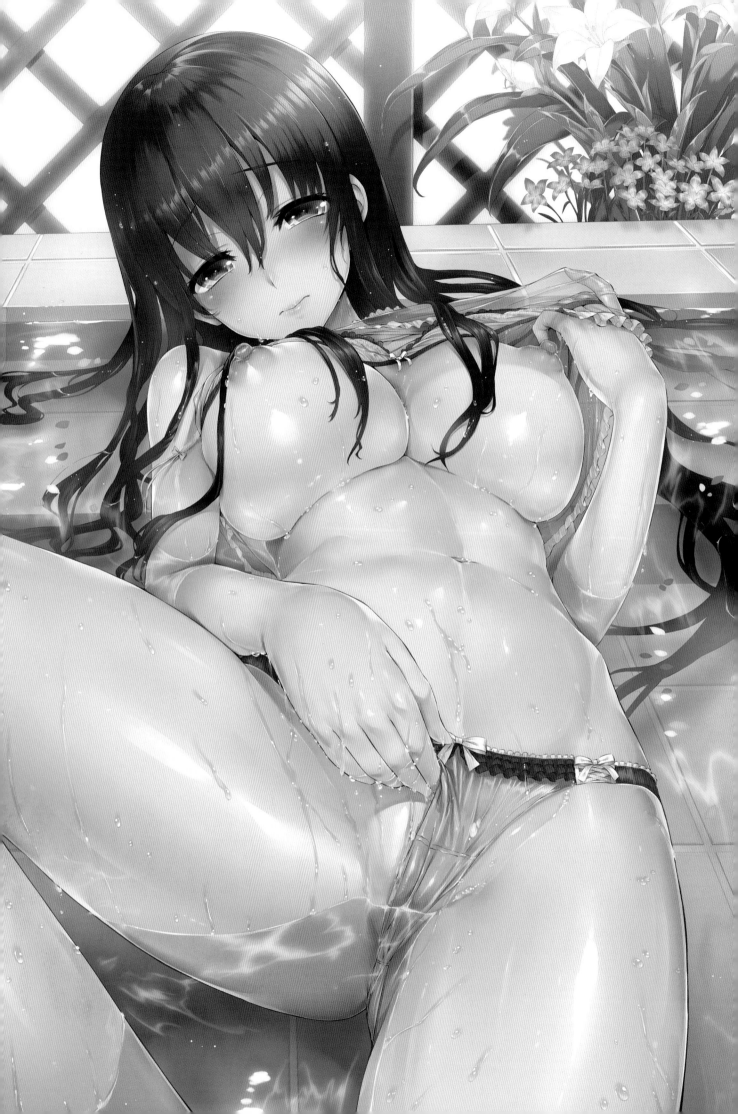

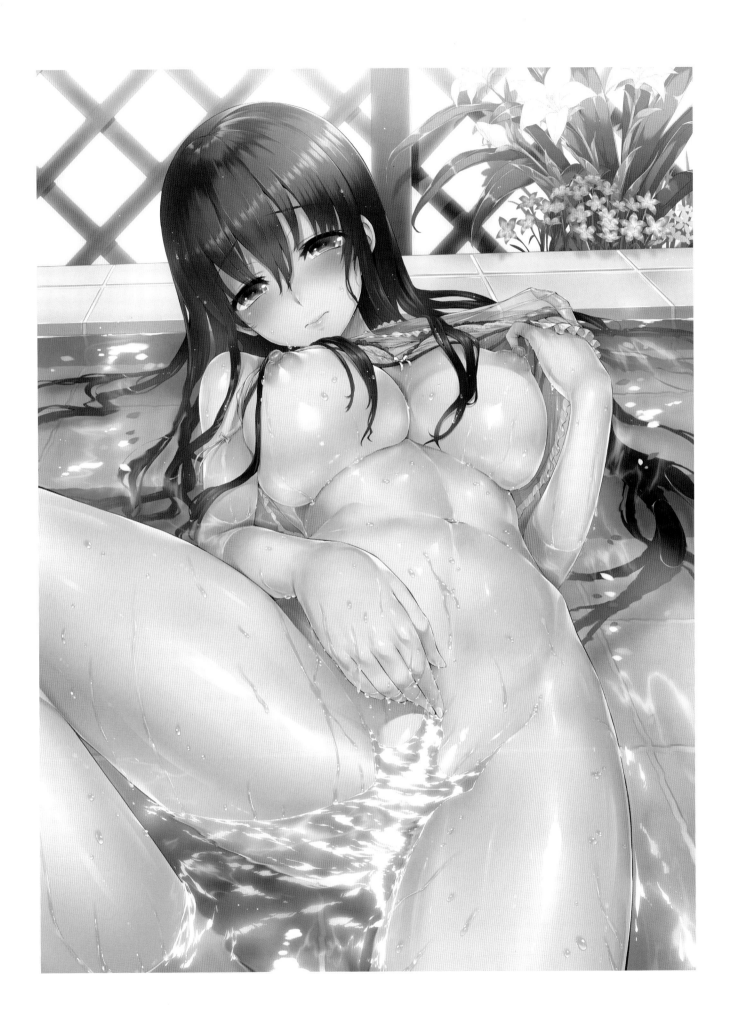

Porno Switch Cover Illustration Kurahashi Yuri
2012

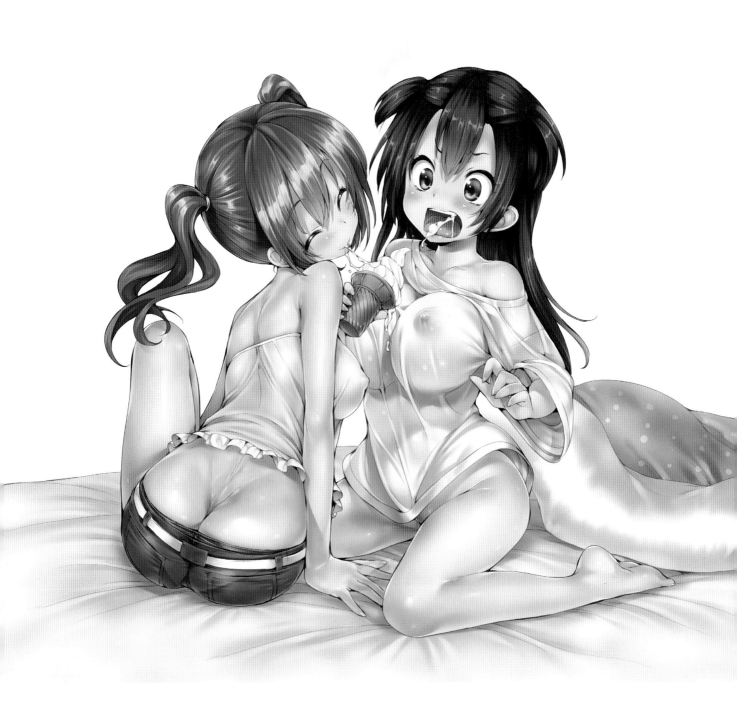

Porno Switch Rear Cover Illustration Konno (left) - Kawashima Kayane (right)
2012

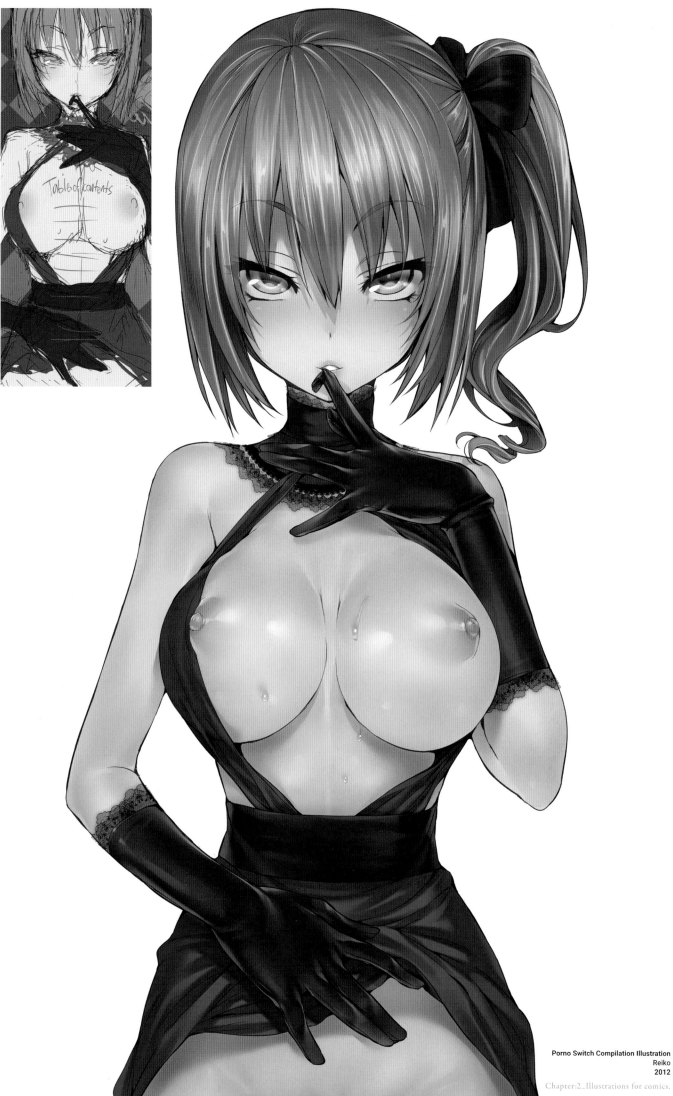

Porno Switch Compilation Illustration
Reiko
2012

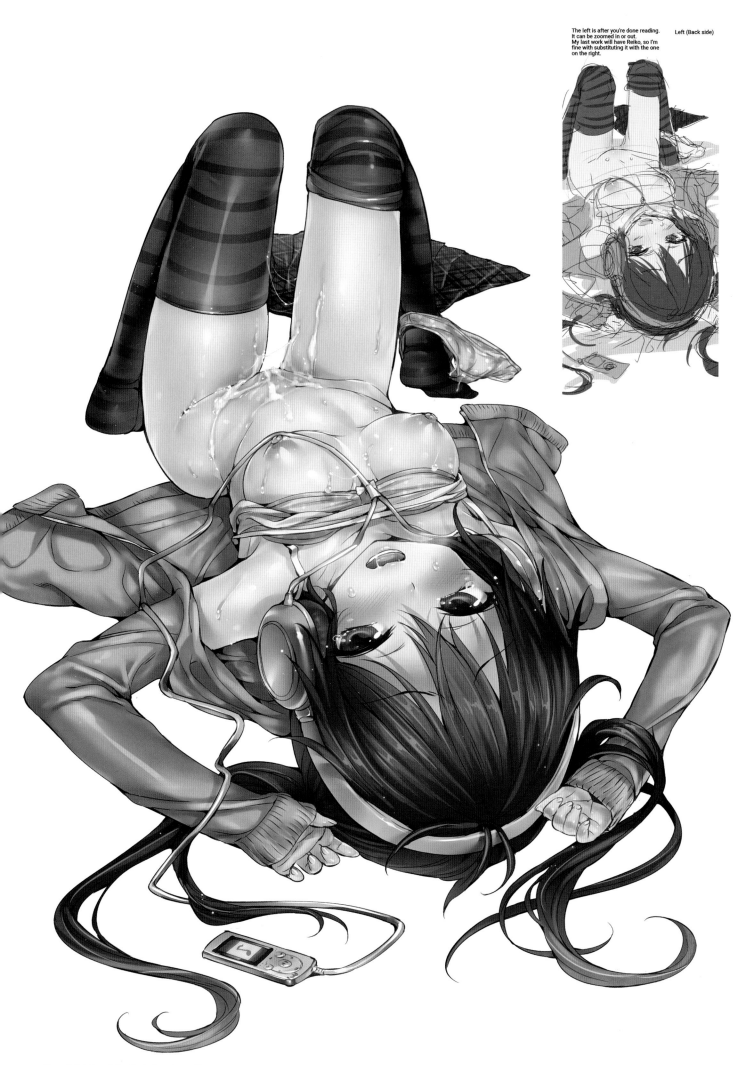

The left is after you're done reading.
It can be zoomed in or out.
My last work will have Reiko, so I'm
fine with substituting it with the one
on the right.

Left (Back side)

Porno Switch Melon Books Special Edition Clear Stick Poster　Kawashima Kayane

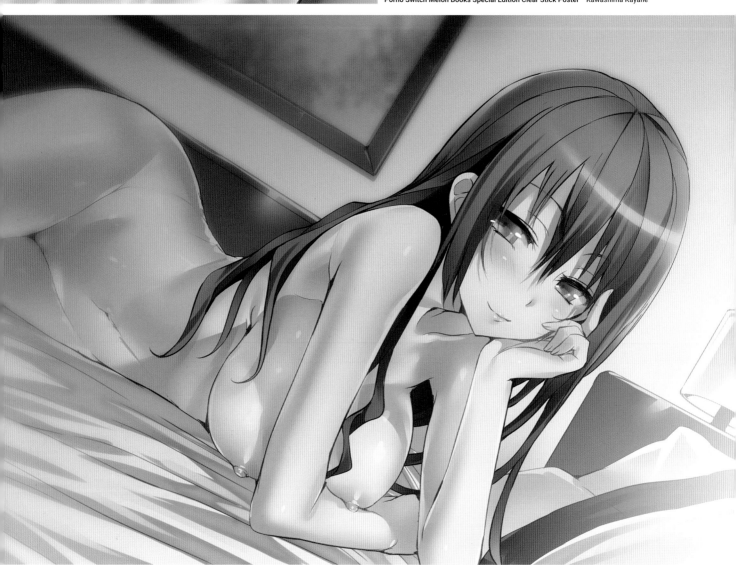

Porno Switch Comic ZIN Special Edition Postcard　Reiko

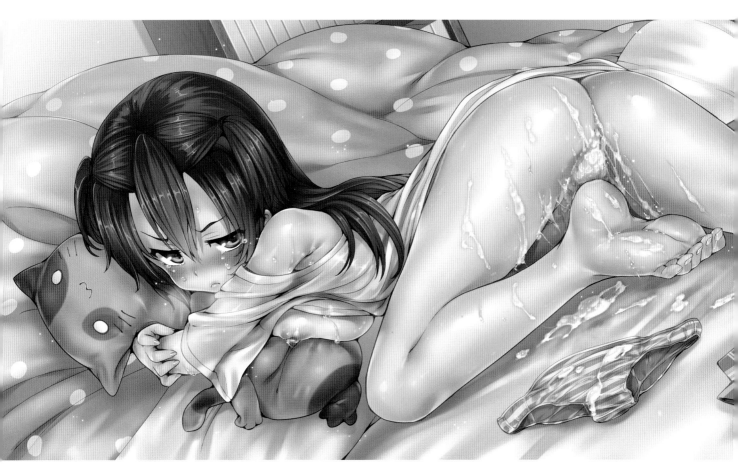

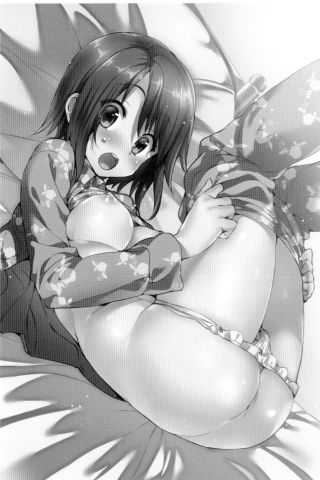

Porno Switch Manga King Special Edition Postcard Aya

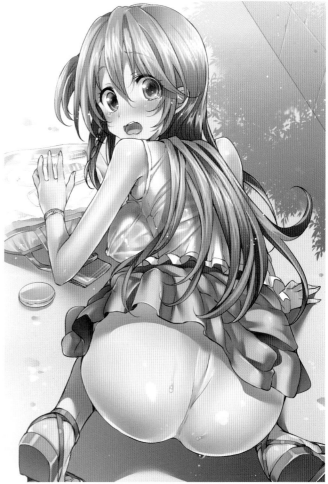

Porno Switch participating retailers Special Edition Postcard Nanami

Porno Switch Special Pack-in Items
2012

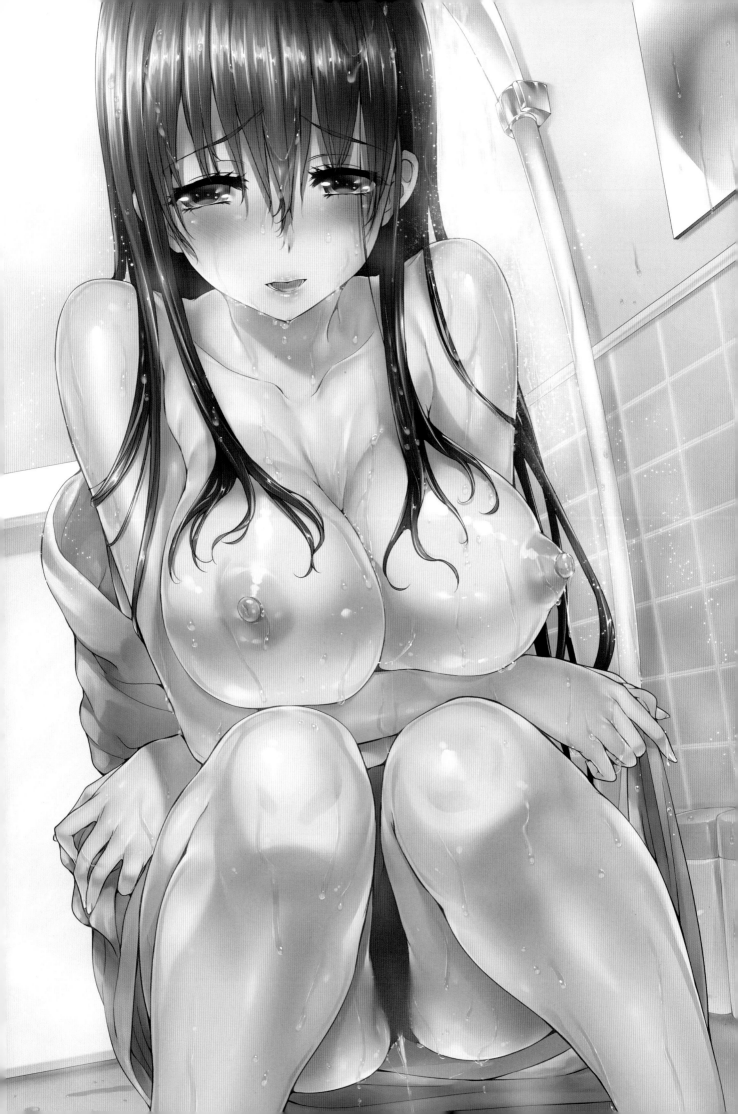

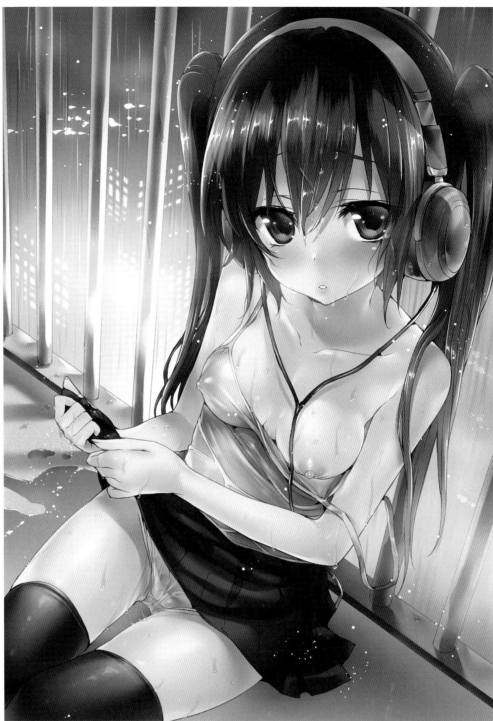

LEFT
Porno Switch Wani Magazine Special Edition Illustration Card Amane Mayu
2012

RIGHT
Porno Switch Toranoana Edition Bath Poster Kurahashi Yuri
2012

71 | Chapter:2_Illustrations for comics.

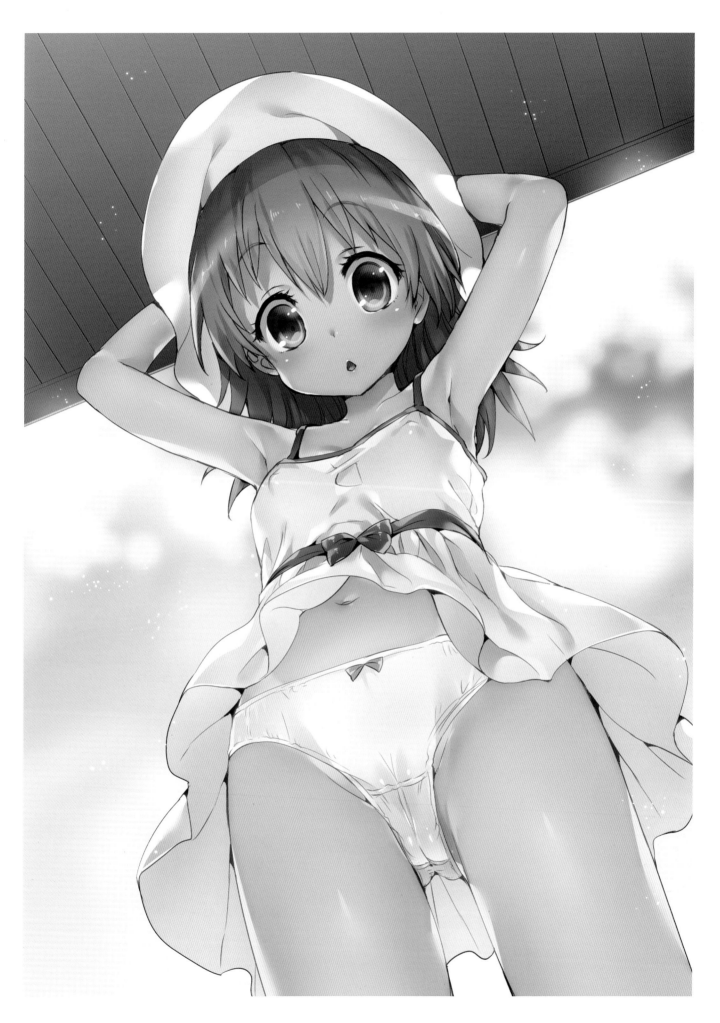

Porno Switch Toranoana Special Edition Pamphlet Mishima Asuka
2012

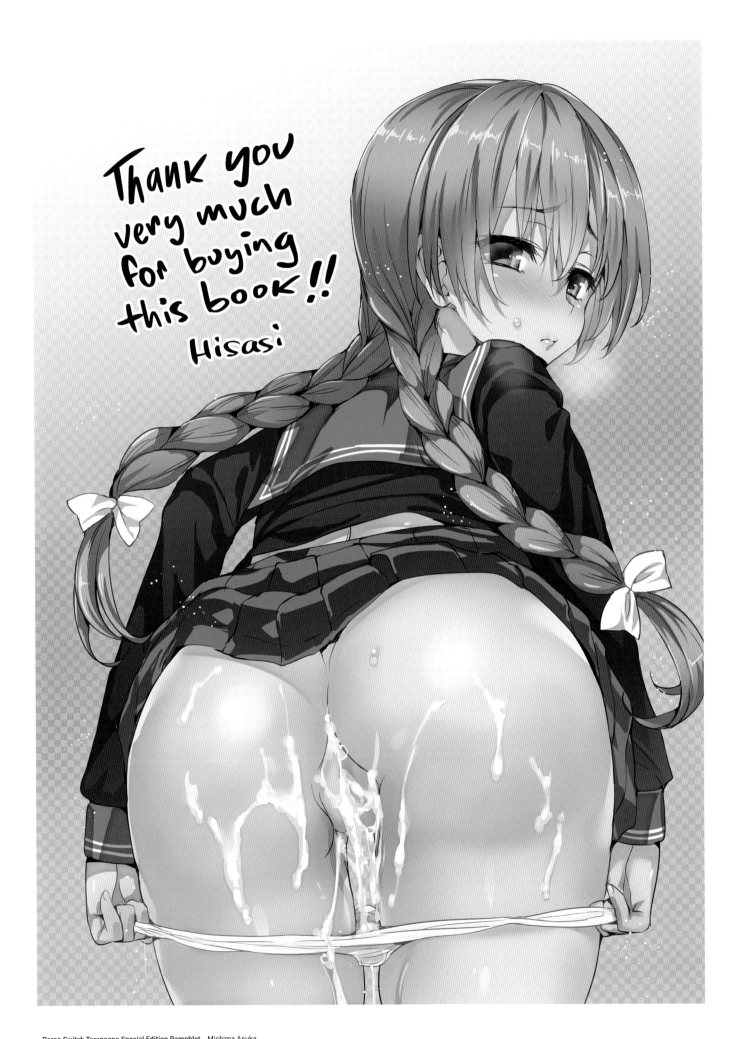

Thank you very much for buying this book!! Hisasi

Porno Switch Toranoana Special Edition Pamphlet Mishima Asuka
2012

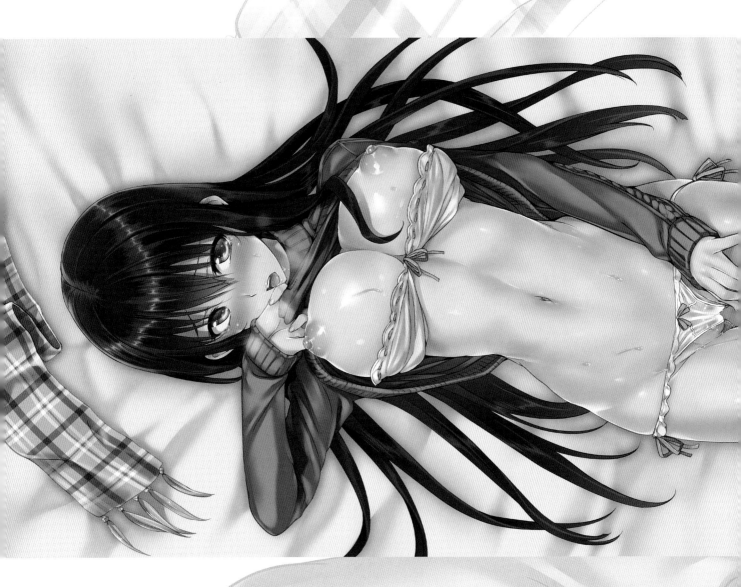

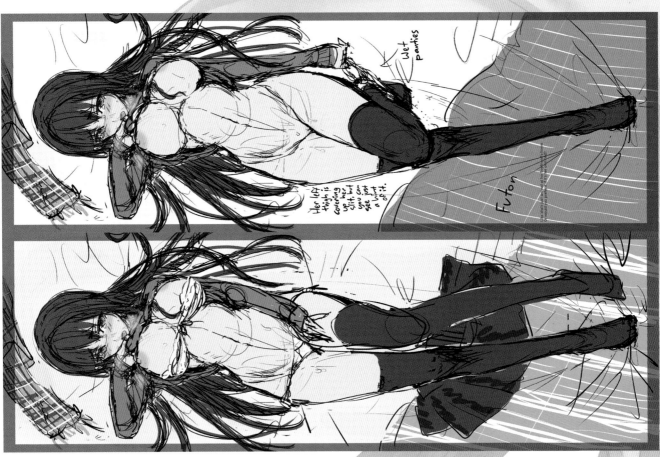

Porno Switch Kurahashi Yuri Dakimakura Cover
2012

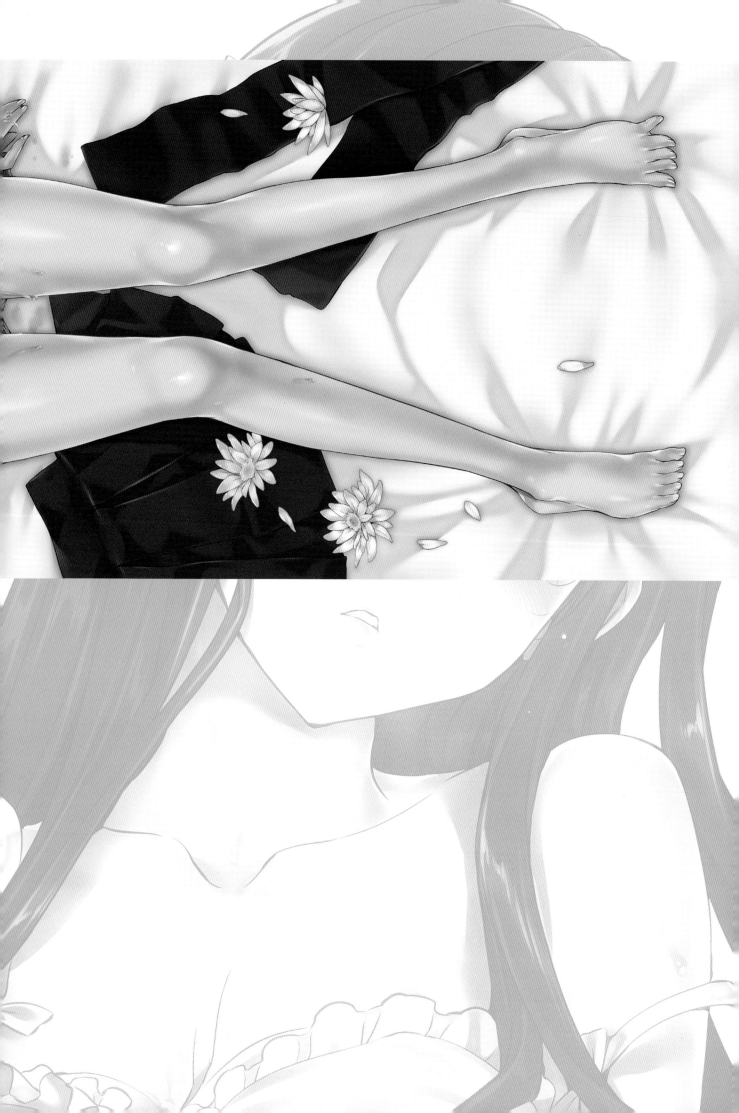

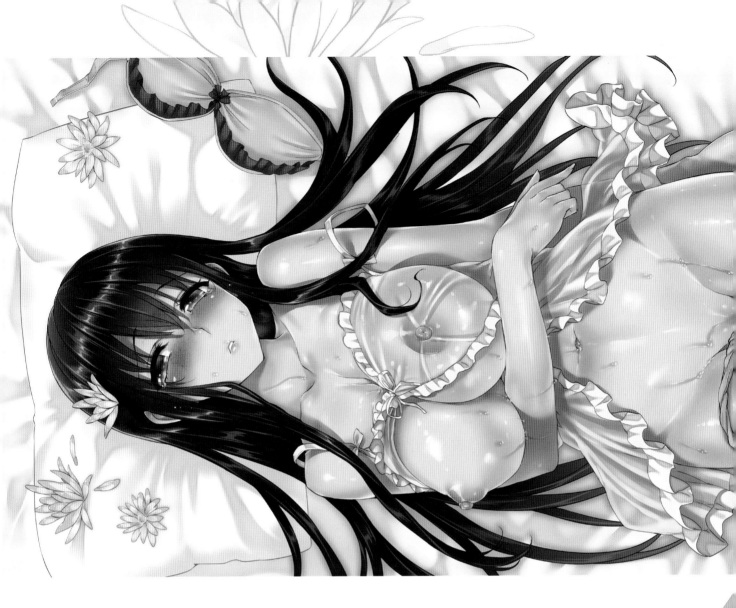

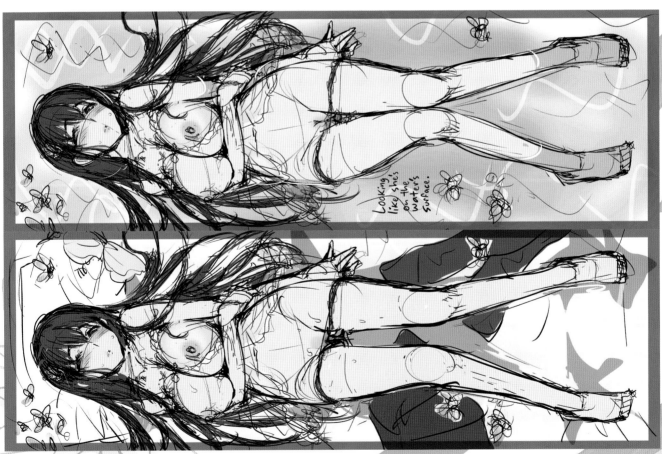

Looking like she's on the water's surface.

Porno/Switch/Kuchinashi Yui Dakimakura Cover
2012

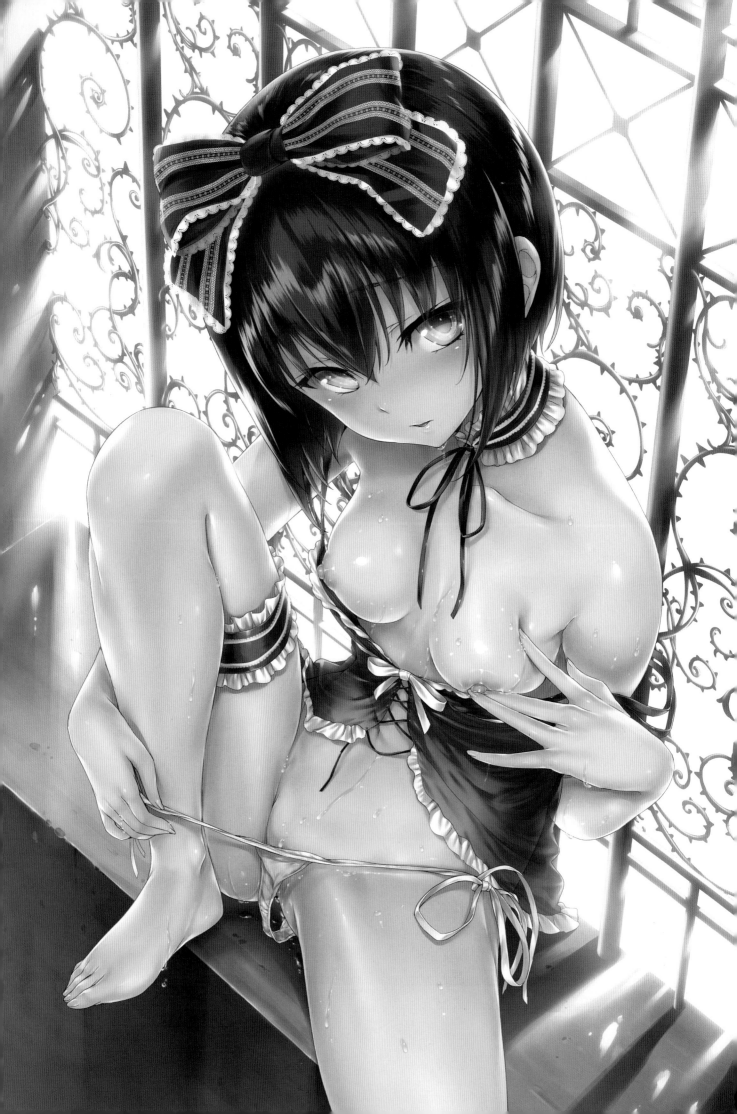

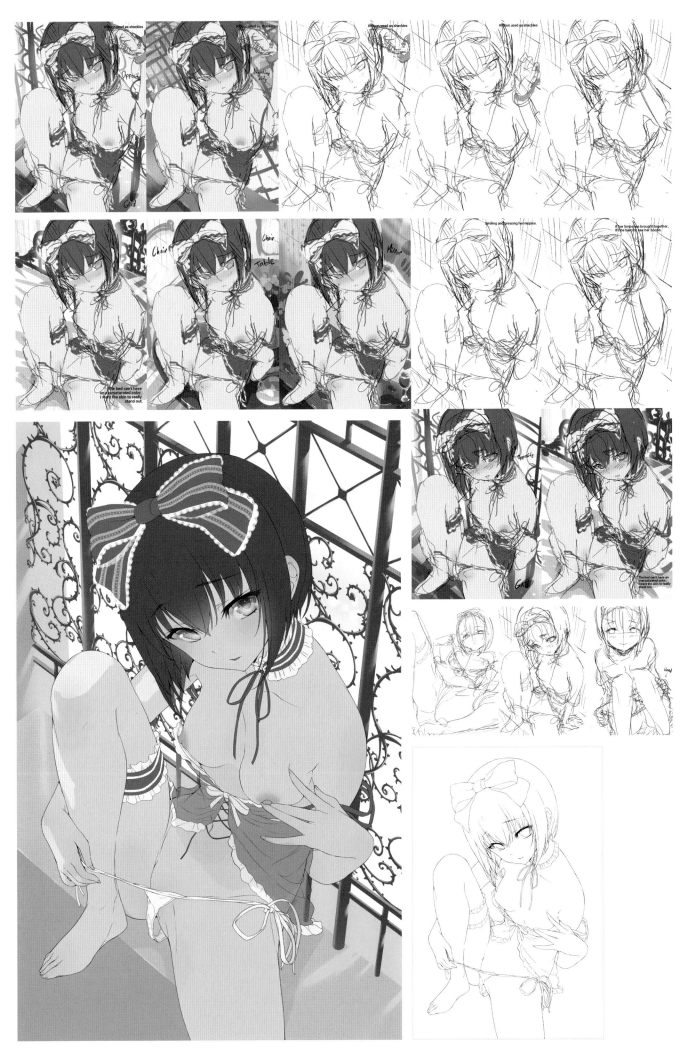

Every Girl Has Her Thorns Cover Illustration Chie
2013

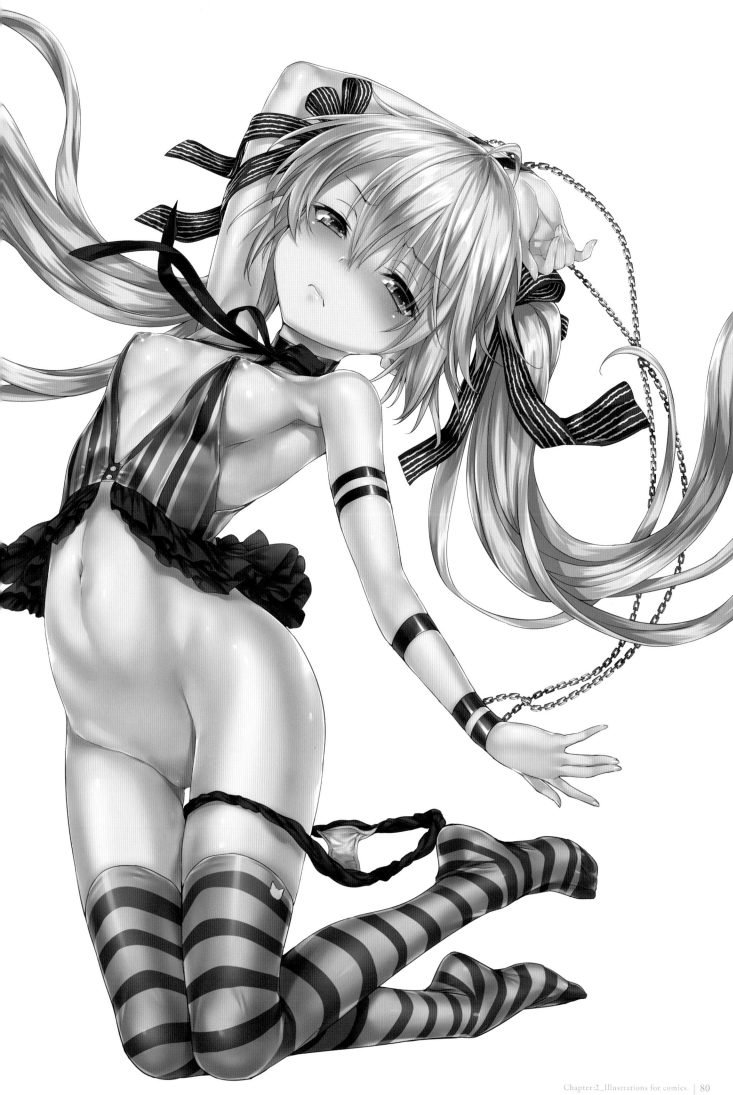

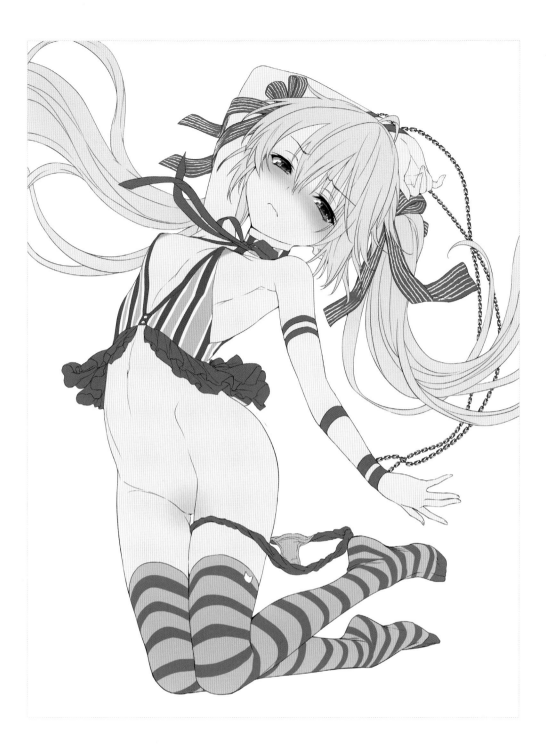

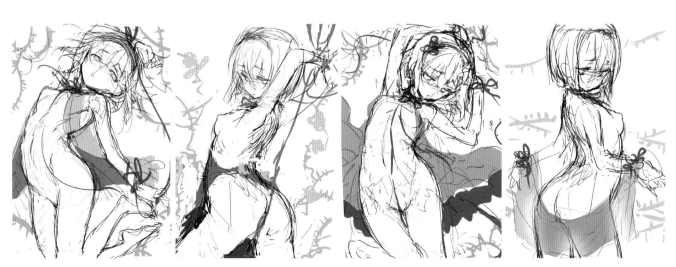

Every Girl Has Her Thorns Rear Cover Illustration Shii
2013

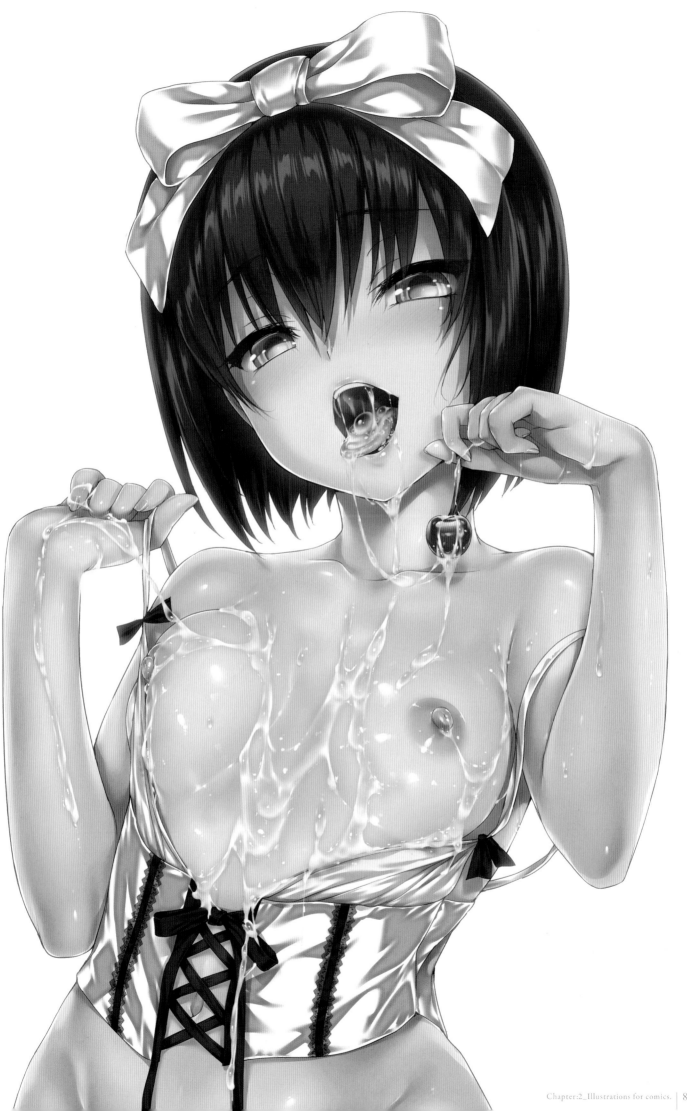

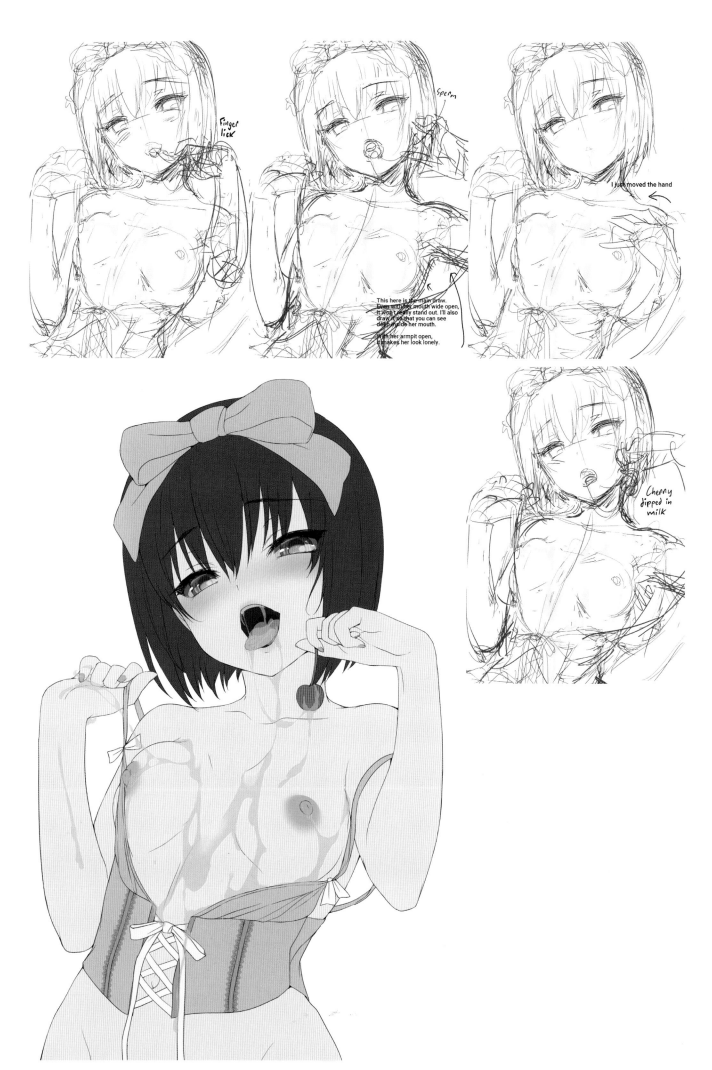

Finger lick

Sperm

I just moved the hand

This here is the main draw.
Even with her mouth wide open,
it won't really stand out. I'll also
draw it so that you can see
deep inside her mouth.

With her armpit open,
it makes her look lonely.

Cherry
dipped in
milk

Every Girl Has Her Thorns Compilation Illustration Chie
2013

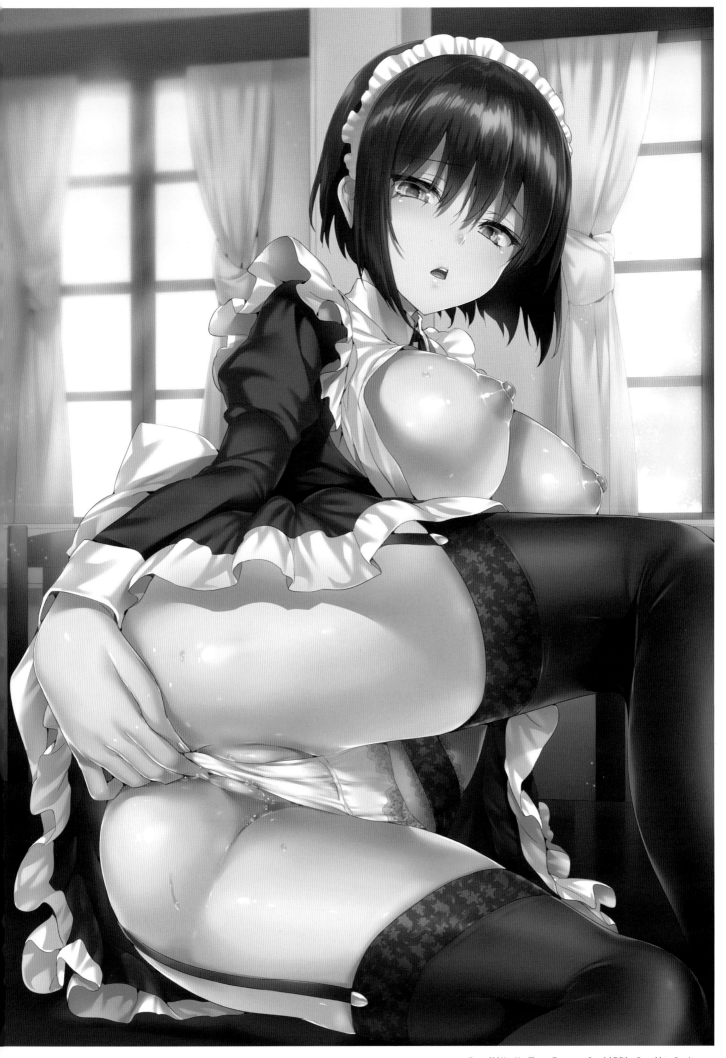

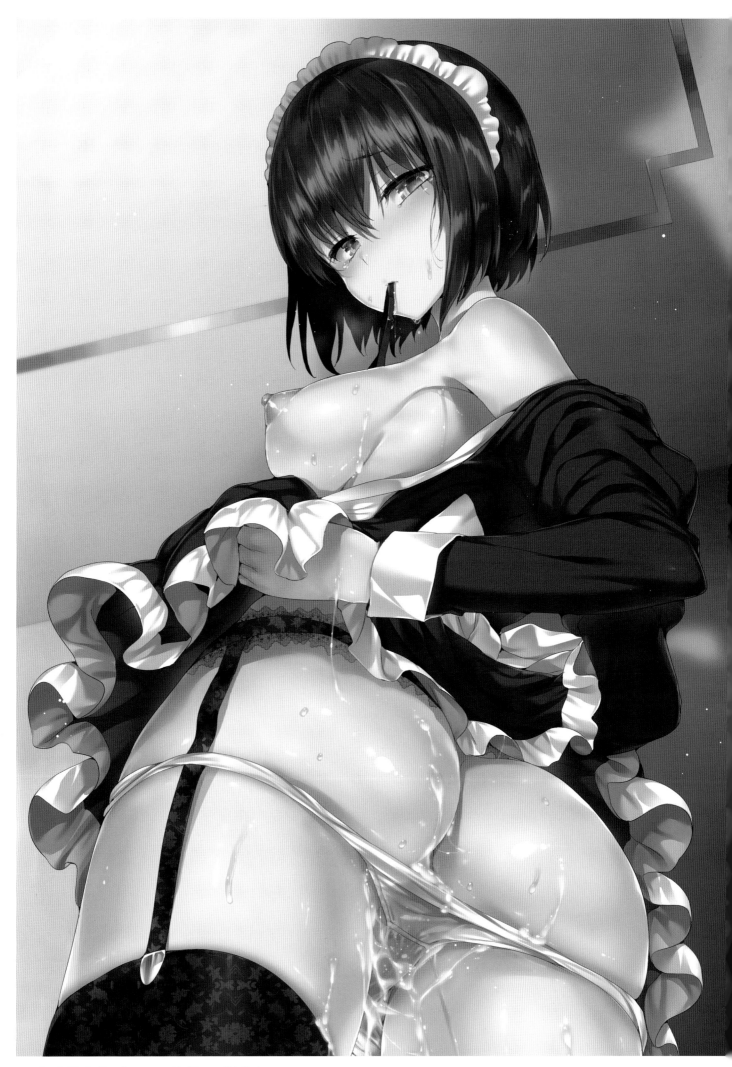

Every Girl Has Her Thorns Toranoana special edition pamphlet Saori
2013

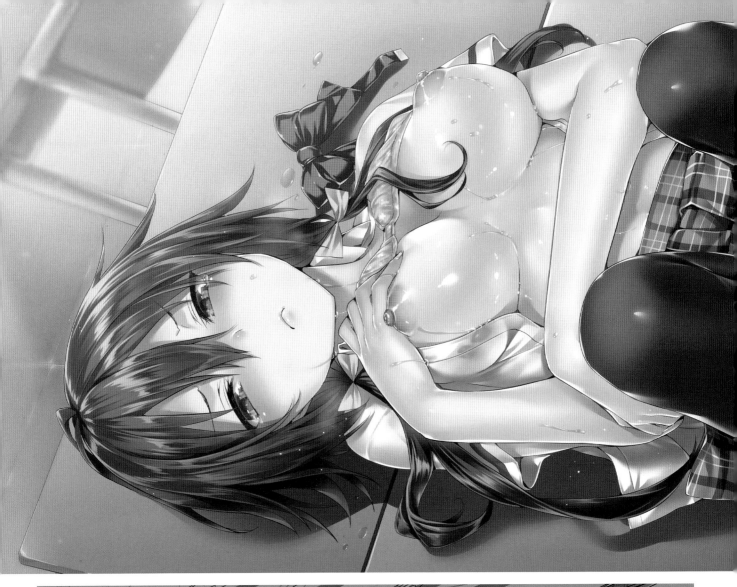

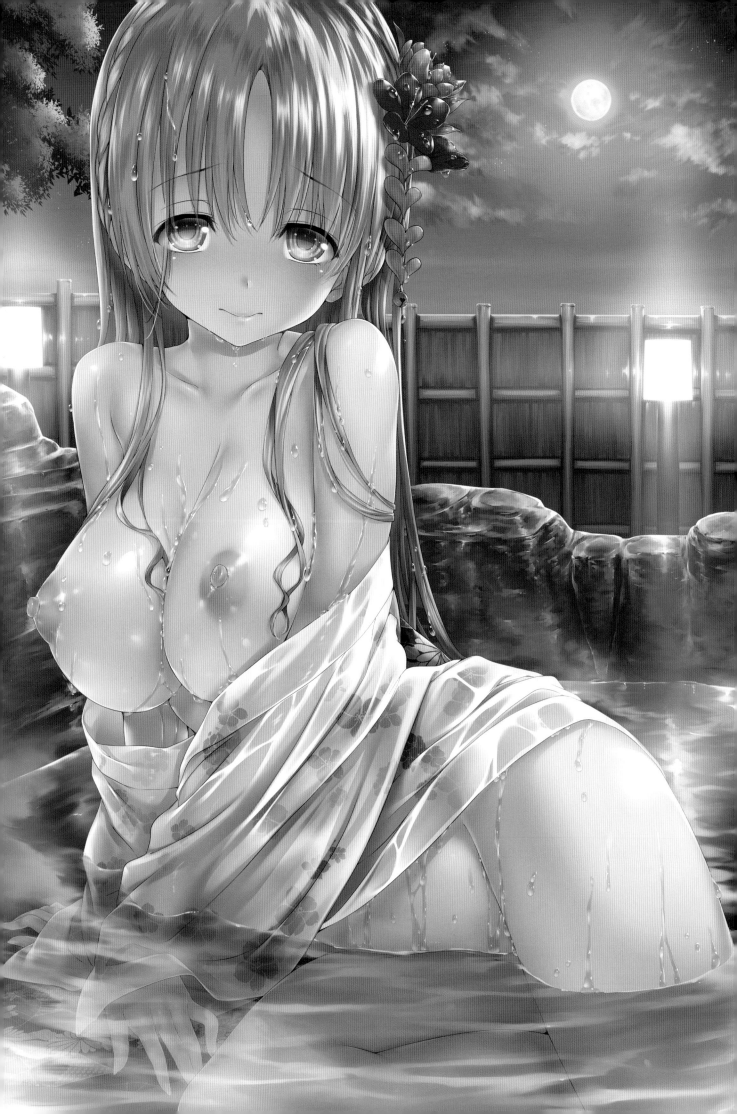

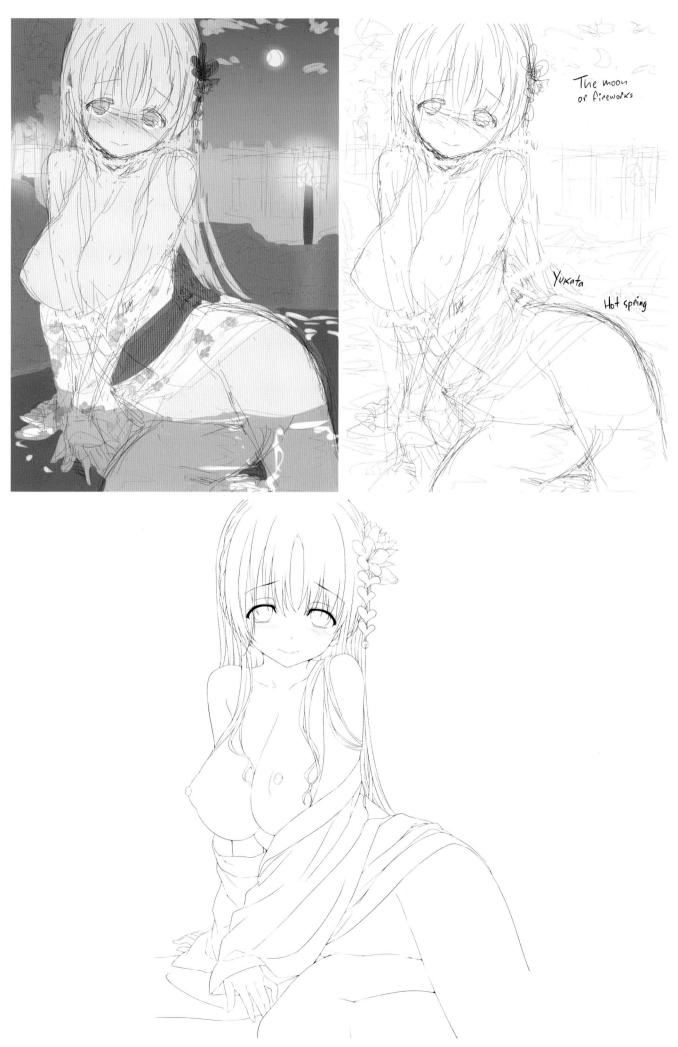

The moon
or fireworks

Yukata

Hot spring

Every Girl Has Her Thorns Toranoana Special Edition B2-Sized Tapestry Hanami
2013

Swimsuit

Sand

Sea

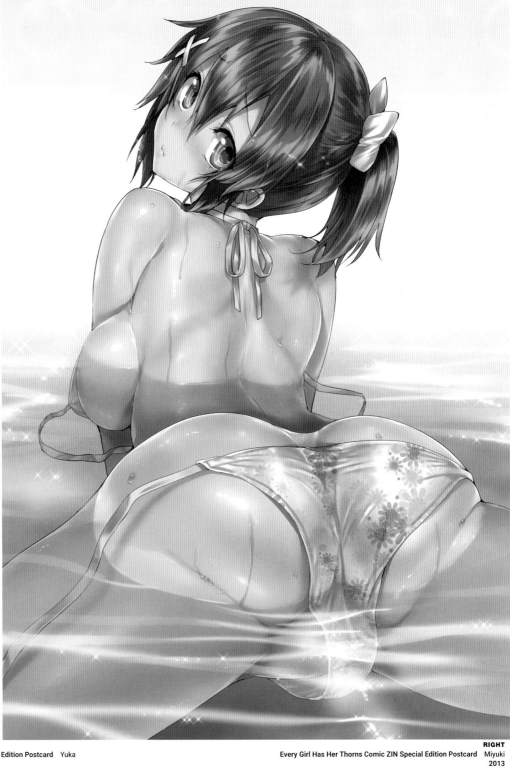

LEFT
Every Girl Has Her Thorns Manga King Special Edition Postcard Yuka
2013

RIGHT
Every Girl Has Her Thorns Comic ZIN Special Edition Postcard Miyuki
2013

Chapter:2_Illustrations for comics. | 90

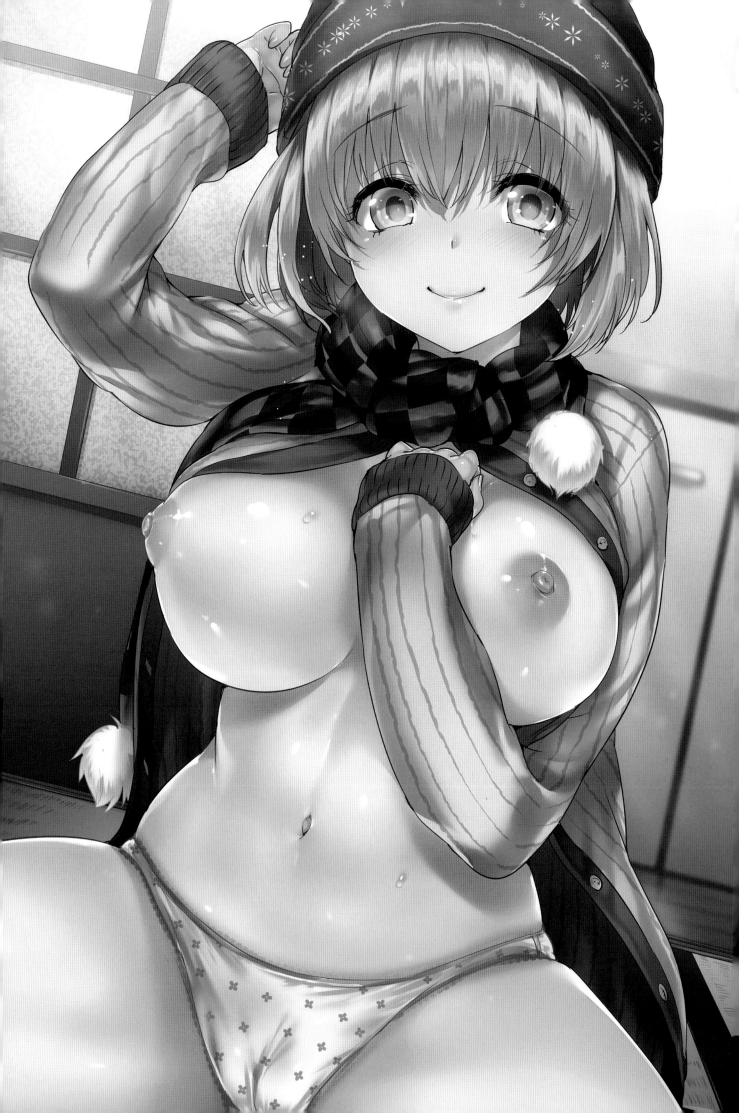

Every Girl Has Her Thorns Chie Dakimakura Cover
2014

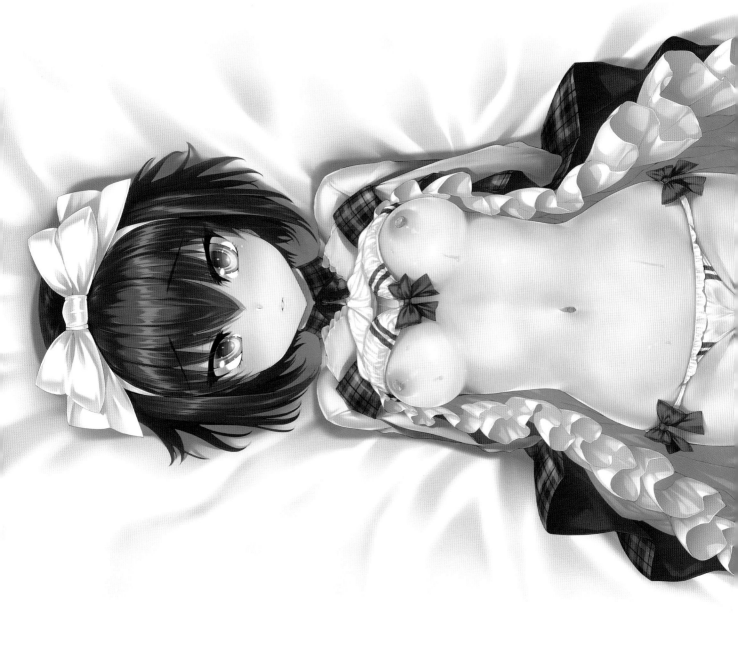

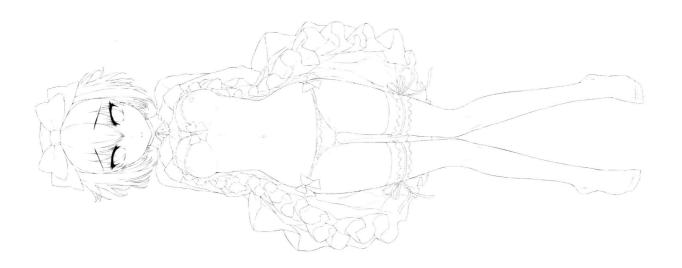

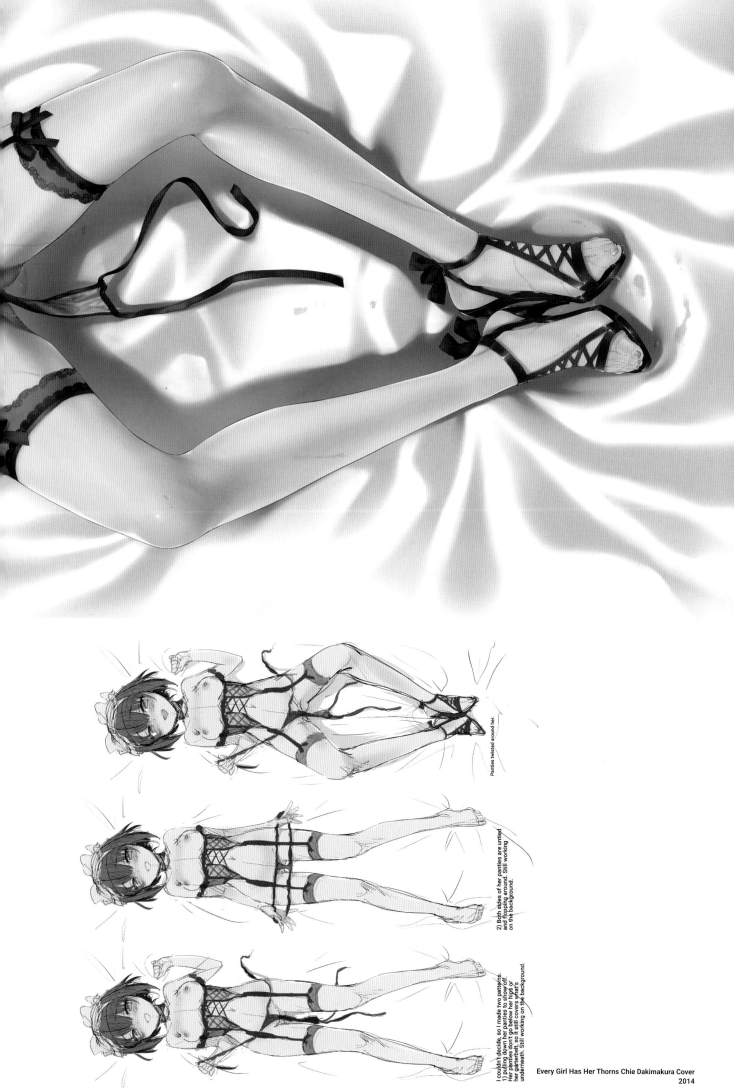

Panties twisted around her.

2) Both sides of her panties are untied and flopping around. Still working on the background.

I couldn't decide, so I made two patterns.
1) pulling down her panties to show off.
Her panties don't go below her hips or her garterbelt, so it still covers what's underneath. Still working on the background.

Every Girl Has Her Thorns Chie Dakimakura Cover
2014

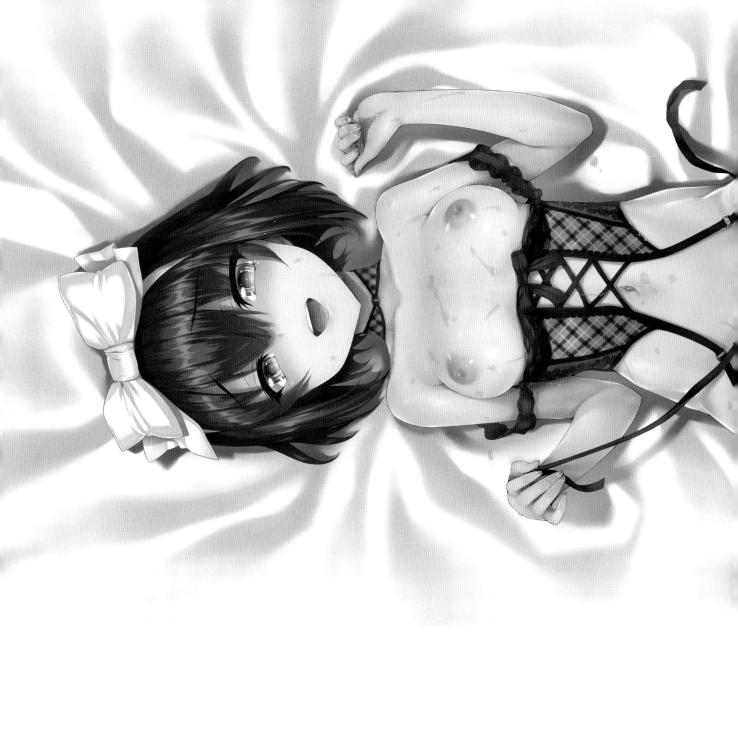

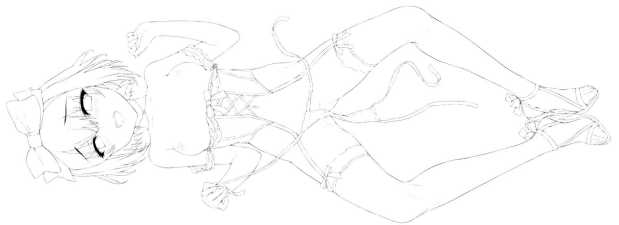

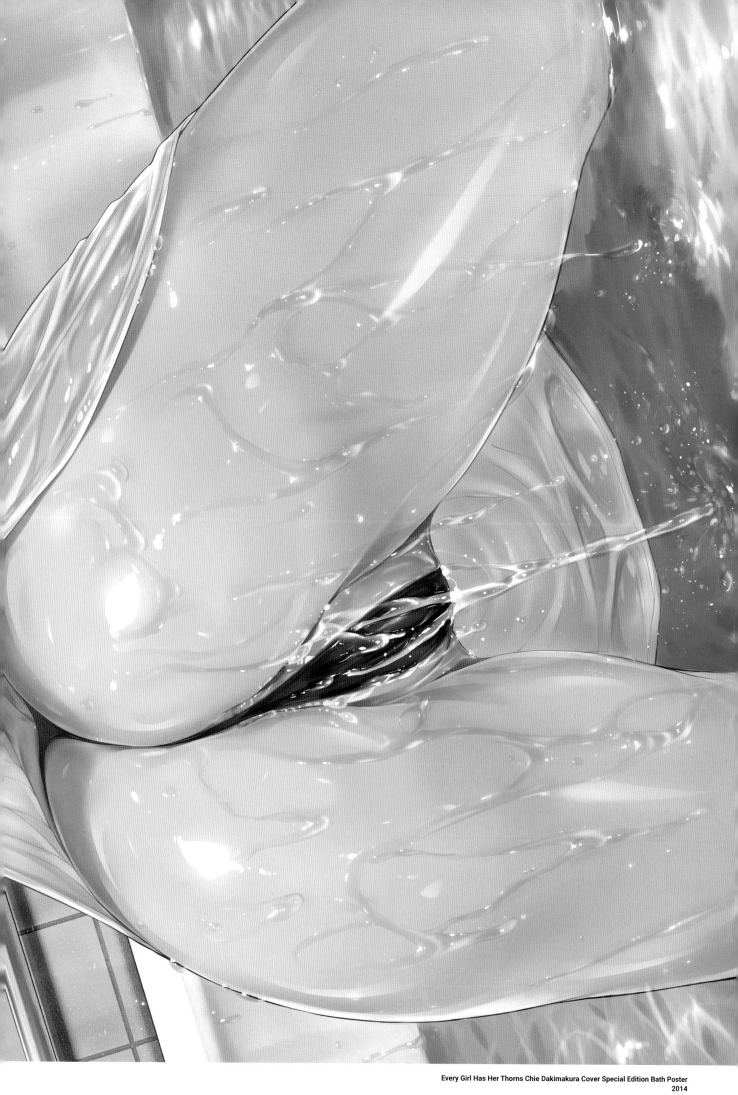

Every Girl Has Her Thorns Chie Dakimakura Cover Special Edition Bath Poster
2014

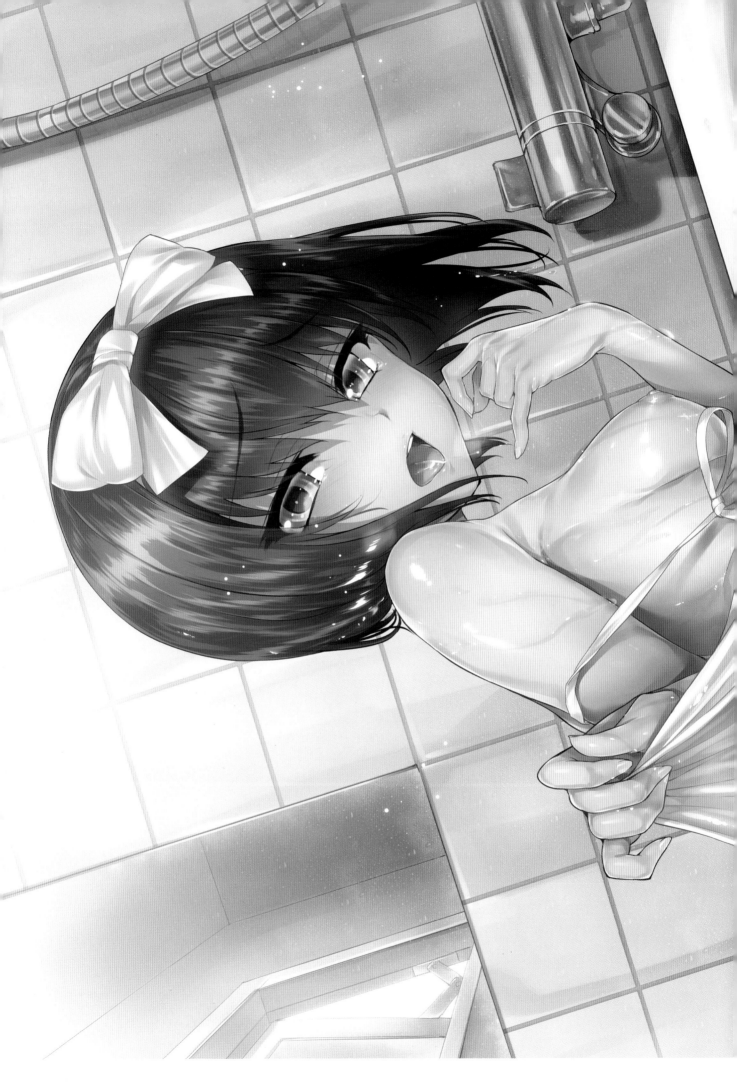

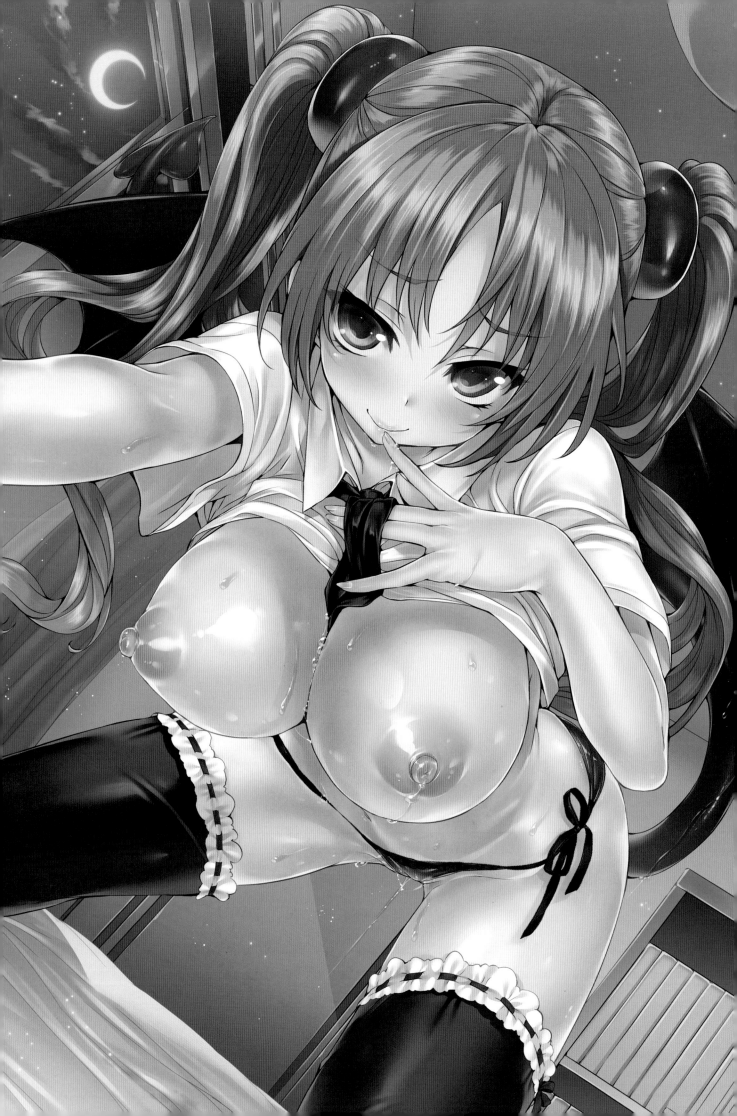

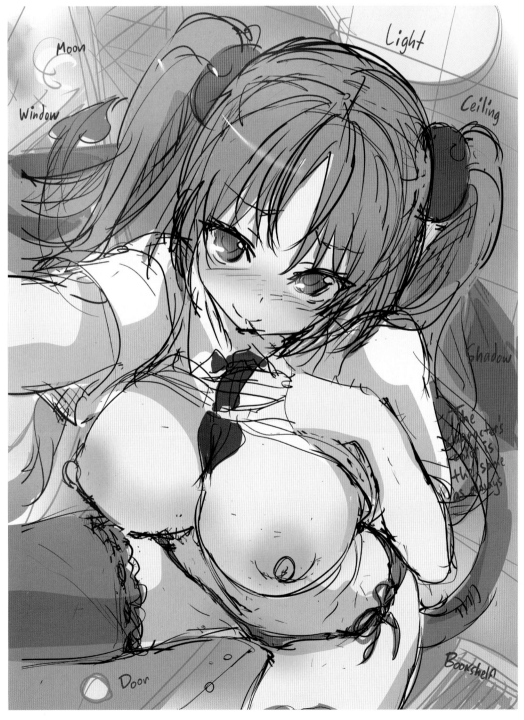

Devilish Girlfriend Cover Illustration Akuno Mika
2013

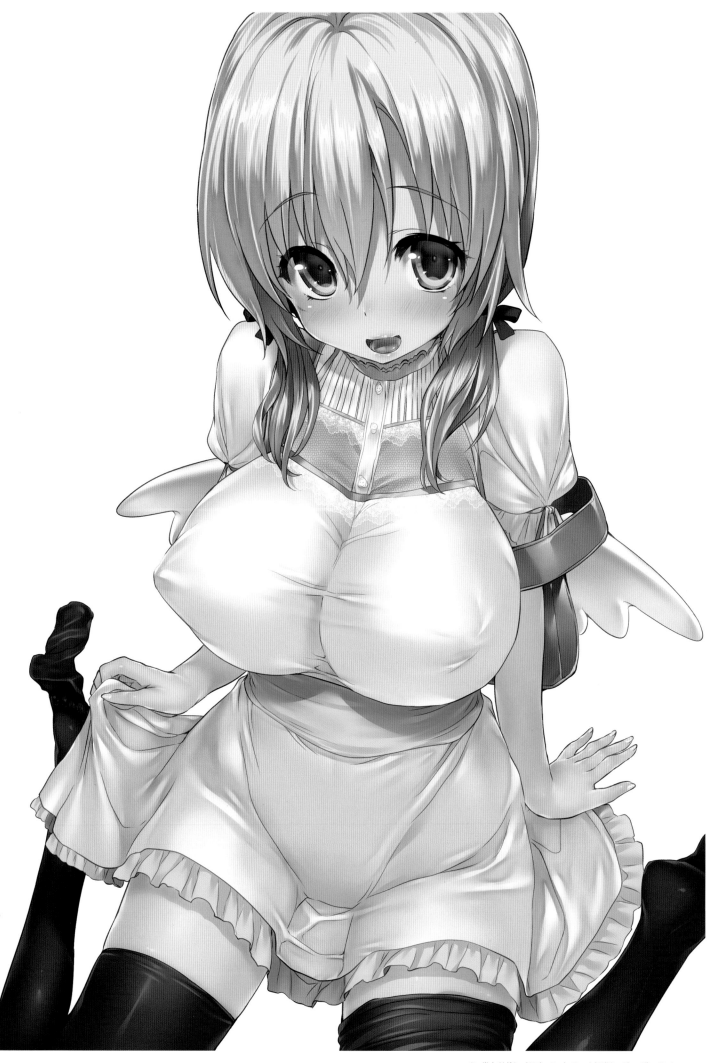

Devilish Girlfriend Melon Books Special Edition Clear File　Tenten
2013

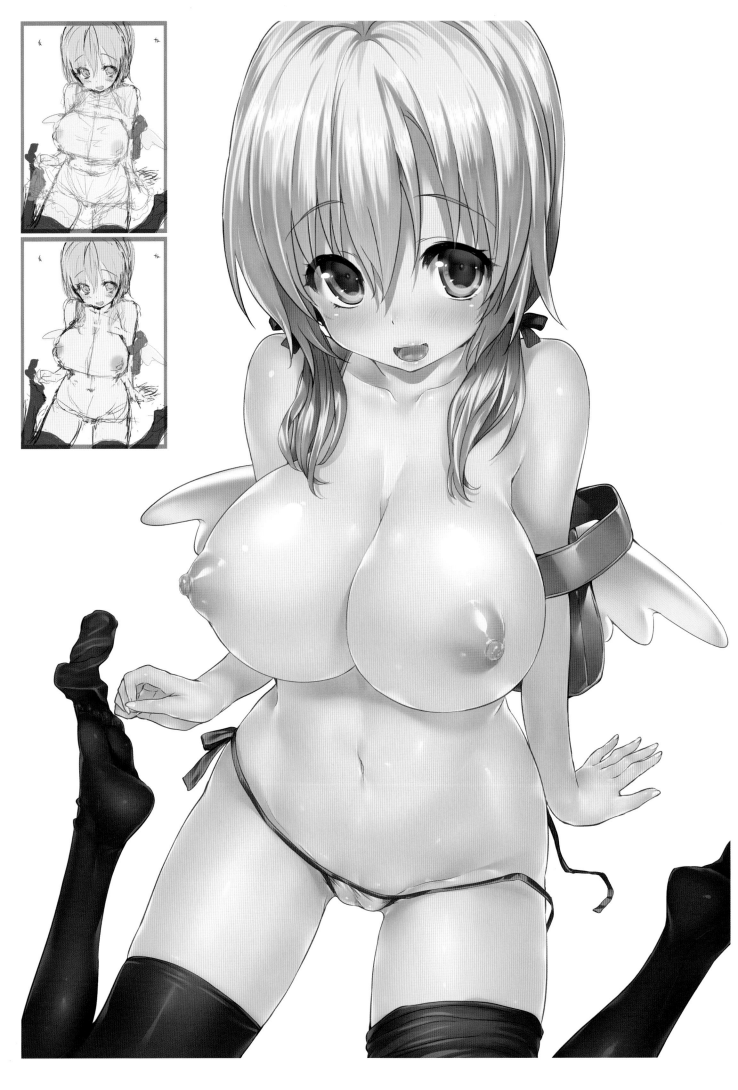

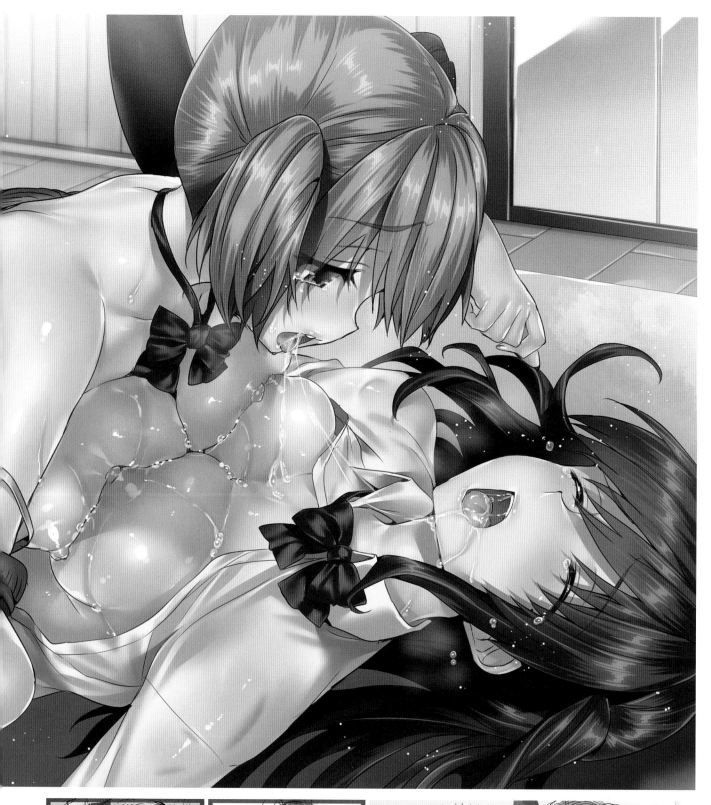

Thanks
for buying..
Hisasi





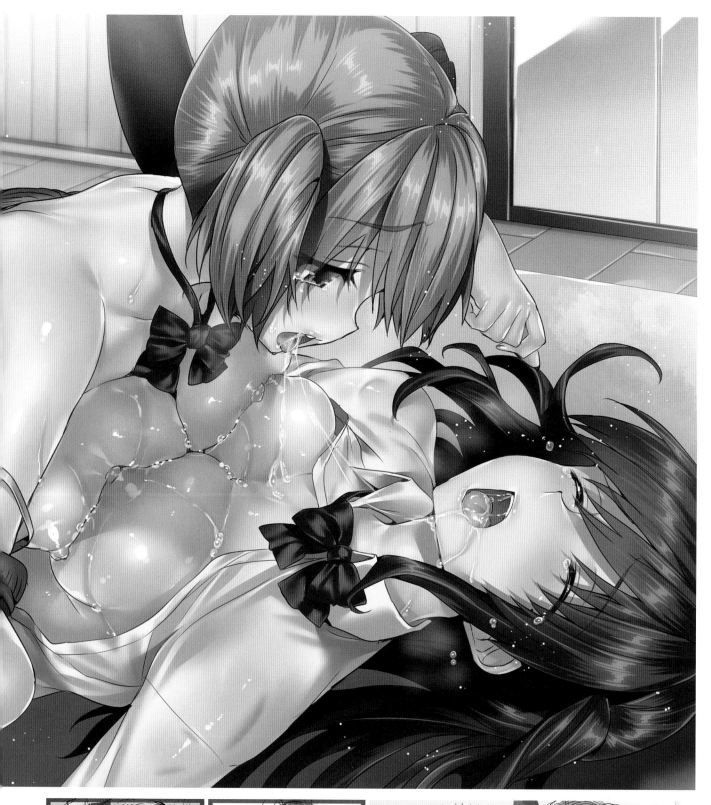

Thanks for buying.. Hisasi

2013
Chapter:2_Illustrations for comics. | 102

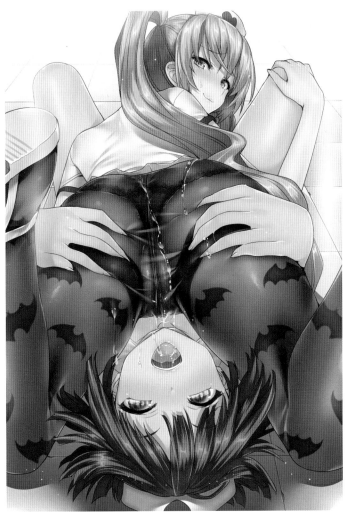

Devilish Girlfriend Comic ZIN Special Edition Postcard Mashiro (Back) - Akane (Front)

Devilish Girlfriend Animate Special Edition Message Sheet Kana (Below) - Mai (Above)

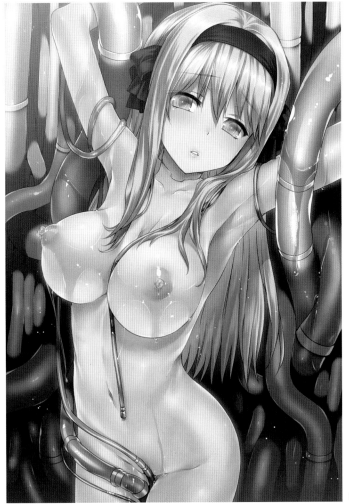

Devilish Girlfriend Manga King Special Edition Postcard Nina

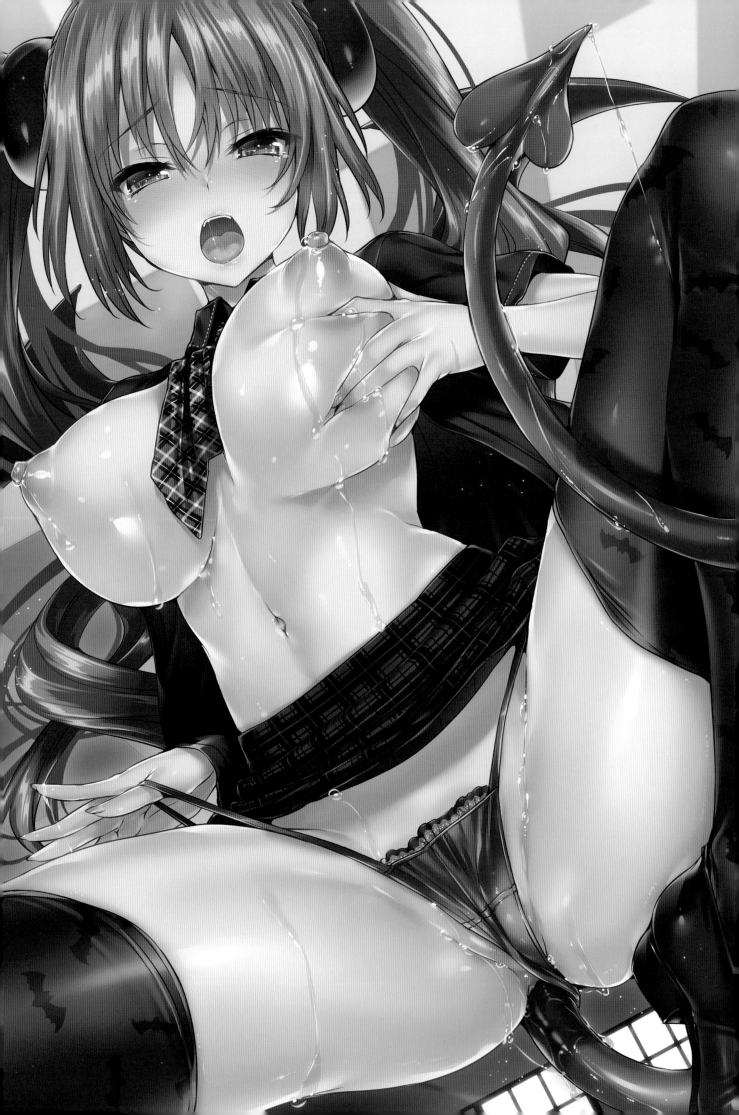

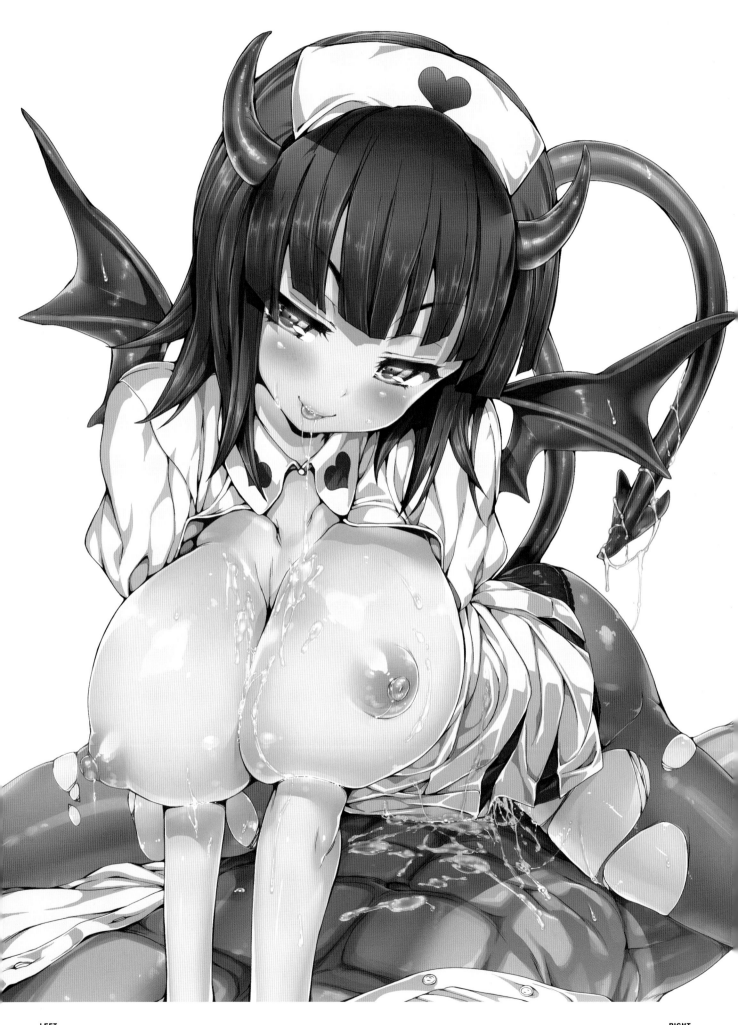

| Chapter:2_Illustrations for comics.

LEFT
Comic Unreal Anthology "Reverse Rape Queens" Cover Illustration Akane
2011

RIGHT
Akuno Mika Dakimakura Cover Magazine Mail Order Special Edition Telephone Card
2013

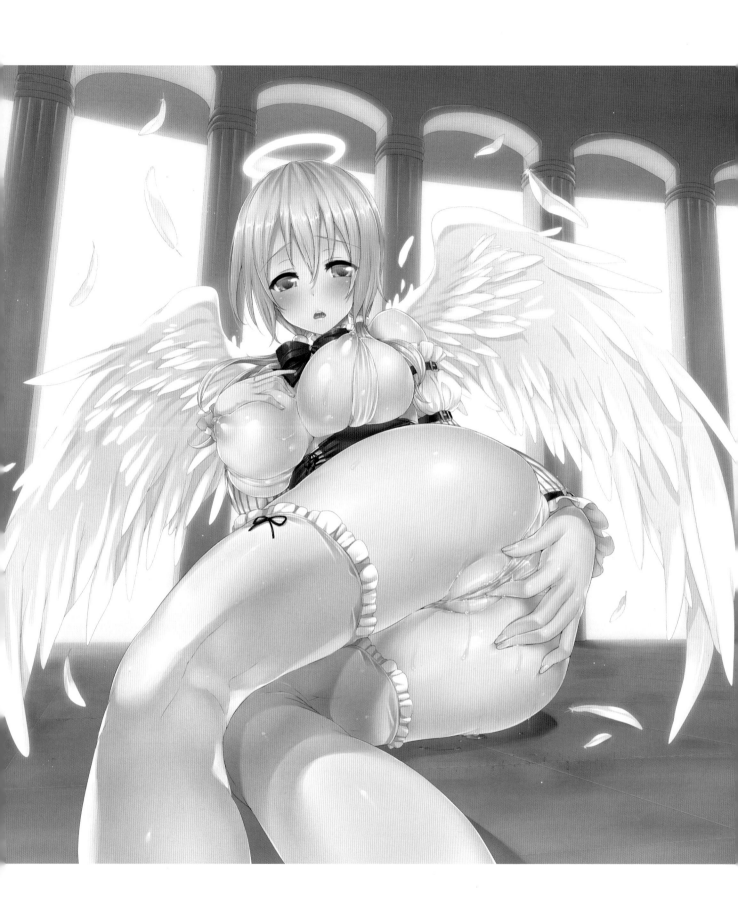

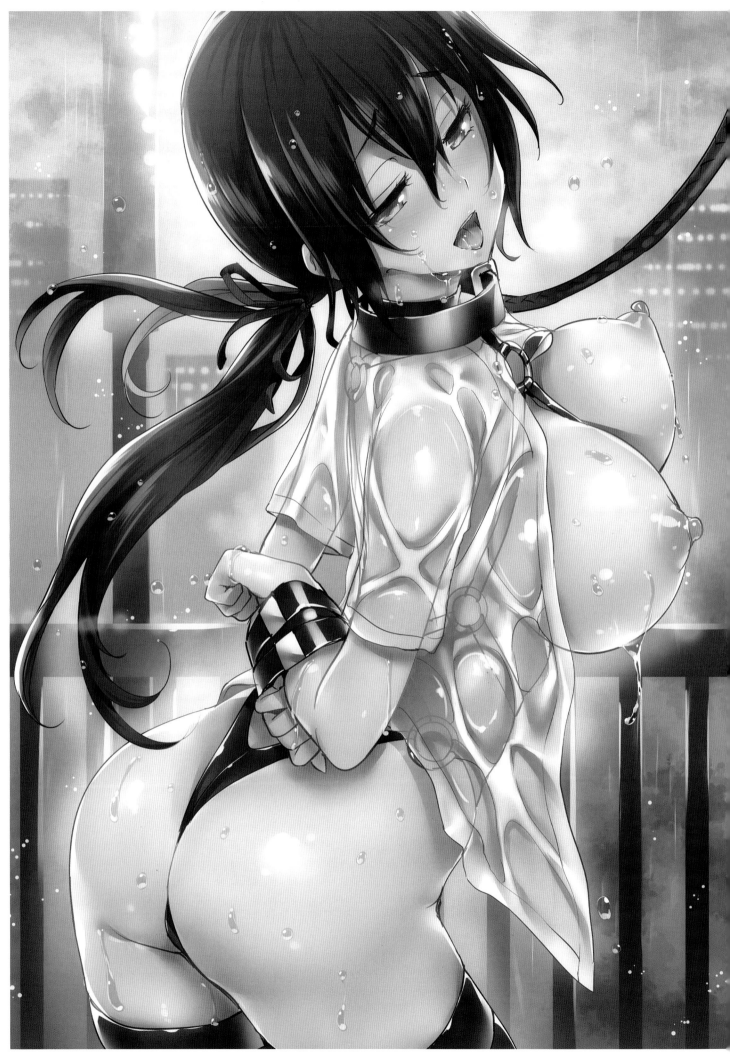

Limited M Girlfriend Masochistic Girl Anthology Toranoana & HMV Special Edition Illustration Card
2013

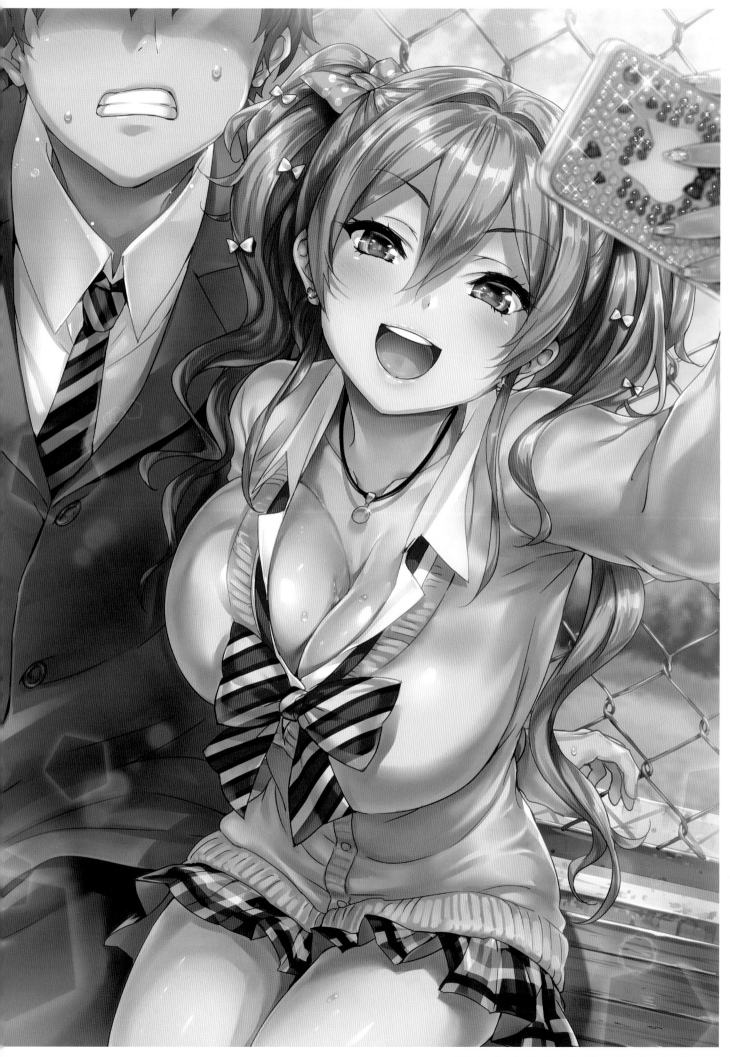

Is This Kogal Actually Being Nice to Me? Anthology Comic Cover Illustration
2017

Chapter:3
Other illustrations.

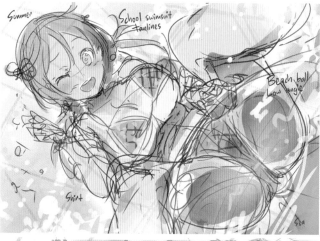

Summer

School swimsuit tanlines

Beach ball low angle

Shirt

Sea

Autumn library, love, with lust implied. Reading her harlequin novel without any concern for the leaves falling all over her. A fairly non-descript book cover, but she's blushing bright red. In truth, you're just looking because she's cute. I thought of a way to give it a sexual tone despite not having anything explicitly erotic.

Designer book cover. Harlequin novel

Autumn

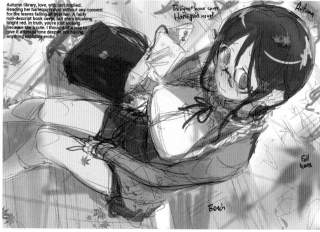

Fall leaves

Bench

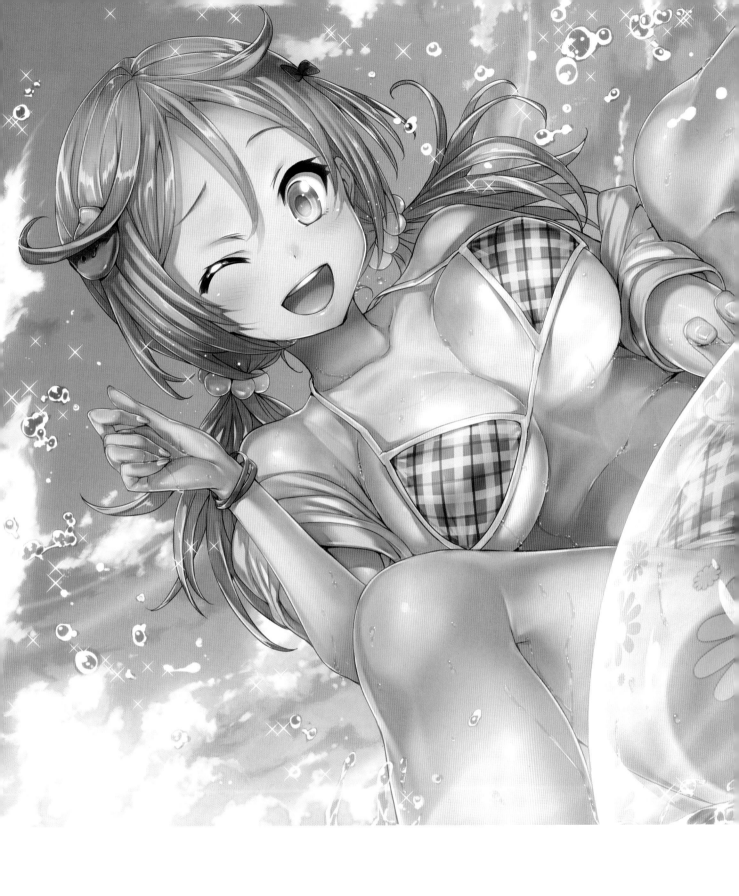

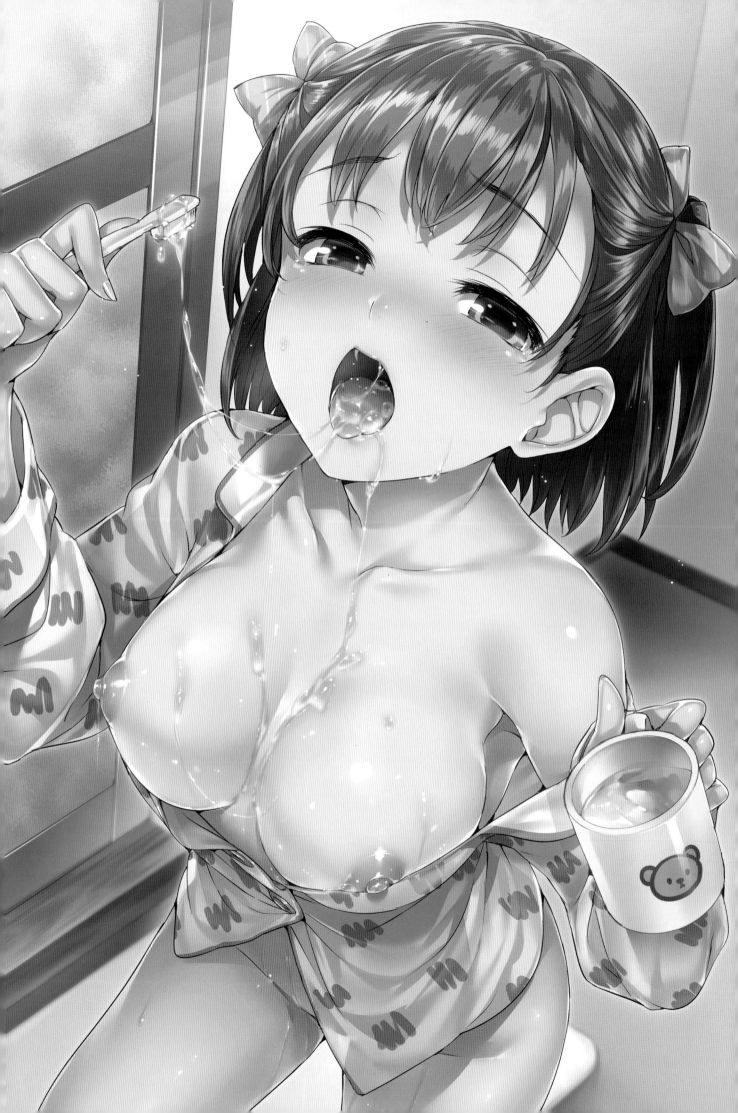

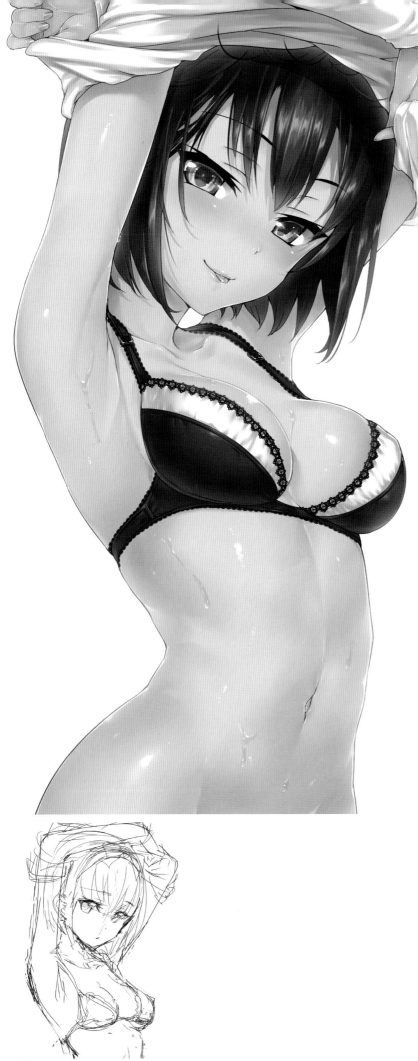

Early morning.
Wearing pajamas
at the bathroom
sink.

LEFT
Waniversary 2015. Special Edition Color Cover. Chie
2015

RIGHT
Wani Magazine Comic Fair 2014 Special Edition Clear File.
2014

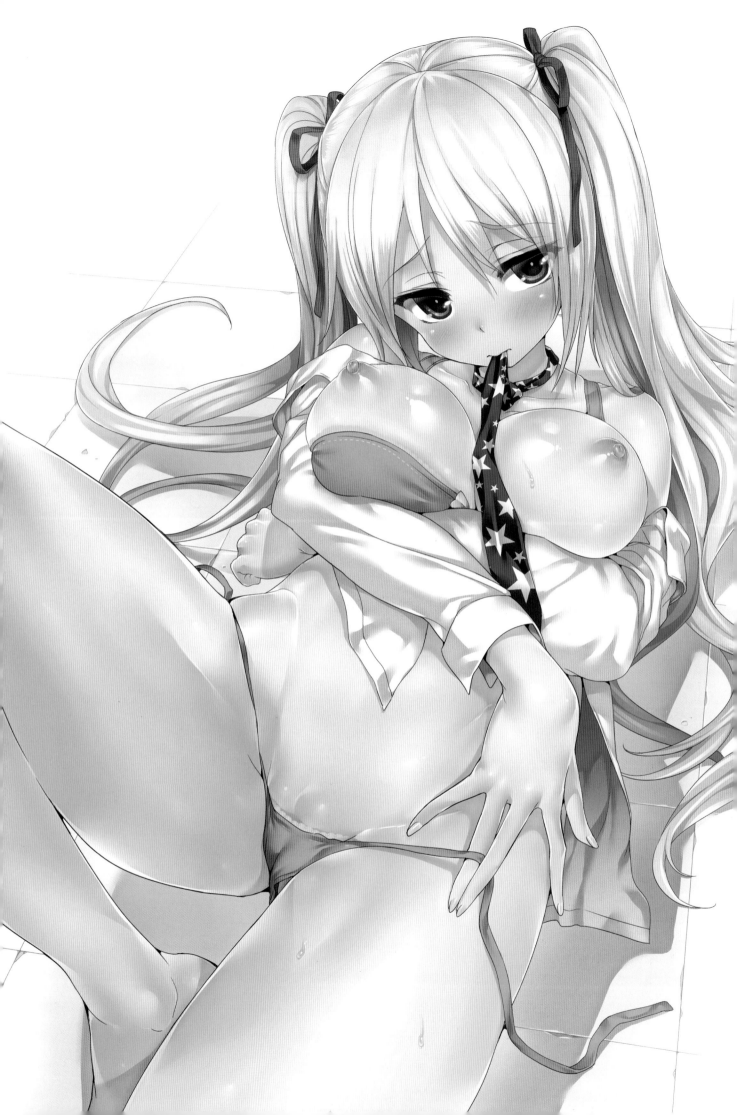

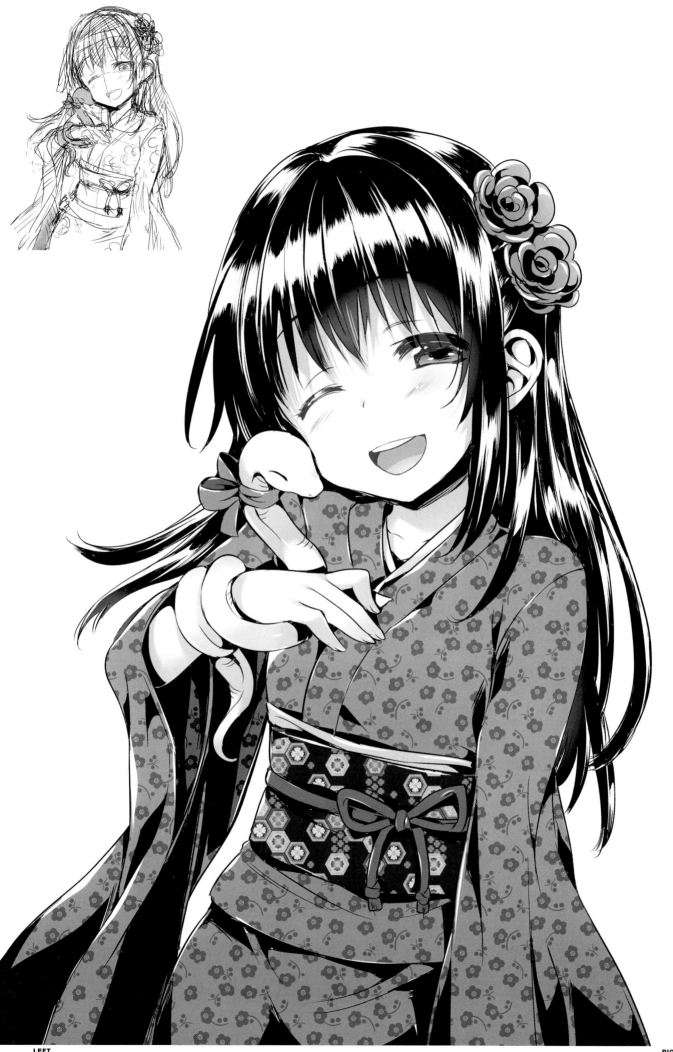

LEFT
Wani Magazine 2013 New Year's Card
2012

RIGHT
Toratsu 12-2011 Vol.175
2011

115 | Chapter:3_Other illustrations.

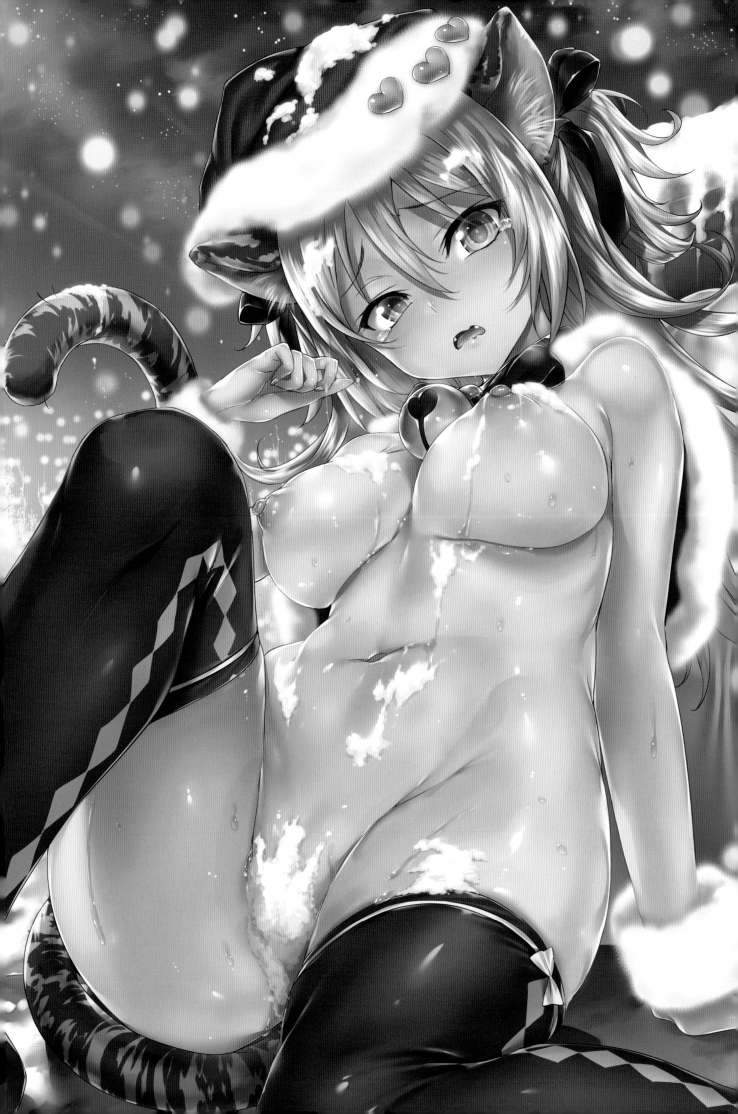

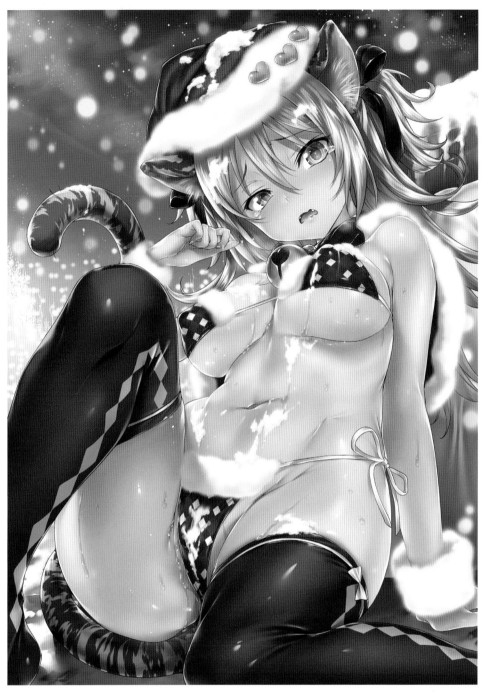

LEFT
Toranoana Girls Collection 2013 WINTER TYPE-A
2013

RIGHT
Toranoana Girls Collection 2013 WINTER TYPE-X
2013

117 | Chapter:3_Other illustrations.

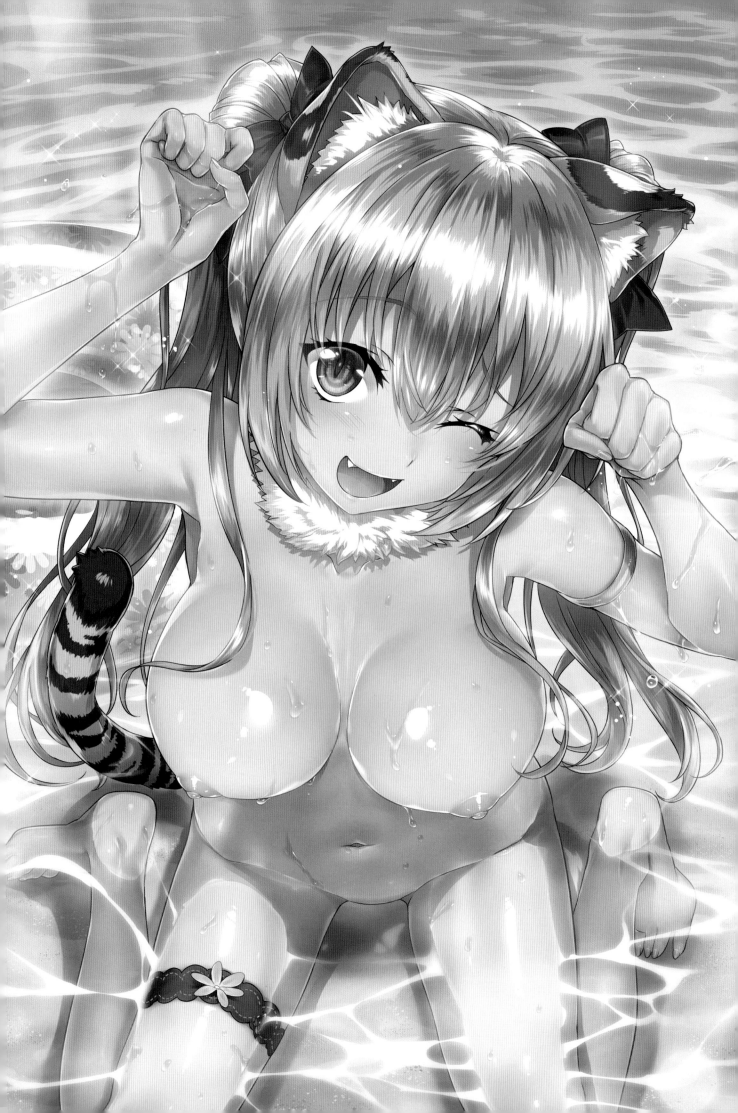

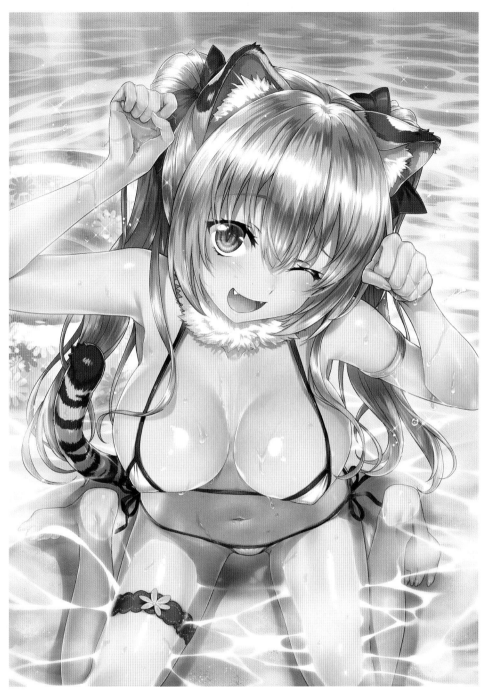

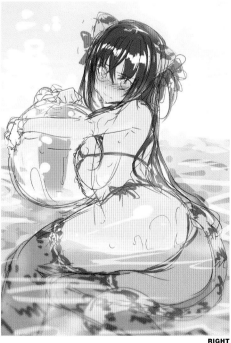

LEFT
Toranoana Girls Collection 2015 SUMMER TYPE-A
2015

RIGHT
Toranoana Girls Collection 2015 SUMMER TYPE-X
2015

119 | Chapter:3_Other illustrations.

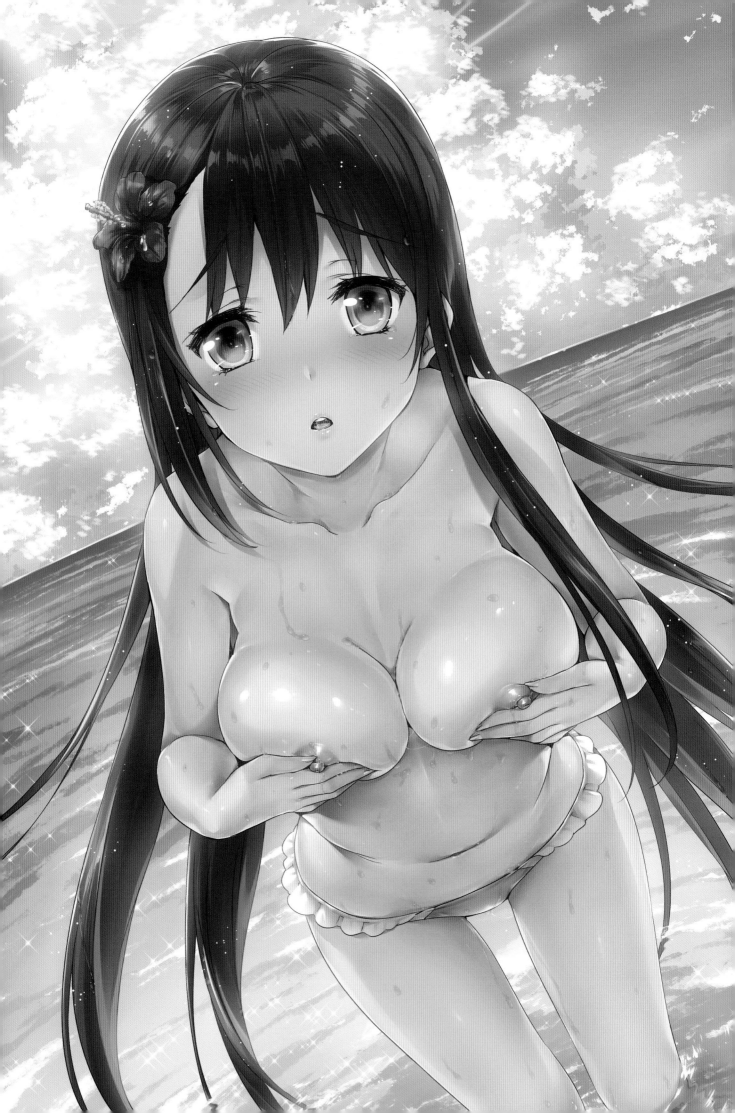

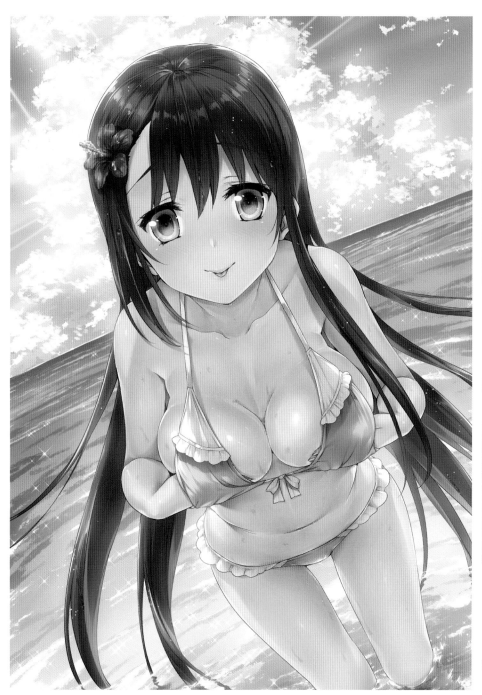

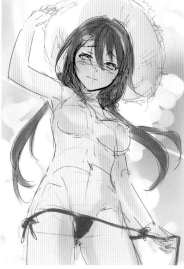

Wet, transparent T-shirt

Cupping her boobs inside her swimsuit.

LEFT
Toranoana Girls Collection 2017 SUMMER TYPE-B
2017

RIGHT
Toranoana Girls Collection 2017 SUMMER TYPE-XB
2017

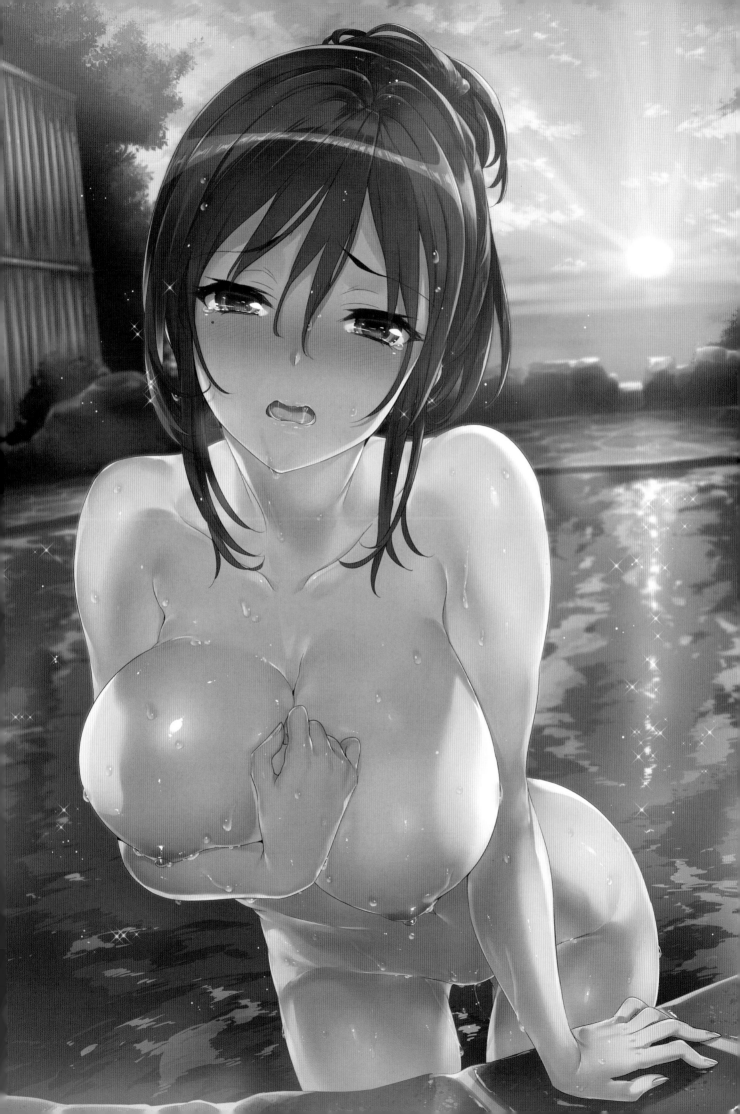

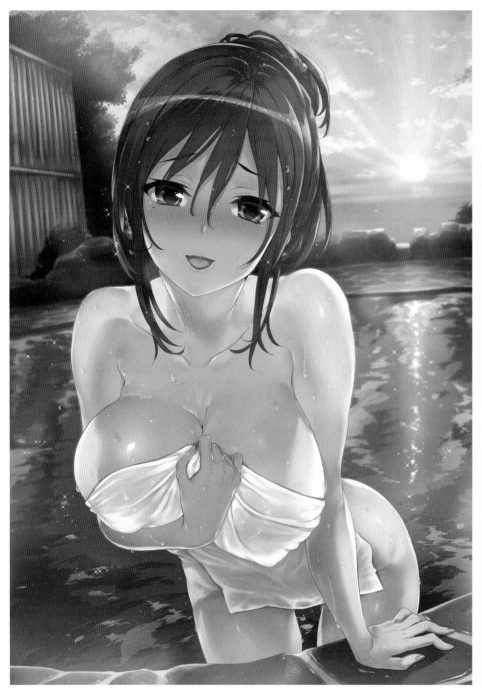

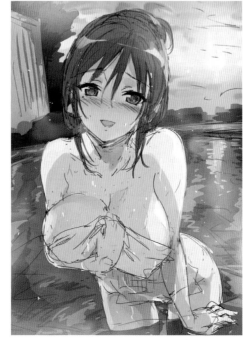

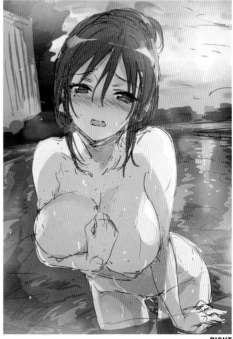

LEFT
Toranoana Girls Collection 2017 WINTER TYPE-A
2017

RIGHT
Toranoana Girls Collection 2017 WINTER TYPE-XA
2017

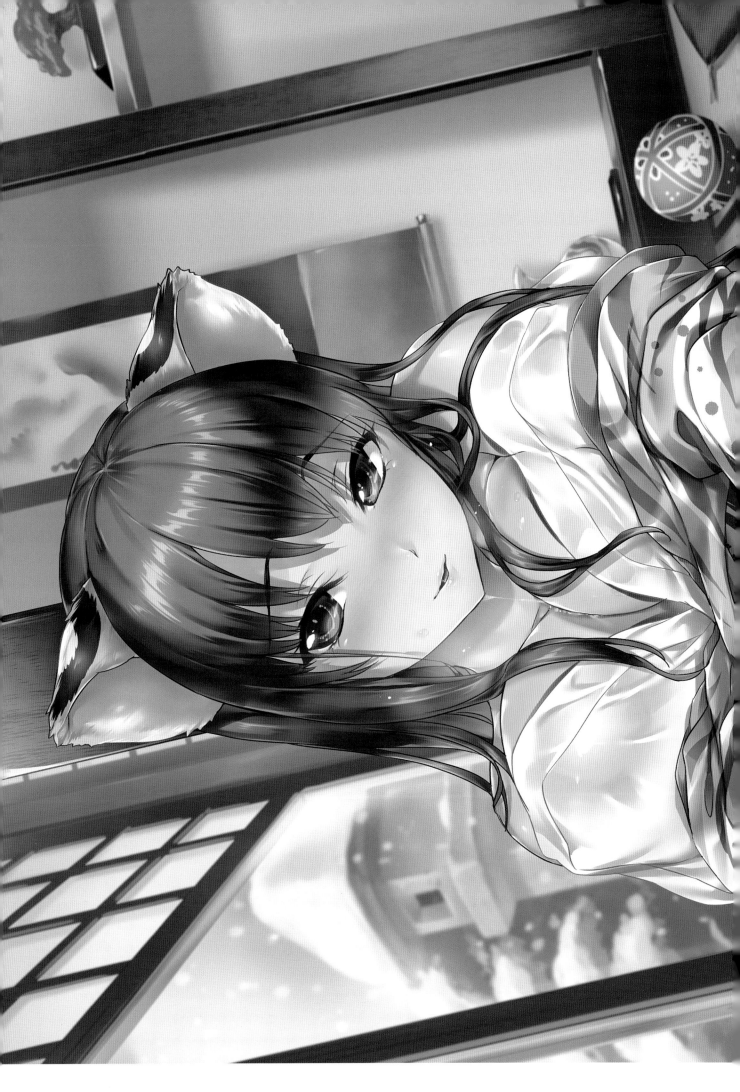

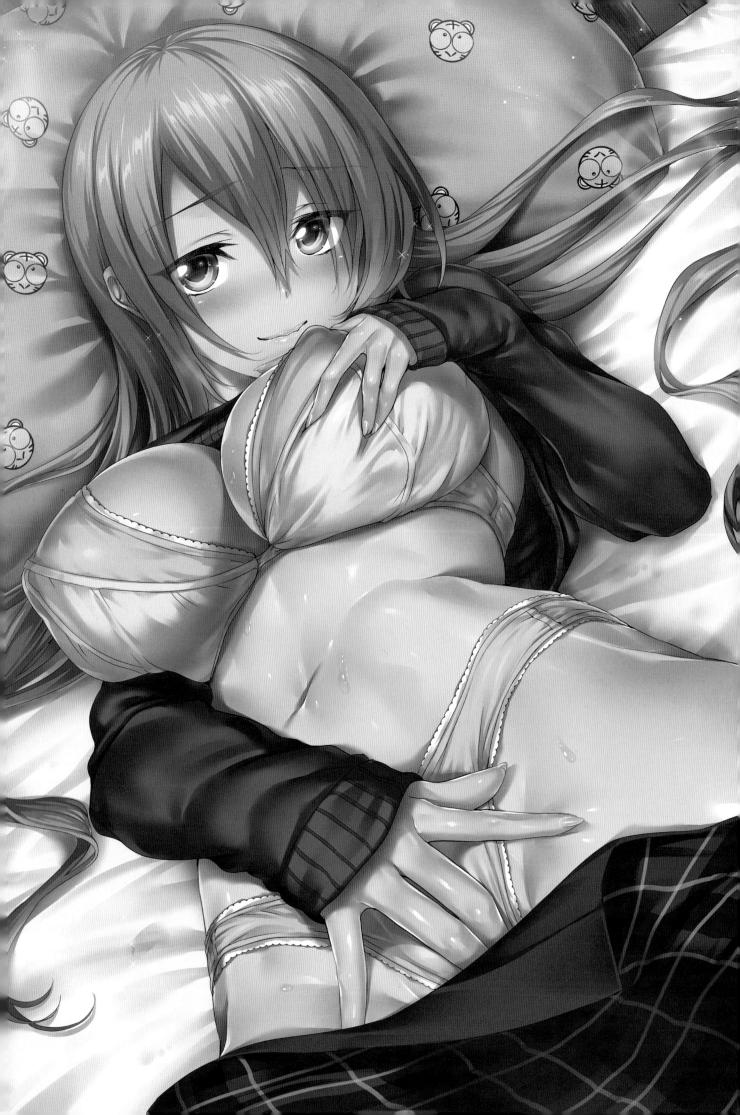

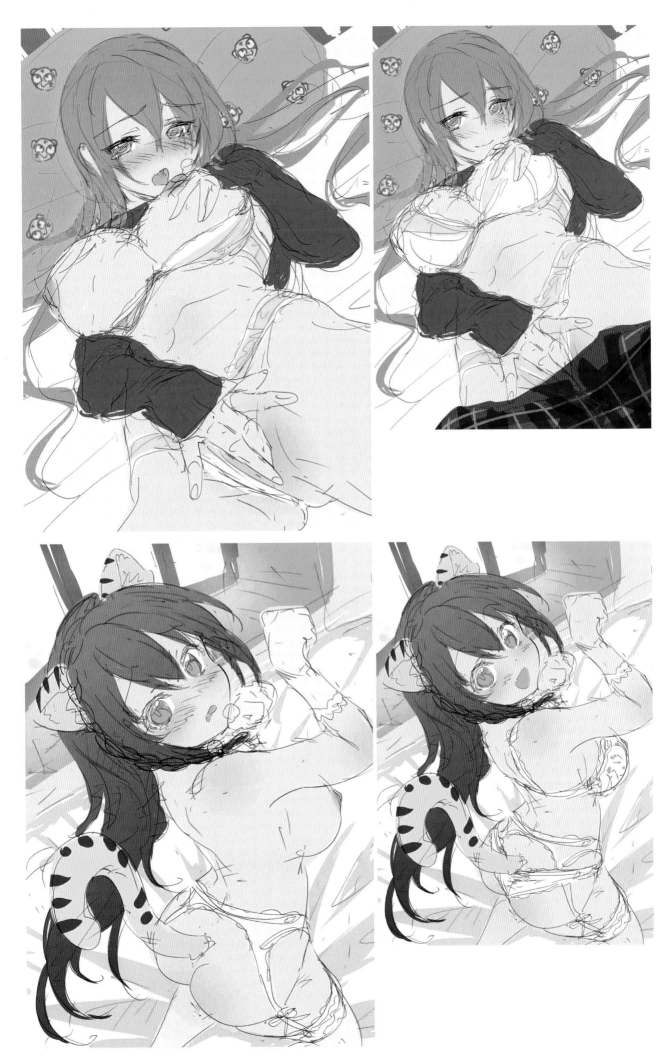

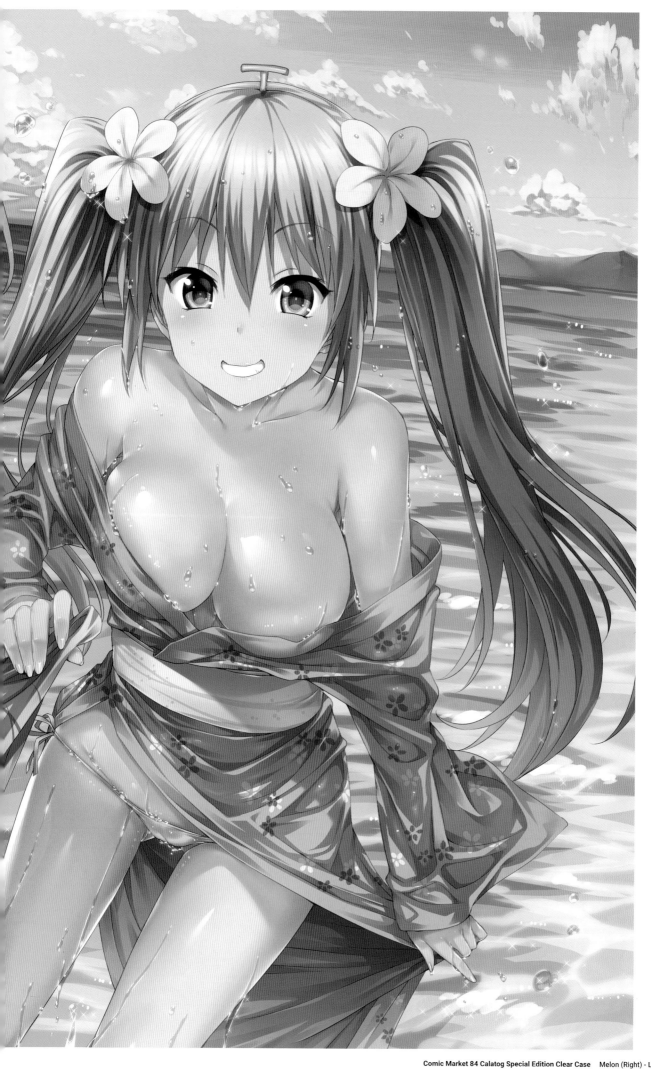

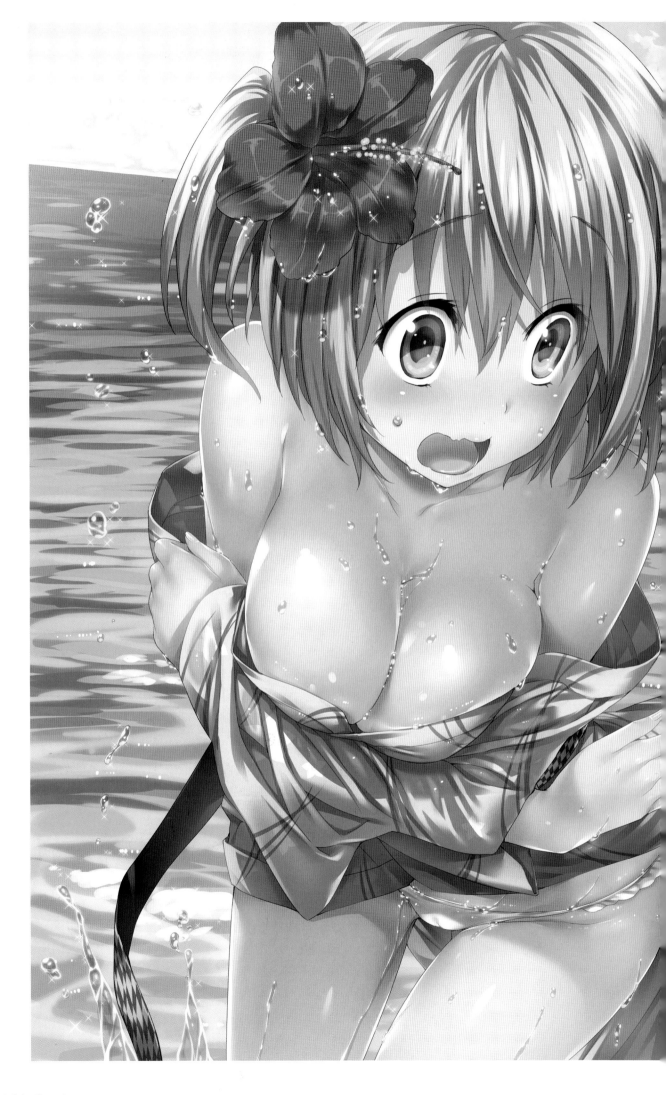

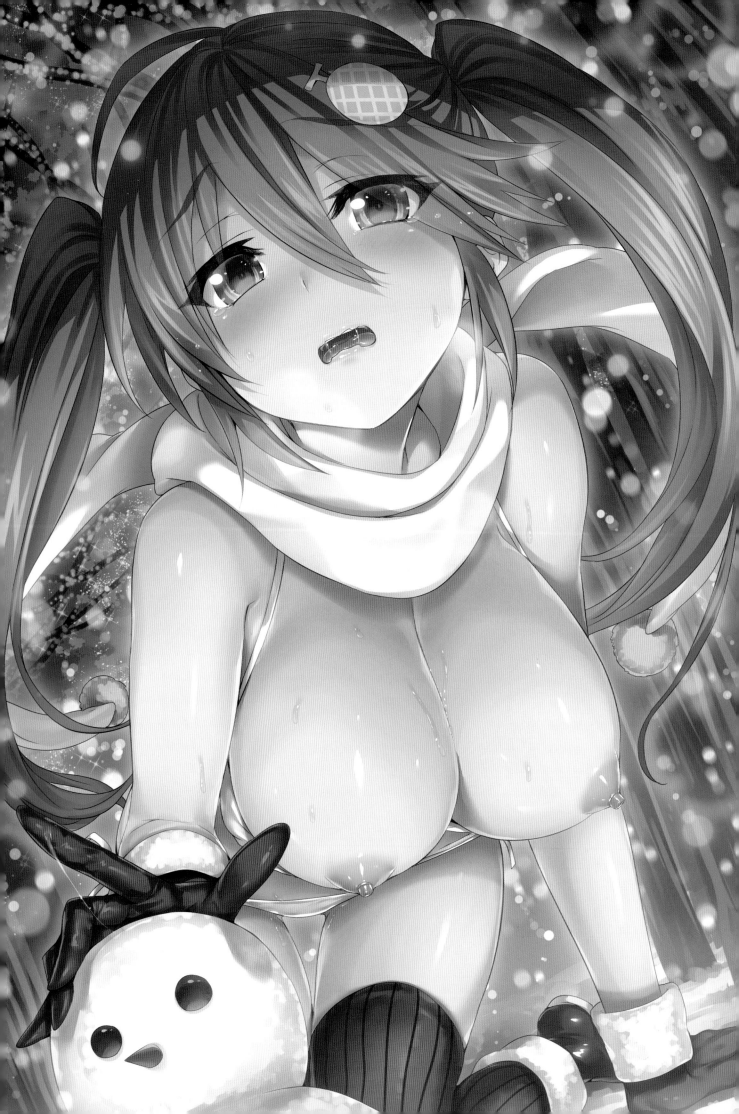

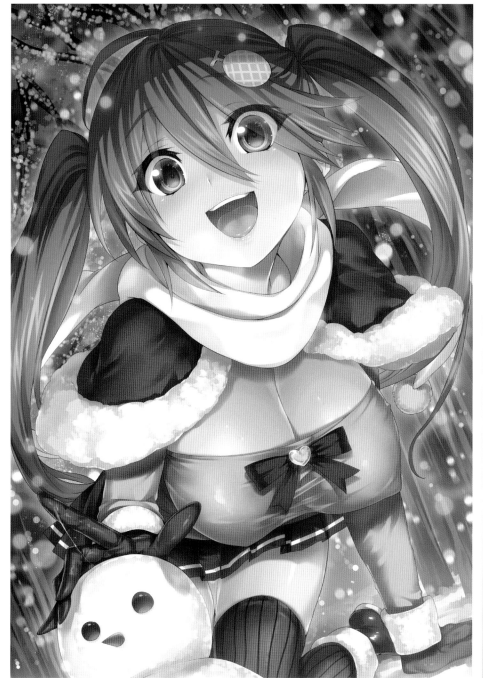

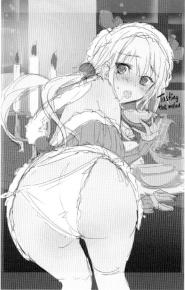

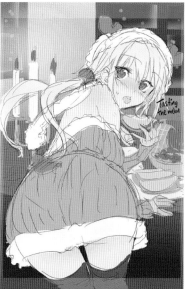

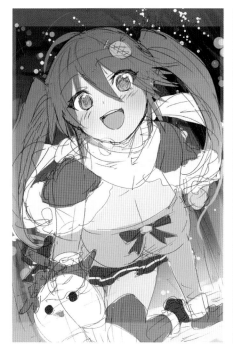

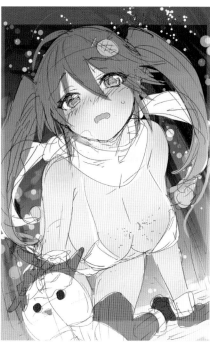

LEFT
Comic Market 91 Catalog Special Edition Illustration
2016

RIGHT
Comic Market 91 Catalog Special Edition B2-Size Tapestry
2016

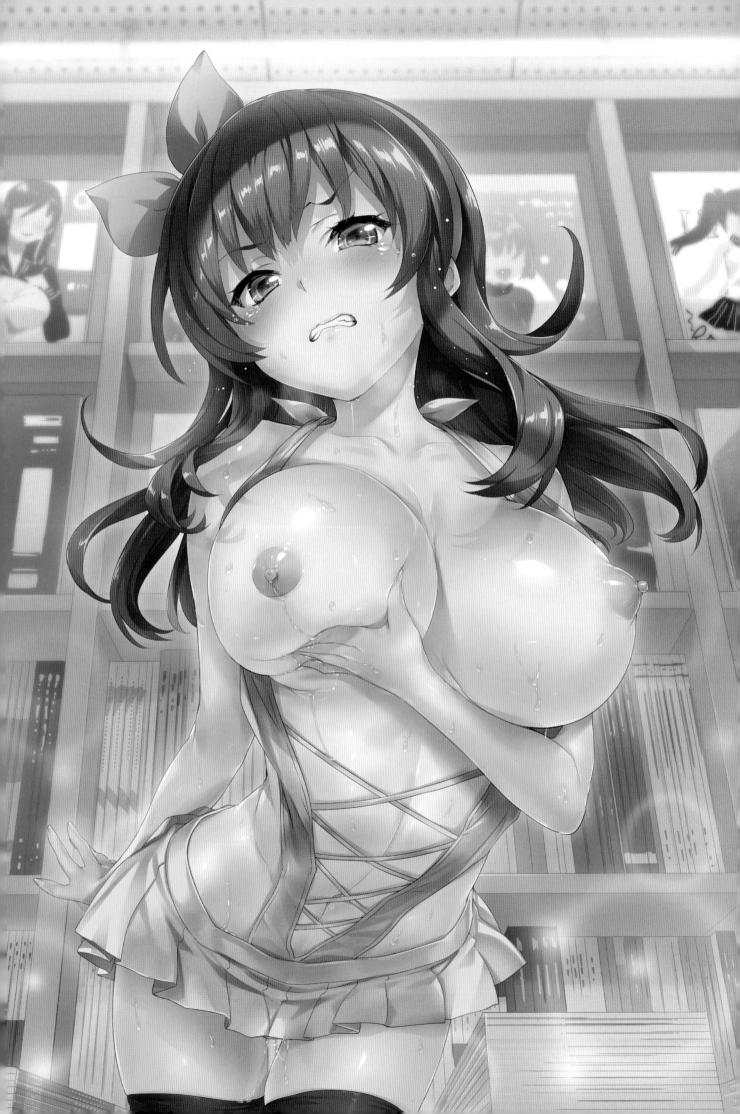

Ringo-chan's trying to reach a book really high up.

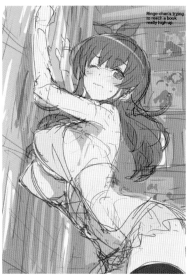

Ringo-chan's trying to reach a book really high up.

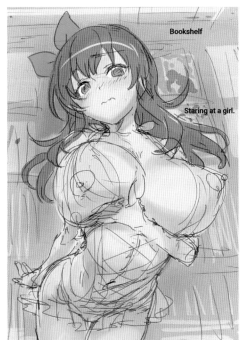

Bookshelf

Staring at a girl.

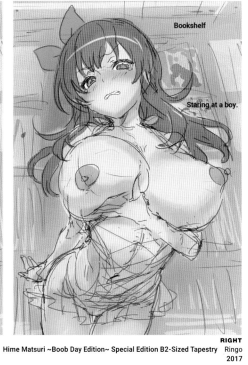

Bookshelf

Staring at a boy.

LEFT
Hime Matsuri ~Boob Day Edition~ Special Edition Book Cover Ringo
2017

RIGHT
Hime Matsuri ~Boob Day Edition~ Special Edition B2-Sized Tapestry Ringo
2017

133 | Chapter:3_Other illustrations.

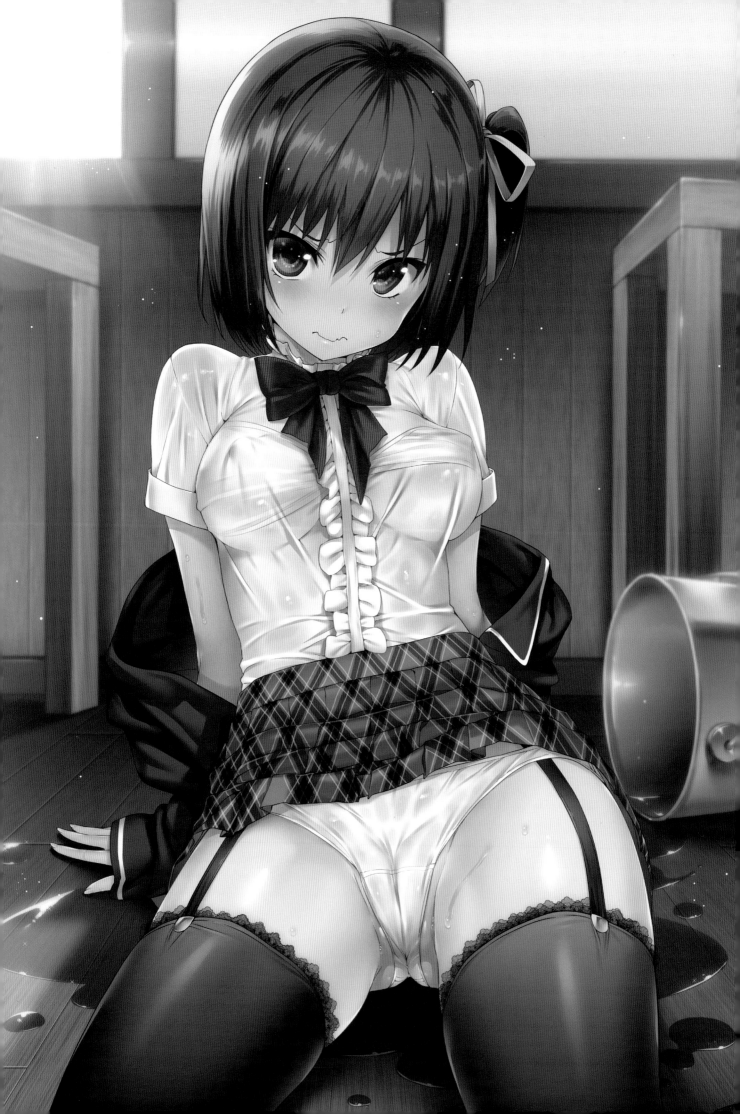

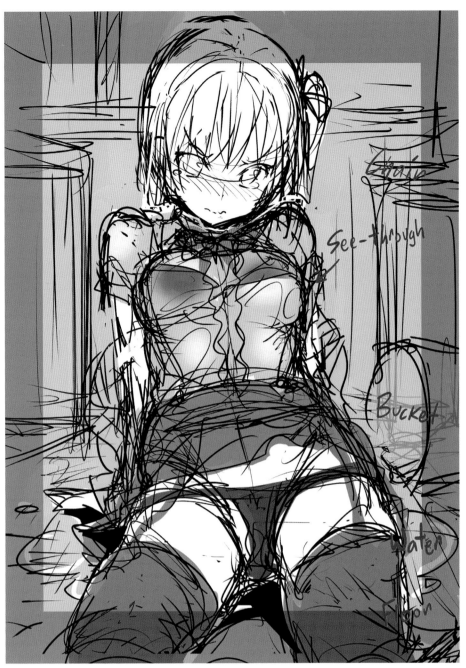

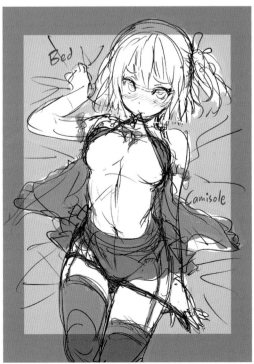

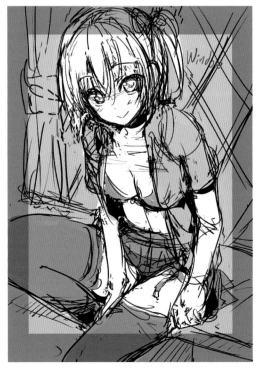

Mune-kyun Spring Fair Special Edition Clear File & Notepad Black Lemon
2014

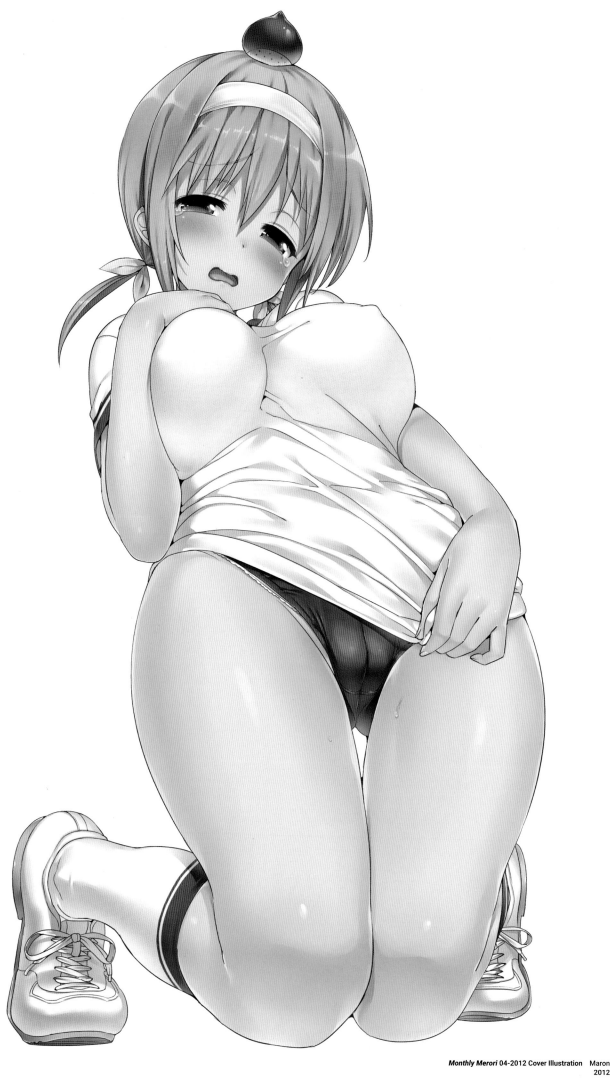

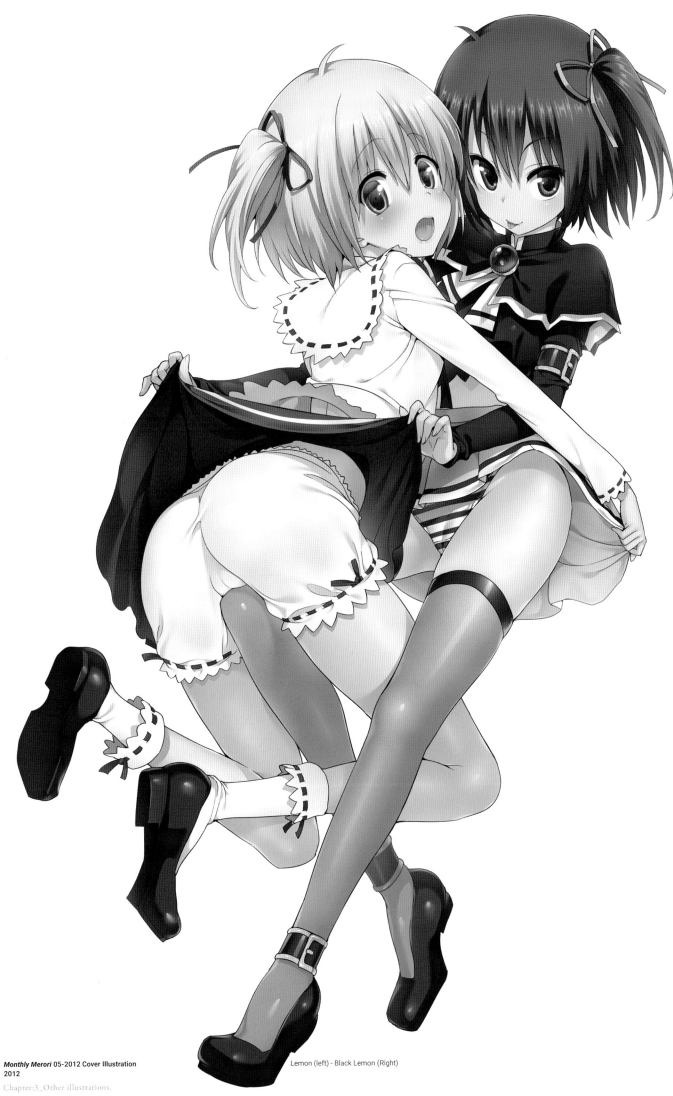

Lemon (left) - Black Lemon (Right)

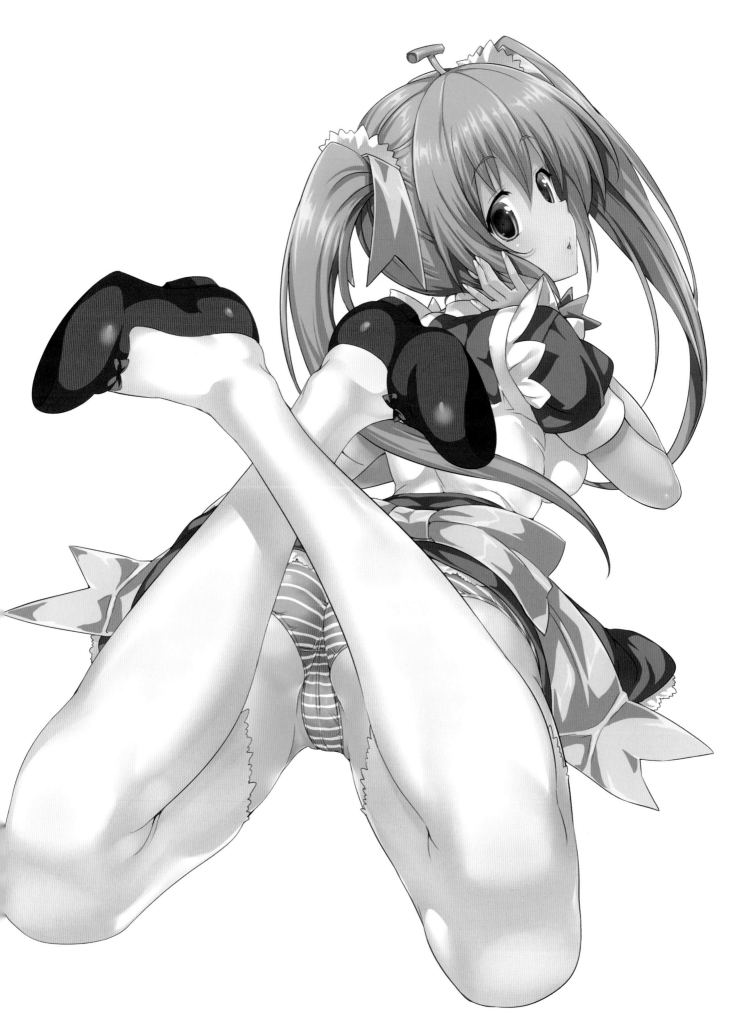

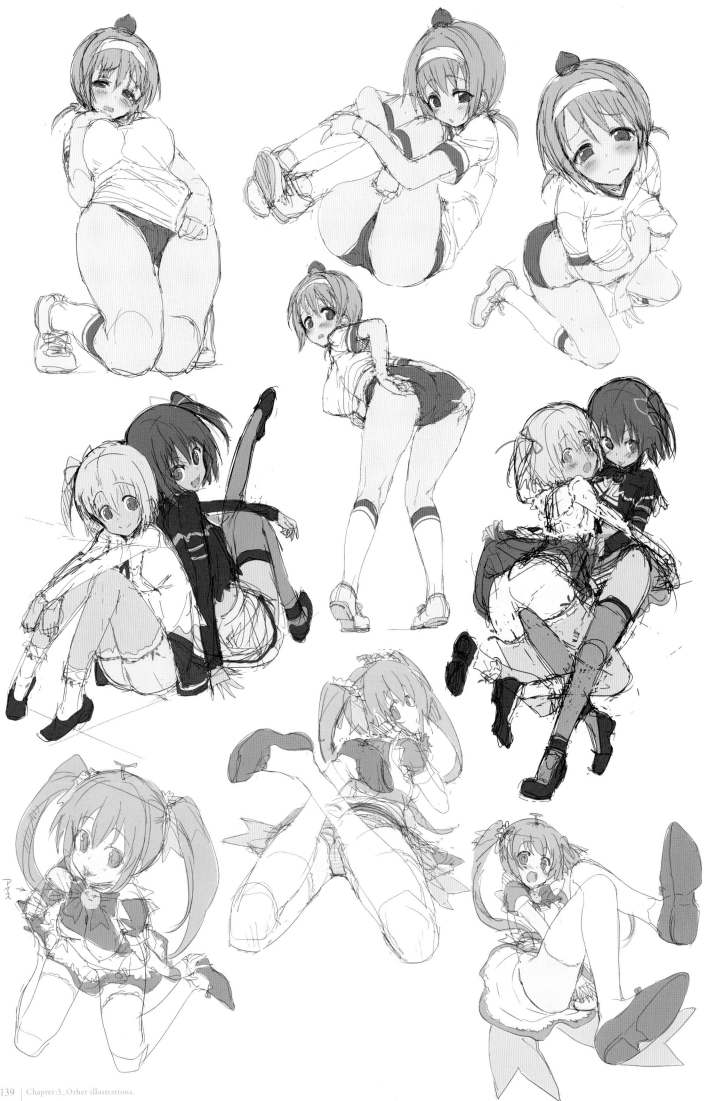

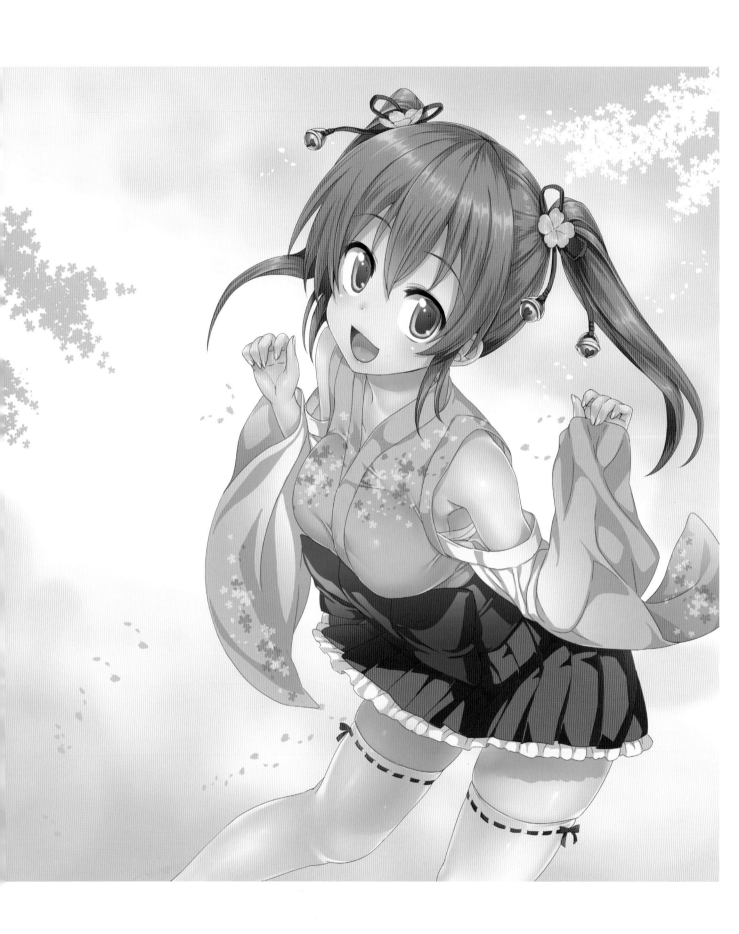

Continuous Attack! Tsubamekaeshi Strike! Ayame Package
2012

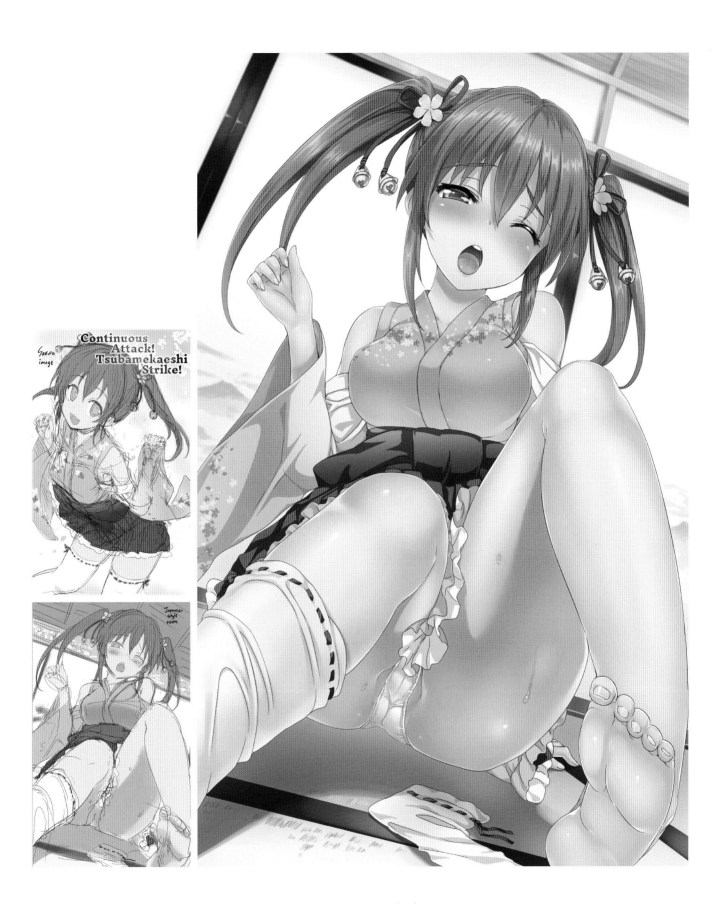

Continuous Attack! Tsubamekaeshi Strike!

Sakura image

Japanese-style room

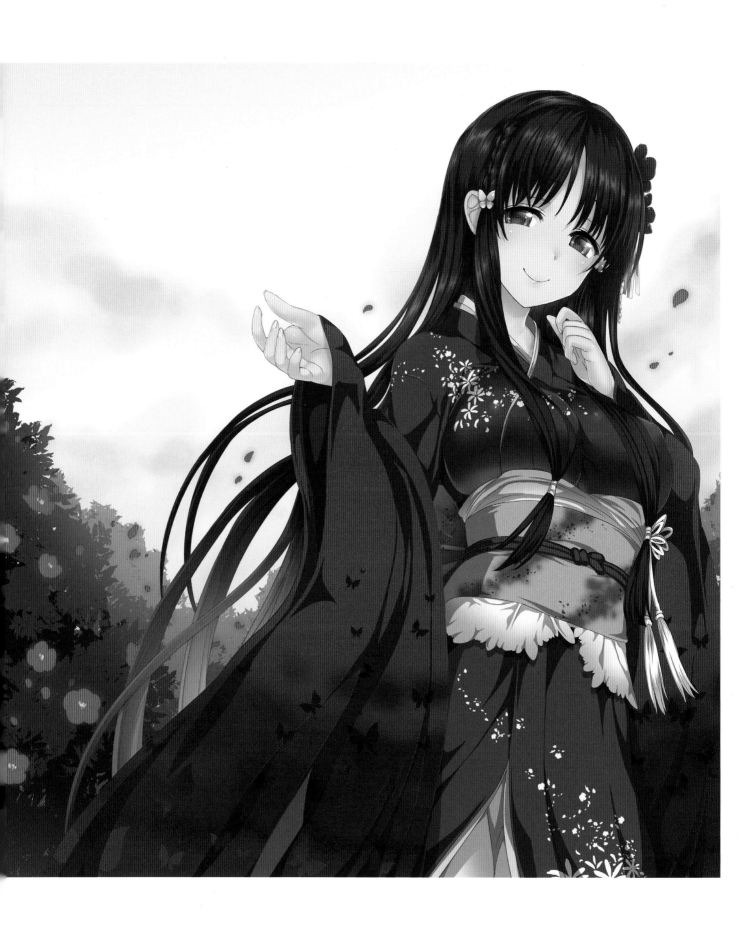

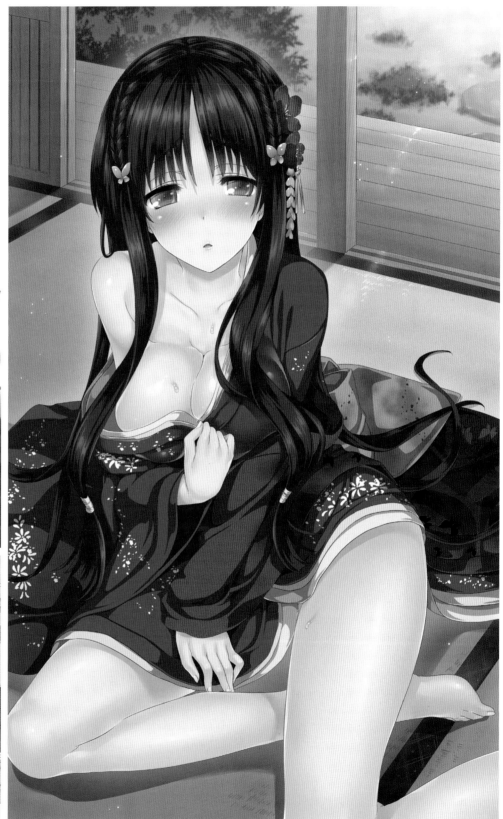

Continuous Attack! Tsubamekaeshi Strike!

A butterfly/peony image

Garden

Nighttime in a Japanese-style room

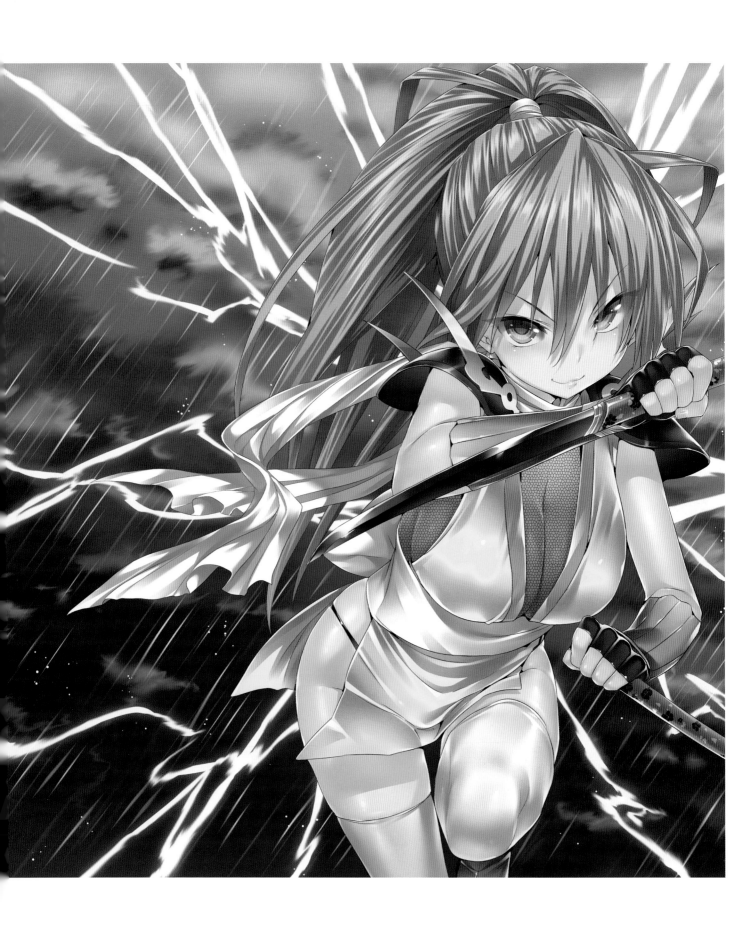

Third Strike! Tsubamekaeshi Electric Shock Raika Package
2013

Chapter:3_Other illustrations. | 144

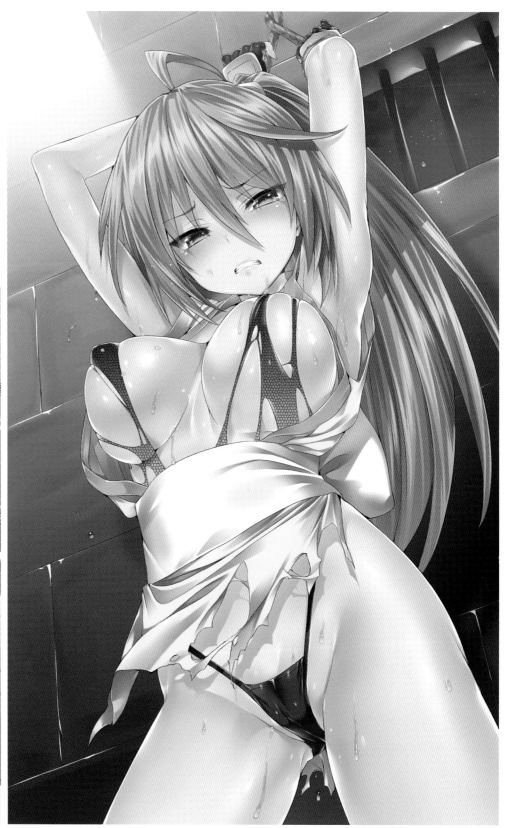

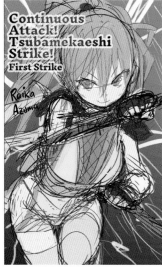

Continuous
Attack!
Tsubamekaeshi
Strike!
First Strike

Raika
Azuma

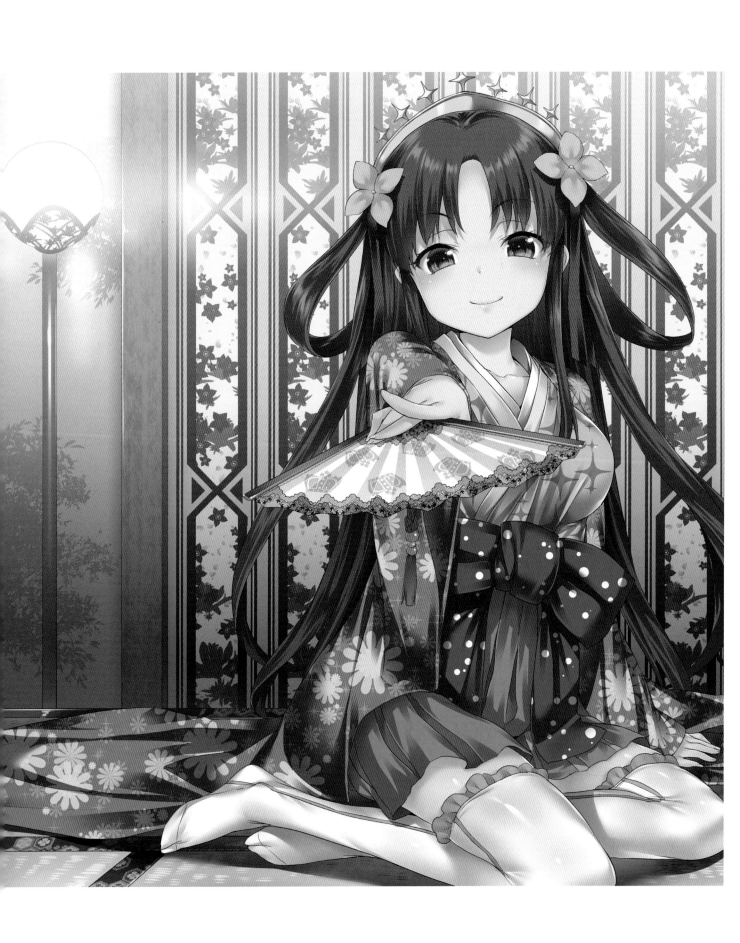

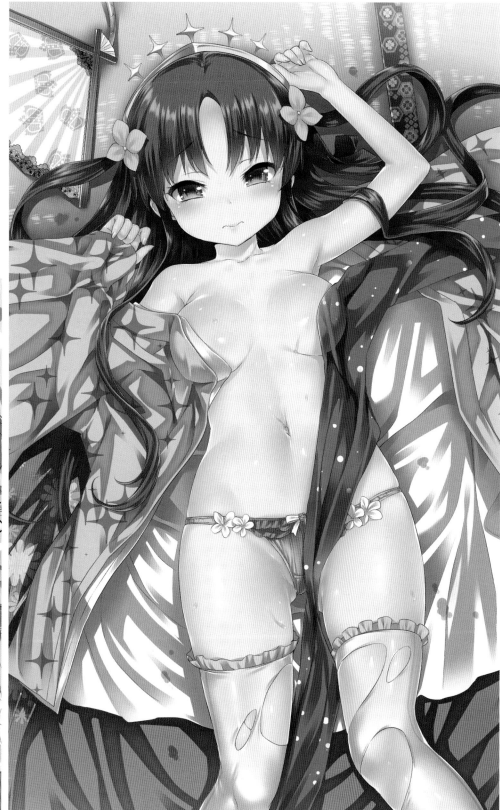

Continuous attack!
Tsubamekaeshi strike!

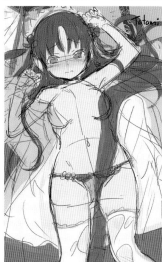

Column 1

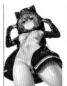

p.42
Comic X-EROS 03-2018 #63
Cover Illustration
2018

p.44
Comic Hana-Man 10-2015
Cover Illustration
2015

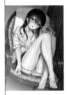

p.46
Comic X-EROS #55.56.57
Three consecutive issues worth of
Limited-Edition Posters
2017

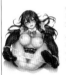

p.48
Comic Kairakuten BEAST Reader Present
Booklet "Ura BEAST" Cover Illustration
2017

A cover for "Ura BEAST" which was planned as a present for those who've continued to support *Kairakuten BEAST*. Normally, I'm not allowed to draw uniforms when it's sold at typical storefronts, but since this was a present, I got really excited at the chance to draw it. I think my true power really comes through in this one. (lol)

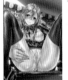

p.50
Comic Anthurium Vol.12
Cover Illustration (GOT)
2014

I got to work on a cover for a different company. It was expected to go on sale in the spring, so I went with a graduation theme. I focused primarily on getting that chunkiness to come through, as well as the reflection from the desk! I've never actually gotten the chance to do reflections like this before.

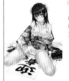

p.51
Comic Anthurium Vol.22
Cover Illustration (GOT)
2015

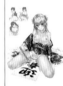

p.52,53
Comic Anthurium Vol.22
Cover Illustration (GOT)
Variants
2015

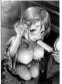

p.54
Comic Grape Vol.22
Cover Illustration (GOT)
2015

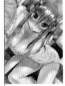

p.56
01-28-2013 "Daily Young Animal Island"
no. 21 (Hakusensha)
2012

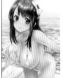

p.58
08-06-2013 "Daily Young Animal" no. 23
Index Reversible Poster (Hakusensha)
2013

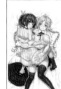

p.60
Comic Unreal 06-2015
supplementary pamphlet cover illustration
(Kill Time Communication)
2015

Column 2

p.20
Comic Kairakuten BEAST 08-2013
Cover Illustration
2013

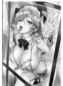

p.22
Comic Kairakuten BEAST 12-2013
Cover Illustration
2013

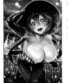

p.24
Comic Kairakuten BEAST 04-2014
Cover Illustration
2014

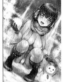

p.26
Comic Kairakuten BEAST 01-2015
Cover Illustration
2014

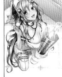

p.28
Comic Kairakuten BEAST 05-2015
Cover Illustration
2015

p.30
Comic Kairakuten BEAST 01-2016
Cover Illustration
2015

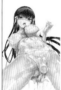

p.33
Comic X-EROS 05-2016 #41
Cover Illustration
2016

I've always been in charge of drawing covers for *Kairakuten BEAST*, but at this point, I got transferred to *COMIC X-EROS*. I was able to put a lot more emphasis on the girl's fluids and the transparency of her swimsuit.

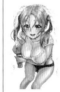

p.34
Comic X-EROS 10-2016 #46
Cover Illustration
2016

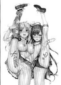

p.36
Comic X-EROS 02-2017 #50
Cover Illustration
2016

The idea behind this cover was to celebrate and cheer on *Comic X-EROS* for its 50th issue. I was a little worried about where they were gonna fit *X-EROS #50* but it worked out pretty well like this.

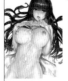

p.38
Comic X-EROS 07-2017 #55
Cover Illustration
2017

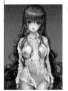

p.40
Comic X-EROS 01-2018 #61
Cover Illustration
2017

I tried my hand at a different coloring technique for this one. I was worried that it almost looked a little too real.

Column 3

First Appearances.

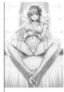

Extra
2018

The cover illustration I drew specifically for this book. I had trouble deciding what to include as the present box, but since I was going for a hard cover, I thought a wedding dress would really fulfill the splendor of it all. I'm gonna keep working hard to bring my works (daughters) to all of you without feeling too embarrassed about it.

Extra
2018

This illustration was a cover candidate, so I decided to use it and switch up the mood a bit with a hyper-colorful piece as a sort of present for you all.

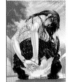

p.4
Comic Kairakuten BEAST 12-2011
Cover Illustration
2011

This is the illustration I drew for the first time I ever got to draw a cover for *Kairakuten BEAST*. I had never been given such an important task, so I remember the pressure being palpable. It was originally for "If We Meet on an Autumn Night..." but a friend of mine suggested I change it up.

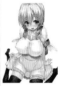

p.6
Comic Kairakuten BEAST 03-2012
Cover Illustration
2012

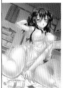

p.8
Comic Kairakuten BEAST 06-2012
Cover Illustration
2012

p.10
Comic Kairakuten BEAST 09-2012
Cover Illustration
2012

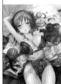

p.12
Comic Kairakuten BEAST 10-2012
Cover Illustration
2012

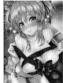

p.14
Comic Kairakuten BEAST 01-2013
Cover Illustration
2012

I always wanted to draw something with the theme of "I'm your present!" I fussed endlessly over how to tie the ribbon, but I really calmed down once I settled on this.

p.16
Comic Kairakuten BEAST 04-2013
Cover Illustration
2013

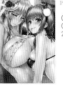

p.18
Comic Kairakuten BEAST 05-2013
Cover Illustration
2013

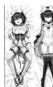

P.92,93,94,95

Every Girl Has Her Thorns
Chie Dakimakura Cover
2014

A dakimakura cover of Chie-chan from Every Girl Has Her Thorns. It feels like the two sides came out totally different. One's tense and the other is relaxed.

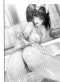

P.96,97

Every Girl Has Her Thorns
Chie Dakimakura Cover Special Edition Bath Poster
2014

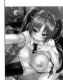

P.98

Devilish Girlfriend Cover Illustration (Kill Time Communication)
2013

The cover for a book I did for another publisher. It's about a half demon, half human girl who gets really naughty when she's in front of the guy she loves. I love the scene where she goes after her dead Kazuya-kun in his bed. (lol)

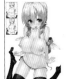

P.100,101

Devilish Girlfriend (Kill Time Communication)
Melon Books Special Edition Clear File
2013

P.102,103

Devilish Girlfriend (Kill Time Communication)
Animate Special Edition Message Sheet
2013

P.103

Devilish Girlfriend (Kill Time Communication)
Comic ZIN Special Edition Postcard
2013

P.103

Devilish Girlfriend (Kill Time Communication)
Manga King Special Edition Postcard
2013

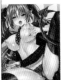

P.104

Akuno Mika Dakimakura Cover Magazine Mail Order Special Edition Telephone Card (Kill Time Communication)
2013

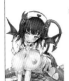

P.105

Comic Unreal Anthology "Reverse Rape Queens" Cover Illustration (Kill Time Communication)
2011

P.106

Comic Unreal "Color Comic Collection 3" Cover Illustration (Kill Time Communication)
2012

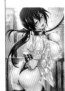

P.107

Limited M Girlfriend Masochistic Girl Anthology (Houbunsha)
Toranoana & HMV Special Edition Illustration Card
2013

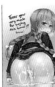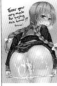

P.73

Porno Switch
Toranoana Special Edition Pamphlet
2012

P.74,75,76,77

Porno Switch Kurahashi Yuri Dakimakura Cover
2012

This is an illustration I did for a dakimakura cover that was sold at Wani Magazine's Comiket booth. At the time, my PC specs were still pretty darn low, so I remember it taking forever to work on. Even now, dakimakura files are so large that it takes a long time to finish.

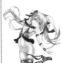

P.78

Every Girl Has Her Thorns Cover Illustration
2013

If you count my work for another publisher, this was actually my third book. They even put it on an app. Chie-chan's got such a cherubic air about her that there's something fascinating about her.

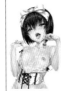

P.80

Every Girl Has Her Thorns Rear Cover Illustration
2013

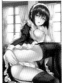

P.82

Every Girl Has Her Thorns Compilation Illustration
2013

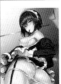

P.84

Every Girl Has Her Thorns
Toranoana Special Edition Pamphlet
2013

P.85

Every Girl Has Her Thorns
Toranoana Special Edition Pmphlet
2013

P.86,87

Every Girl Has Her Thorns
Melon Books Special Edition Clear Stick poster
2013

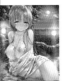

P.88

Every Girl Has Her Thorns
Toranoana Special Edition B2-Sized Tapestry
2013

This is Hanabi-chan from "A Summer Festival's Night" in the book Every Girl Has Her Thorns. It came out as a monochrome release, but if she was in color, she'd look like this. I love drawing hot springs!

P.90

Every Girl Has Her Thorns
Comic ZIN Special Edition Postcard
2013

P.91

Every Girl Has Her Thorns
Manga King Special Edition Postcard
2013

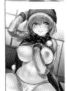

P.62,63

Porno Switch Cover Illustration
2012

This is the cover of my first book, so I've got fond memories of this one. Thankfully, I even managed to make it into the rankings for that year, so it left me very happy indeed.

P.65

Porno Switch Rear Cover Illustration
2012

P.66

Porno Switch Compilation Illustration
2012

P.67

Porno Switch Compilation Illustration
2012

P.68

Porno Switch
Comic ZIN Special Edition Postcard
2012

P.68,69

Porno Switch
Melon Books Special Edition Clear Stick Poster
2012

P.69

Porno Switch
Manga King Special Edition Postcard
2012

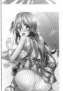

P.69

Porno Switch
Participating Retailers Special Edition Postcard
2012

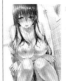

P.70

Porno Switch
Toranoana Special Edition Bath Poster
2012

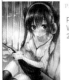

P.71

Porno Switch
Wani Magazine Special Edition Illustration Card
2012

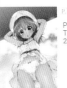

P.72

Porno Switch
Toranoana Special Edition Pamphlet
2012

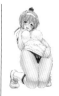

P.136

Monthly Merori 04-2012 Cover Illustration
(Melon Books)
2012

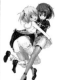

P.137

Monthly Merori 05-2012 Cover Illustration
(Melon Books)
2012

P.138

Monthly Merori 06-2012 Cover Illustration
(Melon Books)
2012

This is an illustration I did for Melon Books of
Melon-chan and it was given away as free
leaflets. I primarily focused on the view of her
panties from behind and those chunky butt
cheeks.

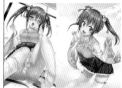

P.140,141

Continuous Attack!
Tsubamekaeshi Strike!
Ayame Package (Prime)
2012

A package illustration for
an onahole, so I tried my
best to capture the
cuteness and sexiness so
that you'd wanna use it.

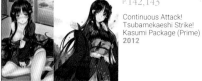

P.142,143

Continuous Attack!
Tsubamekaeshi Strike!
Kasumi Package (Prime)
2012

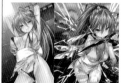

P.144,145

Third Strike!
Tsubamekaeshi Electric
Shock Raika Package
(Prime)
2013

P.146,147

Grand Strike!
Tsubamekaeshi God Strike
Mikoto Package (Prime)
2013

P.120,121

Right / Toranoana Girls
Collection 2017
SUMMER TYPE- XB
(Toranoana)
Left / Toranoana Girls
Collection 2017
SUMMER TYPE-B
(Toranoana)
2017

P.122,123

Right / Toranoana Girls
Collection 2017
WINTER TYPE-XA
(Toranoana)
Left / Toranoana Girls
Collection 2017
WINTER TYPE-A
(Toranoana)
2017

P.124,125

Toranoana Girls Collection 2015 WINTER
TYPE-B (Toranoana)
2015

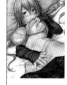

P.126

Comic Market 91 Catalog Special Edition
Clear Desk Pad (Toranoana)
2016

I got the privilege to draw for Comiket's
catalog. Don't you find love sleeves sexy
when you can see her underwear anyways? I
really hope I managed to capture that in this
piece.

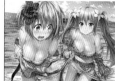

P.128,129

Comic Market 84 Calatog
Special Edition Clear Case
(Melon Books)
2013

P.130,131

Right / Comic Market 91
Catalog Special Edition
B2-Size Tapestry
Left / Comic Market 91
Catalog Special Edition
Illustration (Melon
Books)
2016

P.132,133

Right / Hime Matsuri
~Boob Day Edition~
Special Edition
B2-Sized Tapestry
Left / Hime Matsuri ~Boob
Day Edition~ Special
Edition Book Cover
(Melon Books)
2017

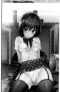

P.134

Mune-kyun Spring Fair Special Edition Clear
File & Notepad (Melon Books)
2014

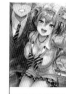

P.108

Is This Kogal Actually Being Nice to Me?
Anthology Comic
Cover Illustration (Ichijinsha)
2017

P.110,111

BONNOU FESTIVAL 108 Exhibit
Illustration (Getsureisha)
2014

My contribution to BONNOU
FESTIVAL 108: The theme was
worldly desires, so I went for
summer, beach, tanlines, and a low
angle shot!

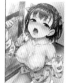

P.112

Wani Magazine Comic Fair 2014
Special Edition Clear File.
2014

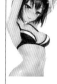

P.113

Waniversary 2015
Special Edition Color Cover
2015

P.114

Toratsu 12-2011 Vol.175 (Toranoana)
2011

P.115

Wani Magazine 2013 New Year's Card
2012

P.116,117

Right / Toranoana Girls
Collection 2013
WINTER TYPE-X
(Toranoana)
Left / Toranoana Girls
Collection 2013
WINTER TYPE-A
(Toranoana)
2013

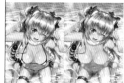

P.118,119

Right / Toranoana Girls
Collection 2015
SUMMER TYPE-X
(Toranoana)
Left / Toranoana Girls
Collection 2015
SUMMER TYPE-A
(Toranoana)
2015

Contributors

Houbunsha	Getsureisha	Ichijinsha
Melon Books	GOT	Kilik
Prime	Toranoana	Kill Time Communication
	Hakusensha	

Thank you for picking up my very first art book, "H girl".

I always hoped I could someday release an art book, so I have to thank my fans for supporting me,

my lead editor, S-san, for putting this plan into motion, my designer, and of course, the fine people at

Wani Magazine for making the call to bring it to market. As the title of the book suggests, this is a

collection of various artworks I've completed between 2011 and 2018.

This has given me the chance to look back at a lot of my old work, and it's been quite a feeling to

reminisce about all the years I've been doing this. I feel truly blessed to have had your support over

the years, which has helped me keep working up until now.

I hope to continue bringing my work to the entire world in all sorts of ways, so I'll be counting on you

to keep cheering me on.

Drawing Windows 10 / Inter Core i7 4.20GHz
Environment Intuos 4

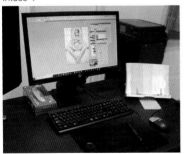

My work environment is rather simple. I have a pen
tablet and a reference stand along with my mobile
phone. A while back, I tried using a tablet screen,
but it didn't really work for me, so I ended up
returning to my pen tab after a few attempts.

Drawing CLIP STUDIO PAINT EX
Software Adobe Photoshop CS5.1

Hobbies Gaming
 Film Festivals

H girl

Hisasi
2011-2018

First published in Japan on January 20, 2019
by WANIMAGAZINE CO.,LTD.

English Edition published on August 24, 2023
by FAKKU, LLC. All rights reserved.

Publishing Team:
Jacob Grady
Brittany Elise
Sebastien Azar
Ryan Jorgensen
Gonzalo Recio
Kimmy N
Chris Champoux
John Seiler

FAKKU, LLC
contact@fakku.net

Printed in Hong Kong, China
ISBN-10: 1-63442-397-6
ISBN-13: 978-1-63442-397-7

FAKKU
BOOKS